UNDERWATER
PHOTOGRAPHY

CHARLES SEABORN

AMPHOTO
AN IMPRINT OF WATSON-GUPTILL PUBLICATIONS/NEW YORK

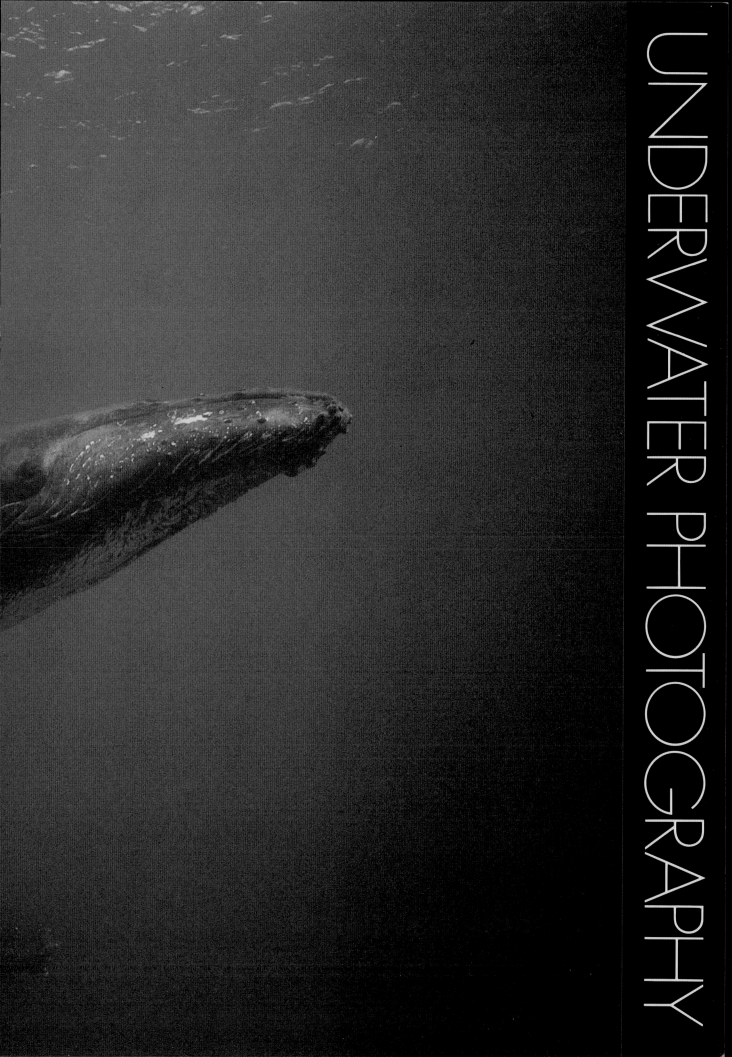

UNDERWATER PHOTOGRAPHY

Subjects for underwater photography abound in number and diversity. The humpback whale (frontispiece) and the manta ray (opposite) were photographed in Maui, Hawaii; the brittlestar (acknowledgments) in Roatan, Honduras; and the nudibranch (contents) and the diver (foreword) in Puget Sound in Washington.

Copyright © 1988 by Charles Seaborn

First published 1988 in New York by AMPHOTO,
an imprint of Watson-Guptill Publications,
a division of Billboard Publications, Inc.,
1515 Broadway, New York, NY 10036

Library of Congress Cataloging in Publication Data

Seaborn, Charles
　　Underwater photography / Charles Seaborn.
　　Includes index.
　　ISBN 0-8174-6335-6　　ISBN 0-8174-6336-4 (pbk.)
　　1. Underwater photography.　I. Title.
TR800.S43　1988　　　　　　　　　　88-14551
778.7'3—dc19　　　　　　　　　　　　CIP

Manufactured in Japan

2 3 4 5 6 7 8 9/96 95 94 93 92 91 90

*To my parents, Nora and John Seaborn,
and my brother, Christian.*

My sincere thanks to the following people and companies for their contributions of time, equipment, services, and advice, which helped me to prepare this book: ALM Airlines; Aqua Visions Systems, Inc.; the entire staff (including Zinger) at the CoCo View Resort, Roatan, Honduras; Linda Riemensnider at DIVI Hotels, Bonaire; Al Politi and John Mahaffey at Eastman Kodak, Inc.; Paul Schutt, Roth Muy, and Dan Kasberger at Helix; Christopher Leinberger at Robert Charles Lesser & Co.; Gale Livers at Ikelite, Inc.; Blain Roberts and the crew at Lahaina Divers, Inc., Maui, Hawaii; the Maui Islander Hotel; Frank Fennel at Nikon, Inc.; and Tan Sahsa Airlines.

Special thanks to my good friend and diving companion, Robert Frerck.

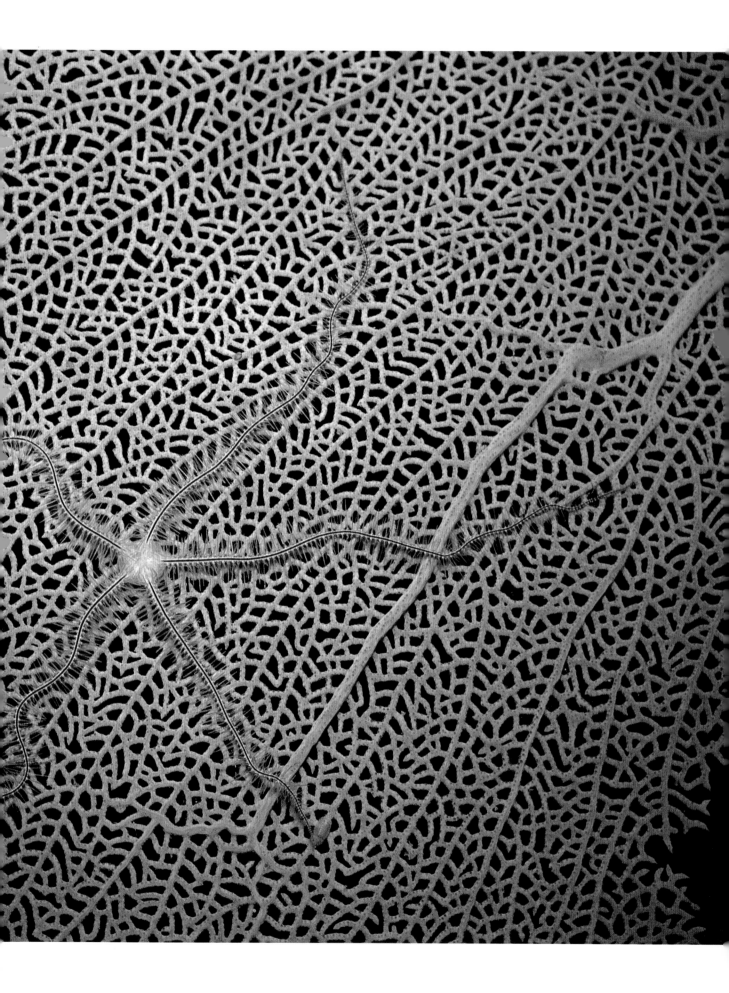

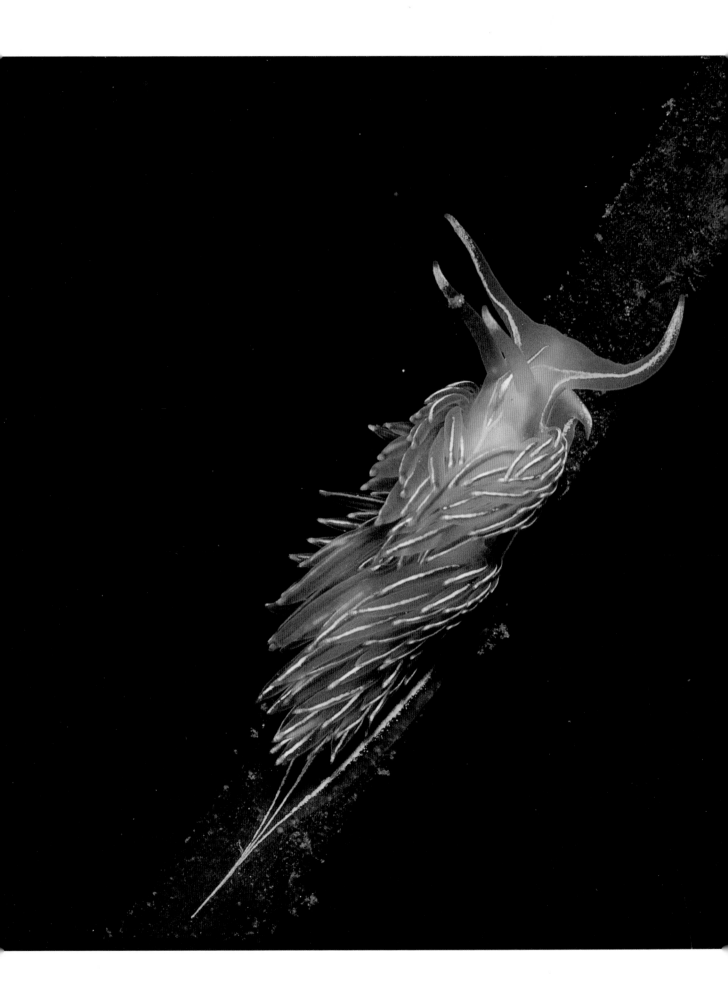

CONTENTS

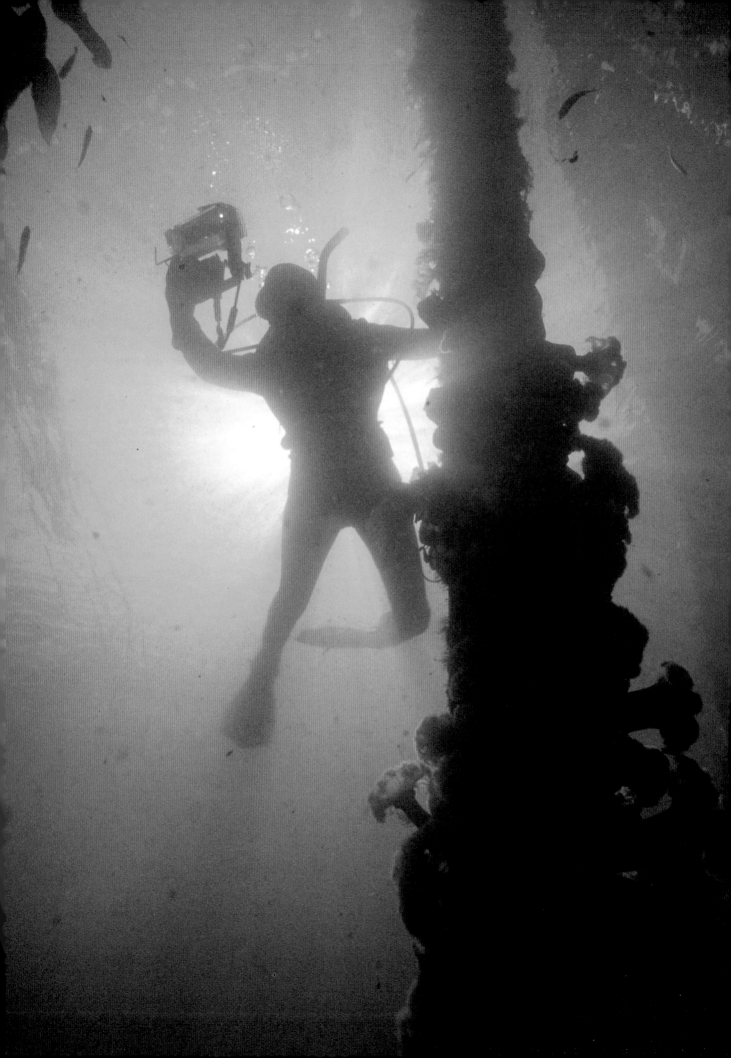

FOREWORD

My first experience shooting underwater photographs was for strictly documentary purposes. While taking a course in marine biology, I was asked to photograph snails, the subjects of a project I was working on. The instructor thrust a Nikonos II into my hands and said, "Go take some pictures." Surprisingly, most of the shots came out fine — if getting something resembling an image on the film can be considered fine. I admit that I didn't really give it much thought then; it simply seemed like another part of the scientific process: recording a subject's behavior.

My second experience involved taking photographs of a documentary nature, too; however, these images had to be not only technically accurate but also interesting to look at and visually appealing. I was teaching at a high school in St. Croix in the Virgin Islands at the time. When I discovered that most of my students had never seen the inhabitants of the coral reefs in their own backyard, I decided to rely heavily on my photographs in order to bring the reef into the classroom. During this period, I got hooked on underwater photography both as part of my profession and as an avocation.

This marked the beginning of my home slide shows — carousel after carousel of slides of sponges, flatworms, hermit crabs, fish, and other seemingly alien creatures. Needless to say, I have patient and understanding relatives and friends (although I did occasionally see someone nodding off after the third 120-slide tray). For the most part, though, they were interested in getting even a brief, if vicarious, view of the aquatic realm.

I hope that this book will aid and inspire you to bring the underwater world to the surface for your friends, family, students, or clients. During the last decade, the technical barriers to capturing images underwater have been removed to the extent that almost everyone with good diving skills, a little practice, and an understanding of the fundamentals can take visually exciting photographs of their aquatic adventures. In fact, many recreational photographers, buoyed by their success with still images, are exploring the newest frontier in underwater photography: video. It is relatively simple for them to go on a dive, shoot 45 minutes of tape, and play the tape back on a monitor in the boat on the return to their resort.

This ability to capture the underwater world on film, however, comes with a responsibility to do so accurately and respectfully. After all, the audience views it through the photographer's eyes. As photographers of this "other world," it is up to us to portray the aquatic environment and its inhabitants with the dignity they deserve as other species we share this planet with. Don't photograph divers sitting in barrel sponges, using inflated pufferfish as footballs, or killing one animal to feed another. Such images strengthen the notion that aquatic creatures are somehow separate and disconnected from their terrestrial counterparts, and not a vital part of the biosphere.

As we would for any other type of wildlife photography, we should learn everything we can about our subjects. Each has a story to tell. Some subjects are seen more readily than others. The challenge is to relate each creature's story visually so that the audience gets an accurate, insightful, and compelling view of life in the aquatic realm.

INTRODUCTION

Since the development of the Aqua-lung by Jacques Yves Cousteau and Emil Gagnan in 1943, we have been able to stay underwater safely and comfortably for extended periods of time. This amazing technological breakthrough allows us to discover, explore, and observe the wonders of the underwater world directly, with our own eyes.

One of the first challenges underwater pioneers, such as Cousteau, faced was capturing the beauty and mystique of this foreign world on film in order to share it with those unable to see it for themselves. This challenge has been answered over the past forty-five years, in both still and motion pictures. Today, television and cable audiences can frequently find a documentary or special about an aspect of the underwater world.

What makes the underwater world so intriguing, and why does it inspire rubber-clad individuals to dive into the sea, dragging with them cameras, lenses, flash units, and film? First, it truly is another world — a world of motion, weightlessness, and virtual silence. Like outer space, it offers us a sense of adventure, the thrill of discovery, and the promise of excitement.

The underwater world also appeals to us because its natural state seems so foreign to ours. In part, this reflects tremendous differences between terrestrial and aquatic ecosystems. Land environments abound with plant life while underwater environments are dominated by animal species. When we describe land environments, we refer to grasslands, redwood forests, and oak tree groves; when we describe underwater environments, we refer to coral reefs, oyster flats, and mussel beds. In addition, the animals we encounter underwater often have unusual, if not bizarre, shapes and colors that provide a never-ending supply of photographic subjects.

Land objects, which take on an entirely different nature and sometimes increase in value when submerged, can be excellent "foreign" underwater photography subjects. Objects, such as doorknobs, old nails, and bottles,

are usually termed junk, but they are considered treasures after resting at the bottom of a body of water for a year or two. The broken hull of a lifeless ship 60 feet below the surface is another intriguing — and perhaps unsettling — photo opportunity that lures many of us into the water. Shipwrecks have a certain mystery about them. The relentless probe of the Andrea Dorea by Peter Gimbel is a compelling example of the lure of long-lost vessels. And marine geologist Robert D. Ballard's discovery of the Titanic's resting place led to a fascinating exploration of this legendary sunken ocean liner.

We also change dramatically when we go underwater. Suddenly we are ultramodern explorers in color-coordinated, high-tech scuba gear, ready for the aquatic adventure of a lifetime.

The purpose of my book is to prepare you for such adventures by introducing you to the basics of underwater photography. I hope that the information here will provide you with some insight into the process of capturing images underwater. Each chapter begins with an overview and contains a collection of photographs that illustrate the concepts included in the chapter. Additionally, the images are described in detail to provide as much information as possible about how each picture was taken. I have successfully used this approach to teach classes on underwater photography, and I hope that it translates for you in print.

Although the fundamentals of land photography — measuring light, calculating exposure, focusing, framing, and composing — are essentially the same when applied to underwater photography, the challenge of capturing images on film underwater lies in dealing with the constraints of the underwater environment. First, you need to learn a new skill: scuba diving. Mastering this exhilarating sport is essential to mastering underwater photography. Because the quality and quantity of light are altered as it penetrates water, you have to change your photographic technique. You also have to become familiar with the collection of

On a shoot in the Florida Keys, I noticed this blue angelfish. By patiently observing it for a few moments from a distance, I was able to position myself in its swim path and anticipate its movements.

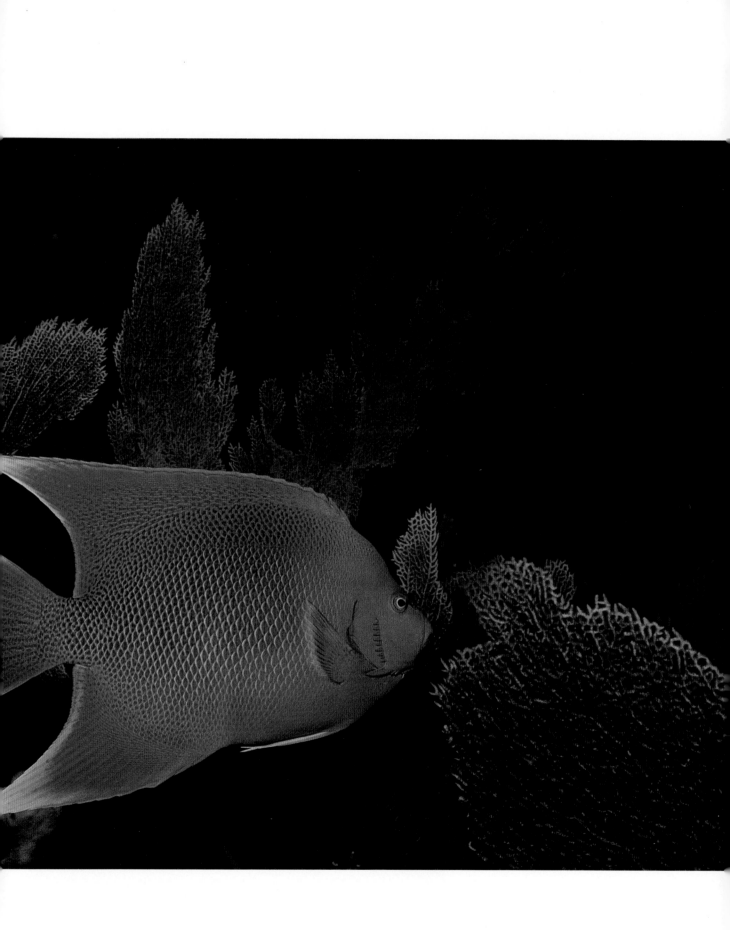

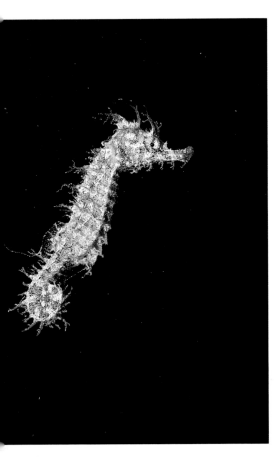

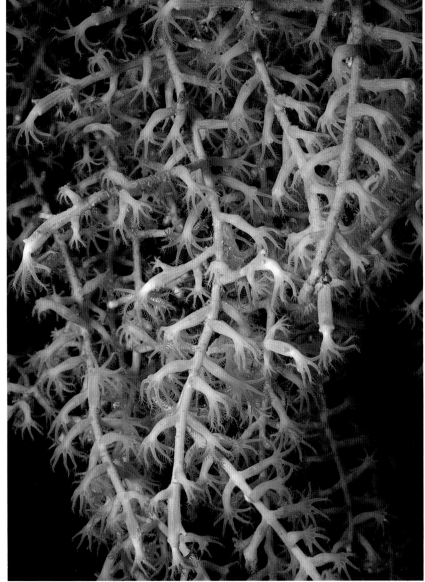

Marine animals and plants come in a tremendous variety of shapes, colors, and sizes, reminding us just how different the underwater world is. I found the seahorse (above) in the Florida Keys, the branching octocorals (right) in Roatan, Honduras, and the white-lined nudibranch (below) in Puget Sound in Washington.

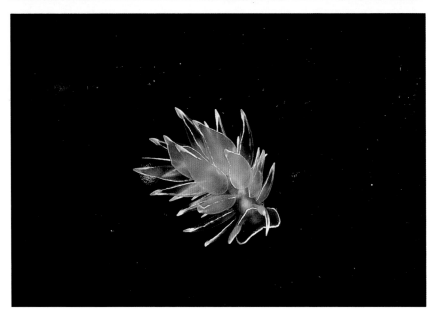

special equipment designed for underwater use so you can handle it easily.

Environmental constraints also require you to develop and sharpen your organizational and planning skills, which make or break any attempt at underwater photography. The logistics of simply getting to your subject are often complex, involving people and events beyond your control. For example, when an electronic flash unit fails underwater, you cannot simply reach into your equipment case and pull out another one. Replacing the flash unit requires you to collect your diving companion, get back to the boat, get back in the boat (which is not always as easy as it sounds), take off most of the gear it originally took you half an hour to put on, find a dry place where you can work on the equipment, and then get back into the water — if the tide, current, or other water conditions have not changed appreciably. Being unable to change film underwater is, perhaps, the best example of a photographic environmental constraint that calls for careful planning. On land, we usually take this simple procedure for granted, but it is a significant part of preparations for an underwater shoot.

On the recreational level, the availability of underwater photography equipment at an affordable price allows sport divers to capture underwater encounters on film and to share these thrilling experiences in still, motion, or video format. More and more divers are putting down spearguns and picking up cameras. On the professional level, the quality of underwater images continues to improve as increasingly advanced camera systems become available (spurred by a rapidly growing consumer market) and as the market for such images broadens. The growing public awareness of the condition of the oceans — through the efforts of such conservation groups as Greenpeace, the Cousteau Society, and the World Wildlife Fund — continues to require high-impact, high-quality images that reveal the delicate nature and the precarious balance of the underwater world.

At any level, underwater photography can be challenging, exhilarating, and rewarding if you have a basic understanding of the photographic process and the underwater world.

Like so many other underwater subjects, this soft coral, photographed in the Philippines, is coated with a thin film of mucus that absorbs the light from an electronic flash unit and reduces its harshness.

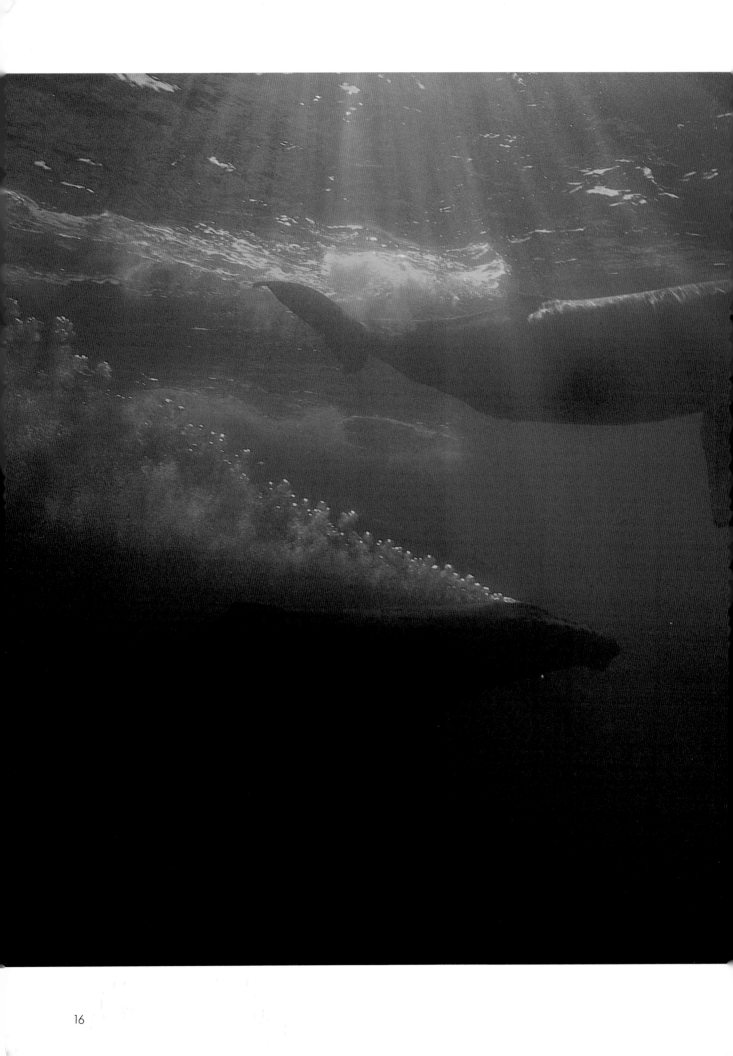

Capturing images underwater poses a series of challenges that aren't present on land. Each time you dive into the water, you enter an entirely new world — where you hear new sounds, including your own breathing, and where colors and sizes appear to be very different.

The aquatic realm imposes some unusual environmental constraints on both camera and diver alike. The relatively poor clarity of water as a medium in which to photograph and the loss of and change in the quality of available light underwater are the most serious constraints that you must account for in underwater photography. (These two factors alone are probably responsible for improving film company profits since the advent of recreational underwater photography.)

The underwater environment also affects your ability to even enter this realm, let alone capture it on film. Your body is not built to withstand periods of total submersion of any real length without life-support systems. Through the development of modern-day diving equipment, you can enter the water; breathe, move comfortably, stay warm, and communicate underwater; and get back on land easily and safely.

Unlike humans, such marine mammals as whales and dolphins have developed adaptations that enable them to deal with the unique conditions present in their aquatic environment. I photographed these humpback whales in Maui from a camera-to-subject distance of 15 feet. Using my Nikonos III with a 15mm lens and taking advantage of the available light, I exposed at f/5.6 for 1/60 sec. on Kodachrome 64.

WATER

The general properties of this liquid medium are significantly different from those of the gaseous medium you are used to operating in—air. Water can hold in suspension a multitude of small and large objects, from microscopic sediment to humpback whales. Furthermore, the amounts of life-giving elements in water, such as oxygen, vary with both its temperature and salinity (saltiness). As a result of its density, water is much heavier than air (a fact that I am painfully reminded of every time I carry my wet dive gear bag back to the hotel after a day of diving). Another property of water that will greatly affect both you and your shooting is pressure. Unlike atmospheric pressure, which varies little even with substantial changes in altitude, water pressure increases dramatically with incremental increases in depth (see page 23).

It is also important for you to keep in mind just how powerful moving water can be. This force is revealed vividly in every rushing river and flooding stream, as well as in every kilowatt generated by hydroelectric dams. As an underwater photographer, you will find that even weak water currents can mean the difference between getting back to the boat under your own power or having the boat come to retrieve you on your solo trip out to sea—and having to live with the embarrassment. While these properties might seem inhospitable and almost impossible to deal with, entering the underwater world and documenting it actually only require familiarizing yourself with them.

Clarity and Turbidity

Water, which is 800 times denser than air, has a tremendous capacity for suspending small, particulate matter for long periods of time. As these little floating things accumulate, they reduce the clarity—transparency—of water and get in your line of sight. (They also reflect, refract, and scatter light as it penetrates water.)

Turbidity is a measure of the amount of particulate matter held in suspension. It varies considerably according to location. Coastal areas near the mouths of rivers are usually very turbid; this is a result of the transport of sand and dirt from the erosion of soil upstream. Open ocean water is perhaps the clearest because it is so far from any sources of erosion or large quantities of small particles, such as sand.

The overall effect of turbidity is a reduction in visibility significantly greater than anything we ever experience on land. The closest parallel I can think of is a very foggy day. In very clear tropical water, really good visibility might be 200 feet (horizontally); in more temperate waters, visibility of 30 feet would cause local dive enthusiasts to celebrate.

A nonenvironmental source of increased turbidity occurs when divers swimming near the seafloor disturb bottom sediments. In most underwater photographers' eyes, such particles are lying dormant, just waiting for some unsuspecting diver (who is not a photographer) to swim by. With fins flailing, the diver creates clouds of sediment as he or she goes by and stirs them up.

These underwater photography limitations dictate that you must get as close to your subject as possible in order to get clear, high-quality images on film. This, of course, reduces the camera-to-subject distance and the amount of water you have to shoot through. As on land, you can manipulate the camera-to-subject distance and resulting picture area through a combination of closeup and wide-angle lenses, depending upon the size of the object(s) to be photographed. For the most part, you can capture small subjects with a closeup lens configuration; larger objects, with wide-angle lenses.

The clarity of water can vary dramatically with depth and within small geographic areas, depending on water temperature, chemistry, and currents. On this Caribbean reef, a visible upper layer of warm, relatively clear water is being displaced by cold, denser water. This is caused by a heavy rainfall. The freshwater is runoff from shore and contains a large amount of particulate matter, which is the result of erosion.

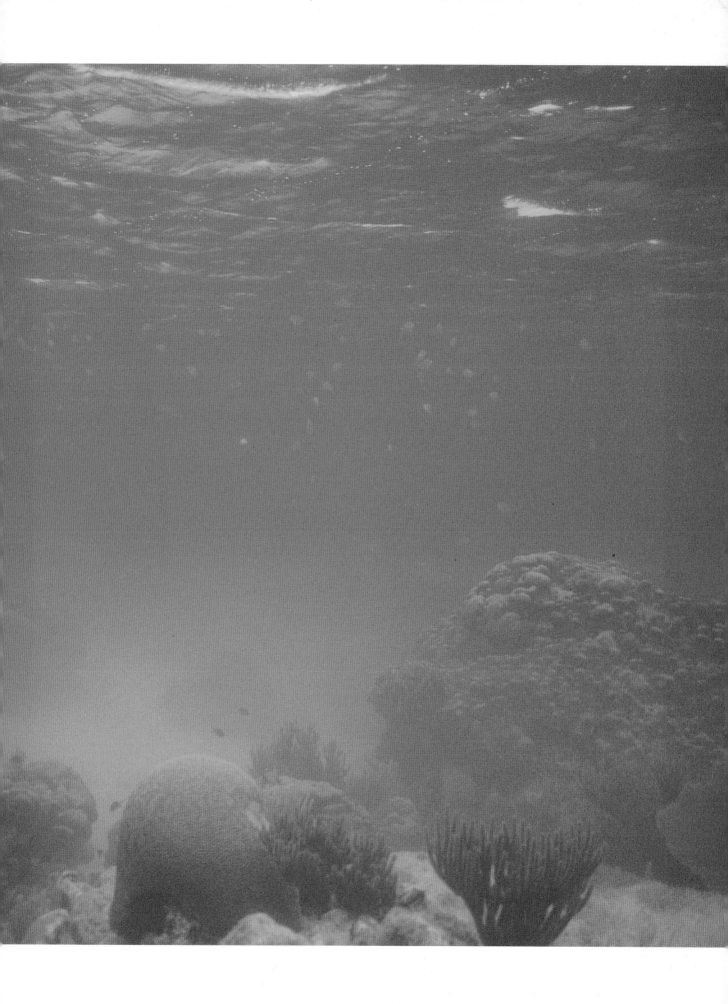

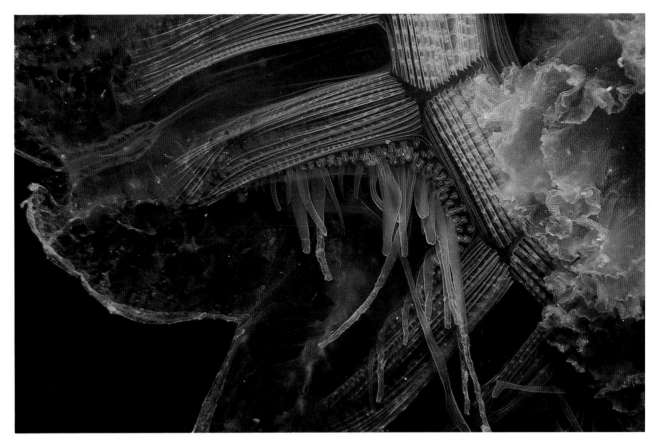

When water clarity is poor, closeups are smart alternatives for photographing larger subjects that require greater camera-to-subject distances; they decrease the amount of water you have to shoot through. For this picture of a jellyfish detail, taken in Puget Sound in Washington, I shot from a camera-to-subject distance of just 3½ inches. I used my Nikonos III, fitted with a 1:2.75 extension tube and a 28mm lens, and a Vivitar 102 flash. The exposure was f/16 at 1/60 sec. on Kodachrome 25.

The clarity of the water surrounding tropical coral reefs is usually excellent and allows for greater camera-to-subject distances. For the shot of a coral-reef wall in the Philippines on the opposite page, the camera-to-subject distance was three feet. Using an Oceanic 2001 flash and my Nikonos III fitted with a 15mm lens, I exposed at f/5.6 for 1/60 sec. on Kodachrome 64.

How close is close? Usually, I won't click the shutter if my subject is more than six feet away. I prefer to be within three feet of my subject, unless I am shooting a very large object (such as a ship) or an image with a lot of contrast (such as a silhouette).

In addition to the problem of maintaining resolution when water clarity is poor, you will find that even the most powerful electronic flash units can only light a subject that is 10 feet away. As such, wide-angle photography and closeup photography are the only options available underwater — there are no telephoto lenses for underwater use or flash units that have the ability to light a subject that is 40 feet away.

Chemistry and Corrosion

The chemical composition of the water you work in affects your pictures and your equipment. Image quality can be affected when you shoot in areas where large quantities of fresh- and saltwater meet; these are large, quiet embayments or deep-water estuaries. In these calm bodies of water, a large inflow of freshwater runoff rests on top of denser saltwater. As a result of this mixing, the water clarity may be greatly reduced. Shooting under such conditions will give you images with an "artsy" quality to them, which may be interesting to look at — once.

Your primary concern about the chemical makeup of water is its corrosive effect on metal. Although the problems associated with corrosion are greatly minimized in freshwater, they can be devastating within a brief period of time in saltwater. Keep in mind that today, much underwater photography equipment is made either entirely or in part with metal fittings, connections, and vessels. This is particularly true of camera housings, electronic flash units, and Nikonos camera systems.

Corrosion is easy to spot on external surfaces, such as flash connections and camera controls. Prevent it from ruining your equipment by following proper maintenance procedures carefully and regularly. The most crucial steps are the post-dive rinse (with freshwater, of course) and regular monitoring of the condition of your equipment. (Specific procedures for fighting corrosion are discussed in the section on equipment maintenance on page 43.)

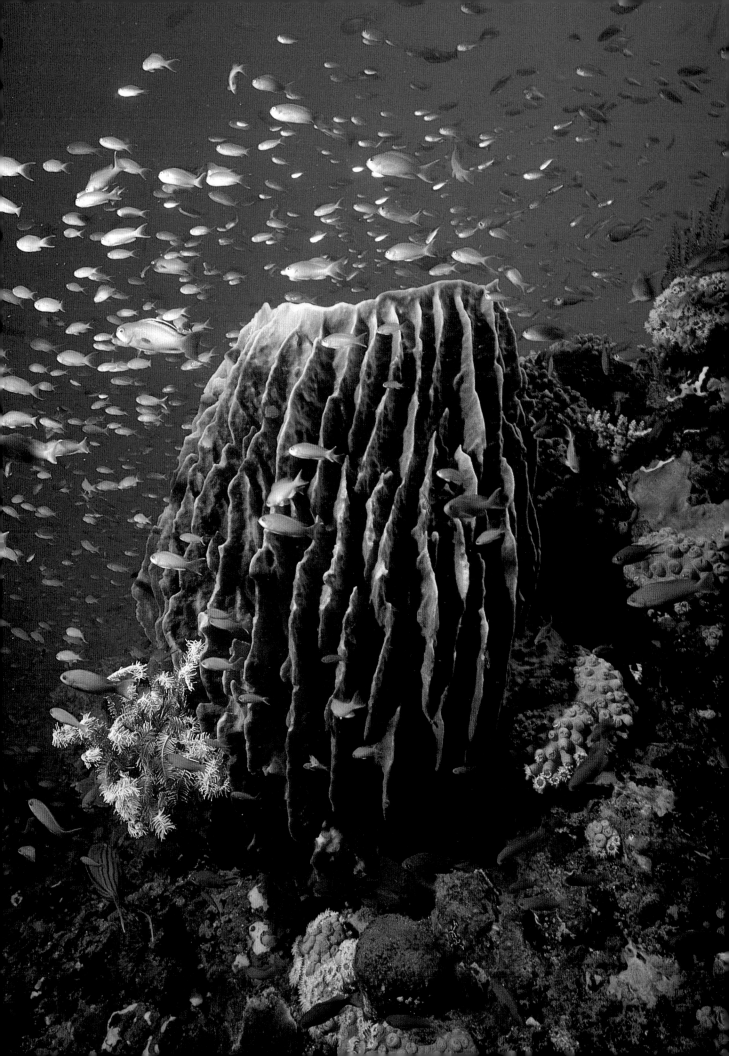

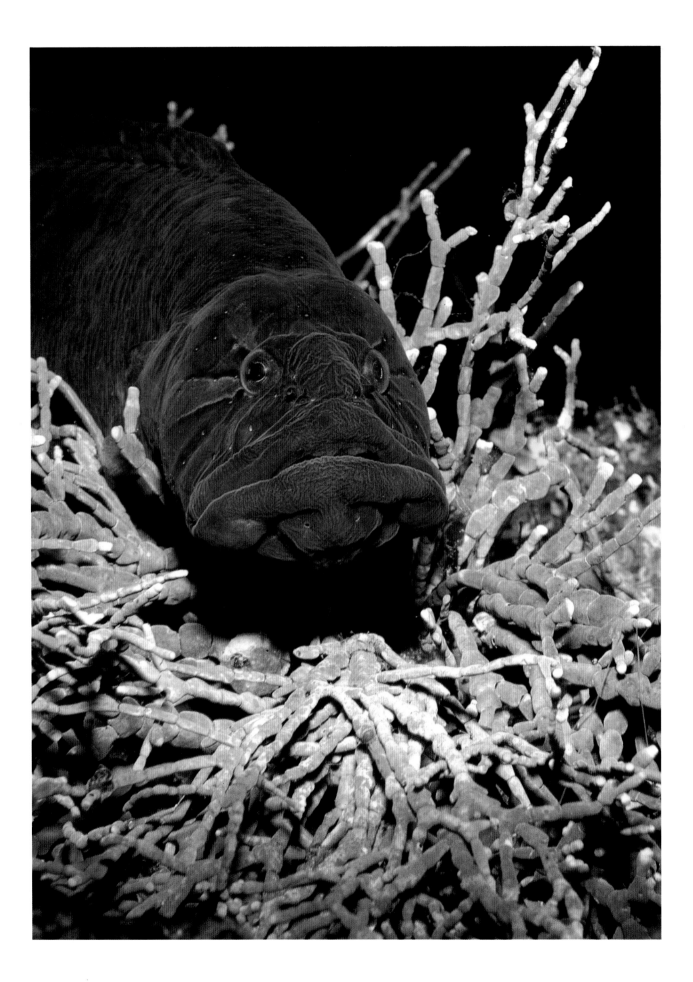

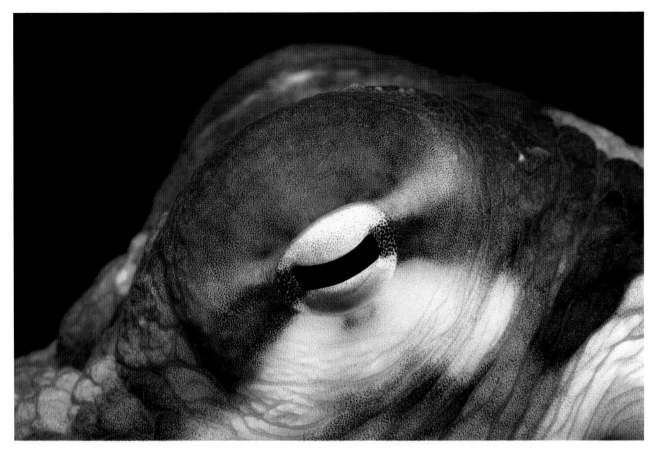

Pressure

Water's density makes it pretty heavy stuff. At sea level, atmospheric pressure is 14.7 pounds per square inch. Put simply, this is what a column of air with a one-square-inch base, extending out into space to the edge of the atmosphere, weighs. Water pressure doubles this figure with every 33 feet of depth. So, at 33 feet below the water's surface, the pressure exerted on one square inch of anything is roughly 29.4 pounds. At 66 feet, this figure doubles to 58.8 pounds per square inch; at 99 feet, it doubles again to 117.6 pounds, and so on. The obvious question is, of course, why don't all the fish and other sea creatures get crushed? The answer is simple: all animals and plants are made primarily of water, which is essentially noncompressible.

Gases, on the other hand, are extremely compressible. This is why keeping film dry is such a problem. You have to use the very property of water you are fighting — its enormous pressure — to create a waterproof seal in a camera (or in any other piece of camera gear or container that must remain dry). Waterproof equipment is edged with grooves within which a rubber seal called an O-ring sits. The grooves line the borders where the unit is opened and closed.

As the unit is submersed, the pressure of the surrounding water pushes its edges together, compressing the rubber O-ring and creating a watertight seal. The deeper the unit goes, the more the pressure increases, which, in turn, actually improves the seal — up to a point. This point is reached when the soft O-ring is compressed so much that it is pushed out of the groove, thereby rupturing the seal. Most underwater units remain watertight to at least 150 feet, a depth that exceeds the prescribed safe-diving limit of 130 feet. Most are tested to withstand even greater depths. And, in fact, the danger of flooding a camera primarily exists near the surface, in the first few feet of water. Because the pressure here is not great, a strong seal may not have formed yet. A bump or knock near an edge of the unit may dislodge the O-ring, breaking the fragile seal and creating a leak or "flood." This is why it is particularly important to treat underwater camera gear gently when you enter the water.

When I mounted a 1:1 extension tube between my Nikonos V and its 35mm lens in order to capture the detail in this octopus eye, I added yet another O-ring to the camera system. This increased the chances of a leak around one more seal. Shooting from a camera-to-subject distance of a mere two inches and using a Nikon SB-103 Speedlight, I exposed at f/16 for 1/90 sec. on Kodachrome 25 for this closeup.

Housed camera systems require a significant amount of care and maintenance in order for you to combat corrosion and to keep them working properly. For this shot of a prickleback on the opposite page, taken in Puget Sound in Washington, I used my Nikon F2 housed in a Giddings-Felgen housing. The camera-to-subject distance was 10 inches. With a 55mm Micro Nikkor lens and an Oceanic 2001 flash, I exposed at f/11 for 1/80 sec. on Kodachrome 25.

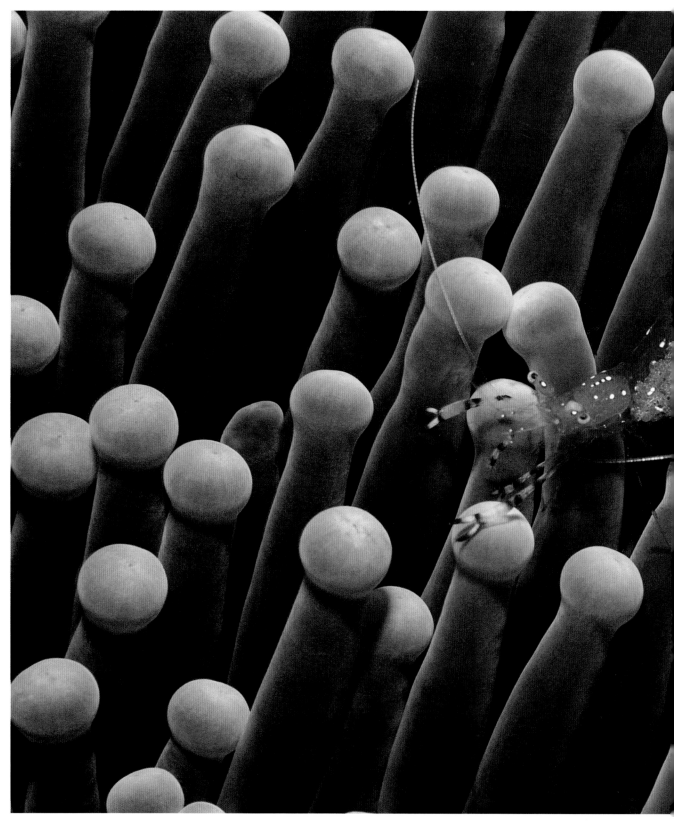

This delicate anemone shrimp isn't crushed by the tremendous water pressure surrounding it because its tissues are made mostly of water as well. On a dive in the Philippines, I photographed this shrimp from a camera-to-subject distance of 3½ inches. I mounted a 1:2.75 extension tube and a 28mm lens on my Nikonos III and used a Vivitar 102 flash. The exposure was f/16 at 1/60 sec. on Kodachrome 25.

Temperature

For the most part, water temperature does not change dramatically over short or even long periods of time, especially in relation to air temperature. Water has a much greater ability to retain heat than air does; consequently, more energy is required to change its temperature.

Most people dive in waters ranging in temperature from 50°F to 80°F. (There are some people, however, who dive beneath the ice-covered lakes of the Midwest.) This range in temperature has little if any effect on underwater photo gear while it is submerged. Temperature is a consideration only when gear is alternately exposed to radical differences in air and water temperature. For example, in the tropics, where the air temperature can approach 90°F, leaving a black camera body — loaded with temperature-sensitive film — on the deck of a boat in the sun is not a good idea. The camera's internal temperature might reach 120°F or more. Then, when you immerse the camera in water with a temperature of 70°F, it will cool rapidly. This, in turn, will change the temperature of the film quickly, potentially damaging or altering it.

I faced a similar problem on a New Year's Eve diving trip in British Columbia. The air temperature was about 35°F, and the water temperature was its usual 50°F. Ordinarily, at the end of a dive, everyone would run to the ship's salon to drink hot cocoa and coffee, huddling around the stove and coaxing each other into another dive. The air temperature in the salon then was about 80°F. As I emerged from the water after my first dive, I noticed the condensation forming on the inside of the salon windows, a result of the dramatic temperature differences and high humidity. Changing film in the warm salon would have meant exposing the inside elements of my camera, which had a temperature of 50°F or less, to the same moisture conditions the windows faced. This would have instantly caused condensation to form on the inside of my camera.

Buoyancy

Another challenging aspect of the underwater environment is weightlessness, which is a result of buoyancy. Mastering your own buoyancy is an essential skill for underwater photographers. You have achieved neutral buoyancy when you can remain suspended and stationary in midwater—and not have to propel yourself in any way to stay there.

The buoyancy equation consists of offsetting the weight of your diving and camera gear by adjusting the volume of buoyant gases and the spaces for them. You do this by filling or partially emptying your buoyancy compensator. Once this level of balance is reached, you can make minor adjustments by controlling the amount of air in your lungs, becoming a "human submarine." Exhaling makes you sink; inhaling makes you rise.

Sometimes you will want to become a "human tripod," remaining stationary on the seafloor or on other structures, mindful of delicate marine life.

To do this, I carry a bit more weight than normal (usually three to six additional pounds), which allows me to remain virtually motionless on the bottom—once I release all the air from my buoyancy compensator and/or dry suit. I am, of course, concerned that I am at that point negatively buoyant, and getting to the surface quickly will require more effort. It doesn't take that much more weight to create negative buoyancy. As you will see, the key to this technique is knowing your own diving limitations.

Although buoyancy is a complex environmental factor, underwater photographers find that being able to "fly" underwater is both exhilarating and quite useful. It enables you to effortlessly angle your camera in a large number of ways. And, as you move around freely, you can often encourage or coax your subject to do the same. Buoyancy, then, offers you a tremendous variety of perspectives as well as the ability to determine the background to a certain degree.

Like this plainfin midshipman, I was able to hover almost motionlessly in Puget Sound. Careful buoyancy control enabled me to capture the fish on film. Shooting from a camera-to-subject distance of one foot, I used my Nikon F2 in a Giddings-Felgen unit, a 55mm Micro Nikkor lens, and an Oceanic 2001 flash. The exposure was f/8 at 1/80 sec. on Kodachrome 25.

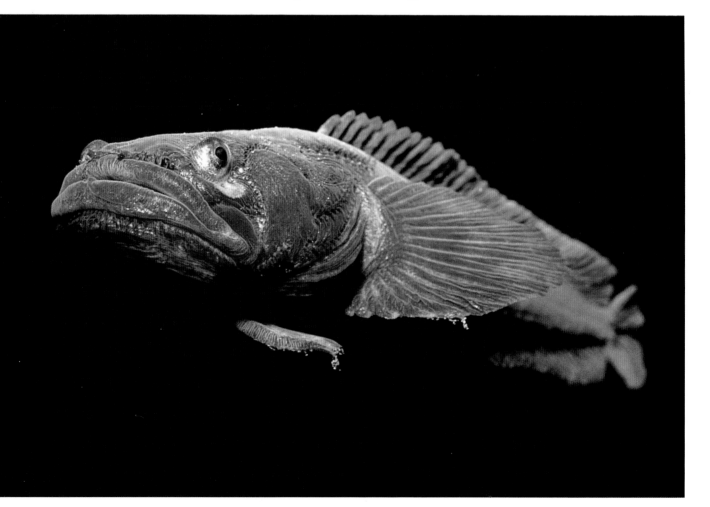

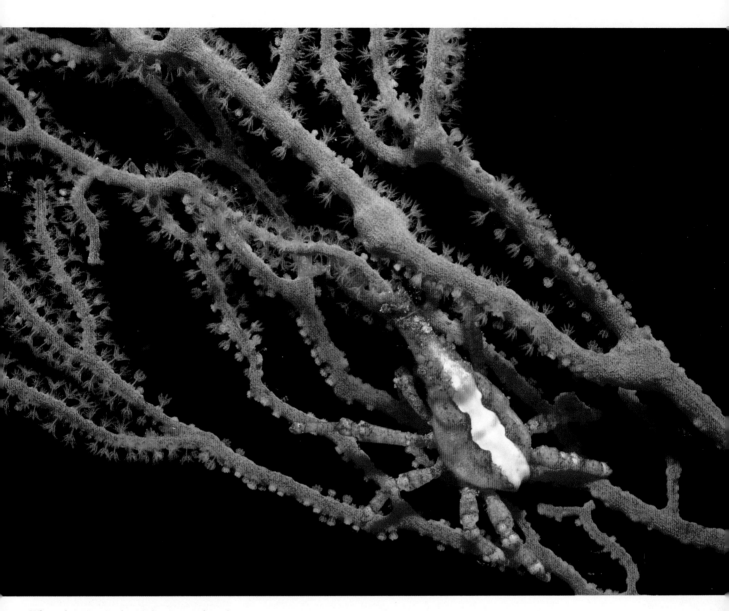

When shooting in the Philippines, I found this small decorator crab on a branching octocoral attached to a vertical reef wall. With good buoyancy control, I was able to hang motionless in the water and to carefully position the framer of the 1:2.75 extension tube around the crab without disturbing it. I used my Nikonos III, a 28mm lens, and a Vivitar 102 flash and exposed for f/16 at 1/60 sec. on Koda-chrome 25. The camera-to-subject distance was 3½ inches.

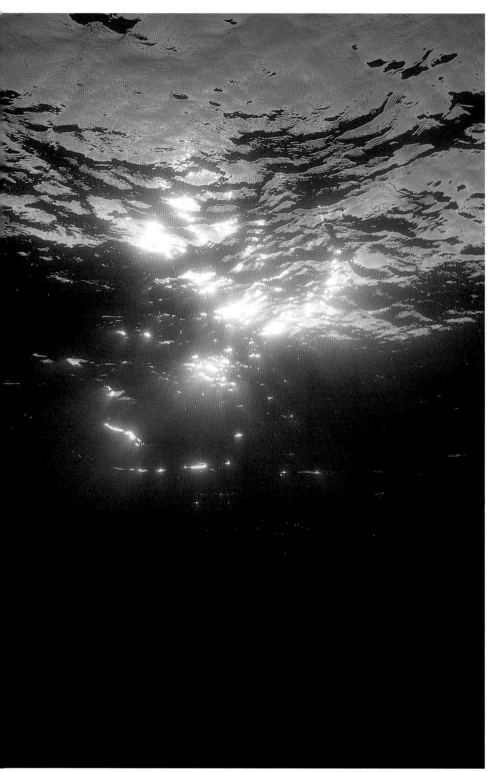

When taking this picture of the late-day sun in Roatan, Honduras, I was 15 feet below the surface of the water. Using my Nikonos III camera with a 20mm lens and Kodachrome 64, I exposed for 1/60 sec. at f/11.

Whether you are photographing on land or underwater, light is the major factor controlling the process of capturing an image on film. Light changes dramatically when it penetrates the water's surface. Both the quantity and quality of light vary according to current water conditions.

Quantity of Light

As on land, the quantity of light determines, to a large degree, the kind of photographs that can be taken and the way they can be taken. The sun provides available, or ambient, light for underwater photography. On an average day about 65 percent of the light coming from the sun reaches the earth's surface.

Once sunlight reaches the surface of a body of water, some of it is reflected back off the water into space. The portion of light that penetrates the surface of the water is altered even further. Absorbance of light increases with water depth. The quantity of light penetrating the water is also greatly affected by the reflecting and scattering of light. This is done by organic and inorganic particles, which include microscopic organisms, microscopic pieces of what once were large, whole organisms, sand, dirt, and dust particles. The depth to which light reaches also varies according to both the chemical composition and location of the water. Clearly, the quantity of natural light available for underwater photography is significantly less than that available above the water's surface.

Quality of Light

The quality of natural light also changes with water depth. When sunlight ("white light") reaches the water's surface, it includes all the colors of the visible light spectrum, from violet to red. (These can be seen when sunlight is directed through a prism that refracts, or bends, it.) In water, the violet and orange-red ends of the spectrum are the first to be absorbed — that is, they are absorbed at the shallowest depths. The blue-green wavelengths penetrate the farthest and, so, are absorbed last. In even the clearest tropical water almost all red light disappears within the first 30 feet, and only 10 percent of the blue light penetrates

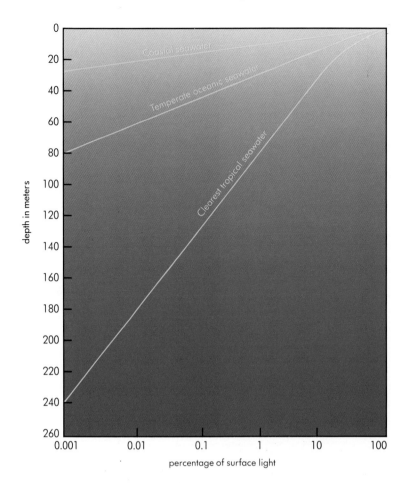

This diagram shows the relative penetration of sunlight through three different types of seawater.

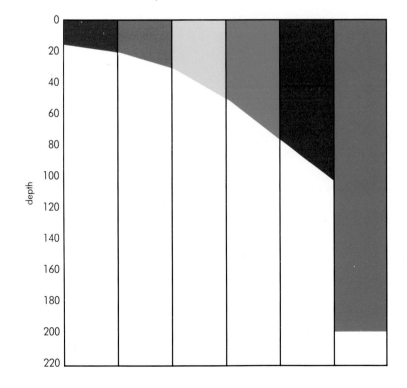

Visible light is made up of all the colors of the rainbow, but different wavelengths of color penetrate to different depths. Red, for example, is absorbed in shallow water, while blue penetrates deepest. By 600 feet all light is absorbed.

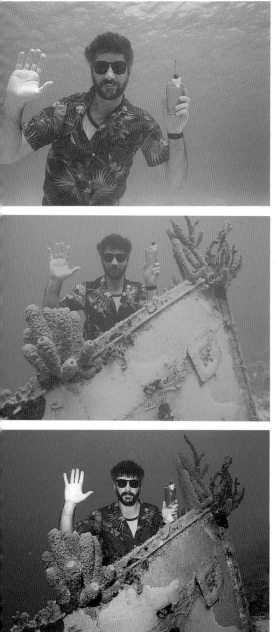

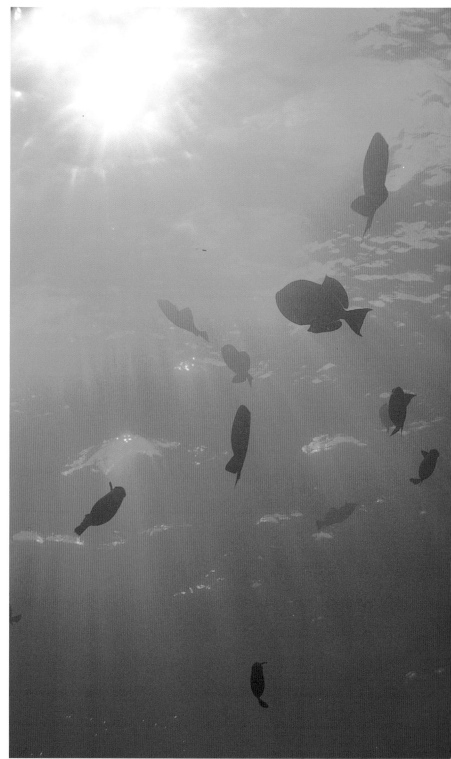

Under natural sunlight at just 10 feet below the water's surface, the colors of this bright shirt are already muted (top). At 65 feet, the red, yellow, and green of the shirt have all been absorbed, turning it muddy and dull (center). With the addition of an artificial-light source — in this case, an electronic flash — at 65 feet, the real colors of the shirt are restored (bottom). Notice the "true" color of the yellow sponge; this is the color it would be if it were brought to the surface and exposed to sunlight.

Under water, most available-light photographs are rather monochromatic because of the differential absorbance of light. In this silhouette of black durgons, taken in Maui, only blues and greens are visible. Using my Nikon F2 in an Ikelite housing with a 55mm Micro Nikkor lens, I exposed for f/8 at 1/80 sec. on Koda-chrome 25. The camera-to-subject distance was 20 feet.

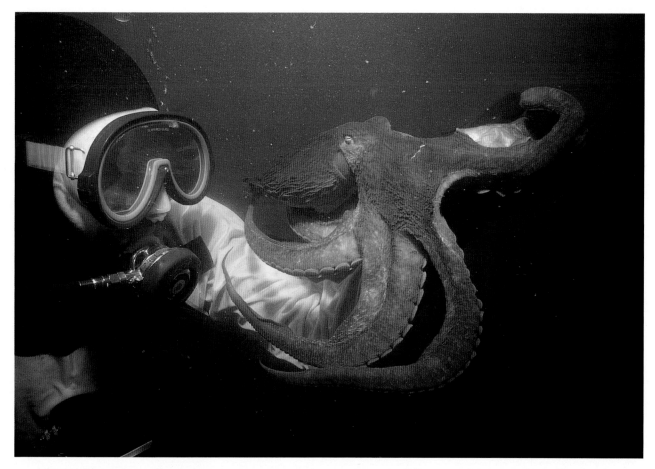

to 300 feet. One of the most disturbing—and captivating—experiences I have ever had underwater was accidentally puncturing my finger at 100 feet and watching myself bleed green blood.

These changes in light intensity and character have a strong impact on underwater photography. Although the limitations of lowered light levels are minimal in shallow water, at a depth of just 10 feet colors are muted and ambient-light photography requires the use of extremely light-sensitive films. And the underwater world becomes essentially green and blue at very shallow depths in even the most transparent waters. You can handle this differential absorption of light in three ways: shoot images that rely on ambient light in shallow water, use artificial light sources to supplement whatever ambient light is available, or use color-correction (CC) filters.

Depending upon the location of your shoot, you may not be able to use ambient light as a light source at all at depths greater than 80 feet. This is especially true in higher latitudes where, in the winter, any deep dives (in

excess of 75 feet) require a powerful dive light just to let you see where you are going. Getting into the water at noon and descending into complete darkness at 100 feet is an eerie sensation. While going deeper than 300 feet exceeds the safe-diving limits of scuba divers, it is interesting to know that practically all light is absorbed at depths greater than 300 feet. Most of the underwater world, then, is a world of eternal darkness.

When light enters water it is not only reduced and altered in quantity and quality, it is refracted (bent) as well. If you have ever leaned over the side of a boat and noticed that the anchor line looks bent at the point where it meets the surface of the water, you have seen the effects of refracted light. This phenomenon occurs at any air/water interface, and it has some profound effects on underwater photography.

Refraction makes everything underwater appear to be about 25 percent closer and larger. When you look at the underwater world through a face mask, you are viewing it through an air/water interface. So, when you estimate the distance between an object

This photograph of a diver and an octopus, taken off the San Juan Islands, was a setup shot. I wanted a picture of a diver interacting with an octopus in a nonthreatening way. Here, the diver appears interested in the creature, and the octopus appears at ease in touching the diver. I decided not to include the diver's eyes because I didn't want them to complete with the eyes of the octopus. The camera-to-subject distance was three feet. I used a Nikonos III camera fitted with a 35mm lens and an Oceanic 2001 flash. The exposure was f/8 at 1/60 sec. on Kodachrome 64.

and yourself, you are calculating the *apparent distance*; the object is actually about 25 percent farther away. The most important question, however, is: what does the camera "see"? Since there is another air/water interface at the lens, it should "see" the object the same way you do.

Refraction also has an effect on image distortion in camera systems in which a "land" camera is placed in a waterproof housing. Such housings have front ports that provide the window for the camera lens. Essentially, the port acts as an additional lens element, and its curvature can affect the outcome of the image. If completely flat, the port refracts light just as a face mask does and the viewing area of the lens is reduced. For example, when placed behind a flat port, a land 28mm lens has the viewing angle of a land 35mm lens. In addition, the presence of a flat port increases the size of the image by 25 percent. This can be an advantage with closeup work.

If the port is curved or has a dome, refraction is decreased or eliminated, respectively. And, the greater the curvature of the port, the smaller the

amount of refraction. These types of ports are actually another lens element: you have to adjust them in order to alter the bending of light as it enters the housing. This is particularly important when you use wide-angle lenses in a housing; there will be noticeable distortion at the edges if you use a flat port. On the other hand, the dome maintains the viewing angle of the lens behind it and reduces distortion.

Finally, because a dome port acts like an additional lens, a virtual image of the subject is created only a few inches from outside the dome. The lens behind the port must be able to focus on this virtual image. For a subject focused at infinity, the virtual image is located at a distance from the film plane that is about twice the diameter of the dome. For example, if the housing has a 6-inch diameter dome, the virtual image will be located about 12 inches away from the film plane. For everything to be in focus, the lens you're using must be able to focus down to 12 inches. If it doesn't, you can add a diopter. The best solution, however, is to use a close-focusing lens from the start.

The speed of light changes as it travels from one substance to another, such as from air into water. This alters the angle of the light, which, in turn, causes refraction—the bending of light. As a result, with flat ports, objects appear to be closer and about 25 percent bigger; the angle of view of a lens underwater is decreased by the same percentage. This loss can be corrected through the use of dome ports, which act like additional lens elements.

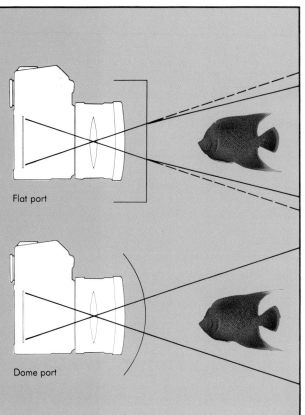

Flat port

Dome port

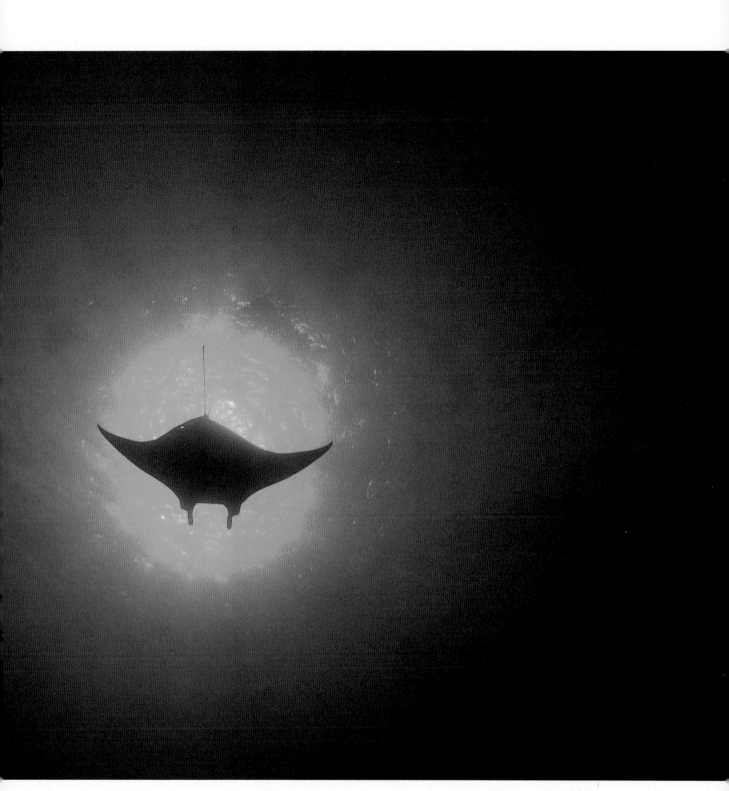

Getting this shot reminded me of just how well adapted to the underwater environment marine life is — and how poorly suited humans are to this world. While this manta ray casually flipped a fin to glide effortlessly through the waters off Maui, I went through a full tank of air in just 12 minutes by swimming as fast and as hard as I could in an attempt to keep up, which I barely did. Shooting from a camera-to-subject distance of 10 feet in available light, I used my Nikonos V with a 15mm lens. The exposure was f/16 at 1/90 sec. on Kodachrome 64.

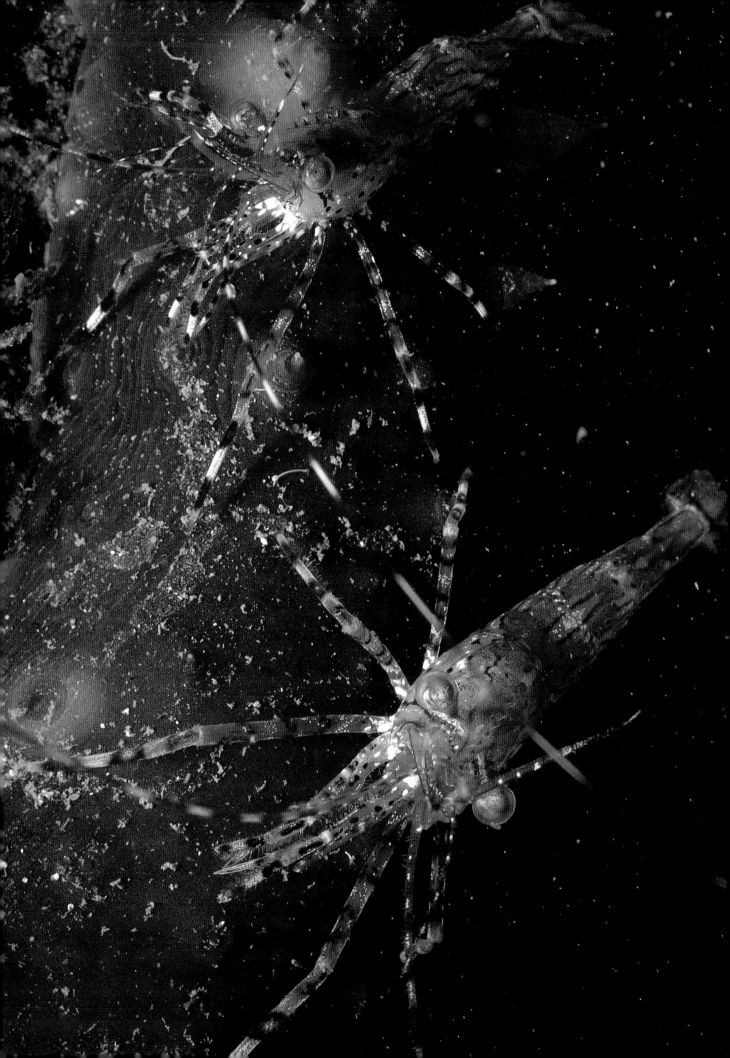

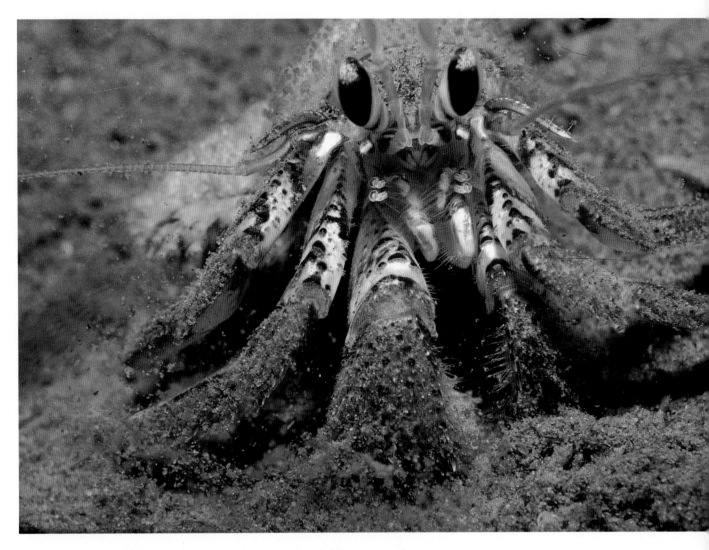

By adding a Vivitar 283 flash, a powerful electronic unit, I was able to capture the subtle colors of this tiny juvenile hermit crab (above). The flash also provided enough light output to allow me to stop down and increase the depth of field. For this shot, taken in Hoods Canal in Washington, I used my Nikonos II fitted with a 1:1 extension tube and a 35mm lens. I exposed at f/16 for 1/60 sec. on Kodachrome 25. The camera-to-subject distance here was a mere two inches.

Without the color contrast provided by the light from my Vivitar 102 electronic flash, the coon-striped shrimp in the picture on the opposite page would blend in with the sea cucumber in the background. On this dive in Puget Sound in Washington, I had my Nikonos III. For this shot, I used a 28mm lens and a 1:2.75 extension tube. The exposure was f/16 at 1/60 sec. on Kodachrome 25; the camera-to-subject distance was just 3½ inches.

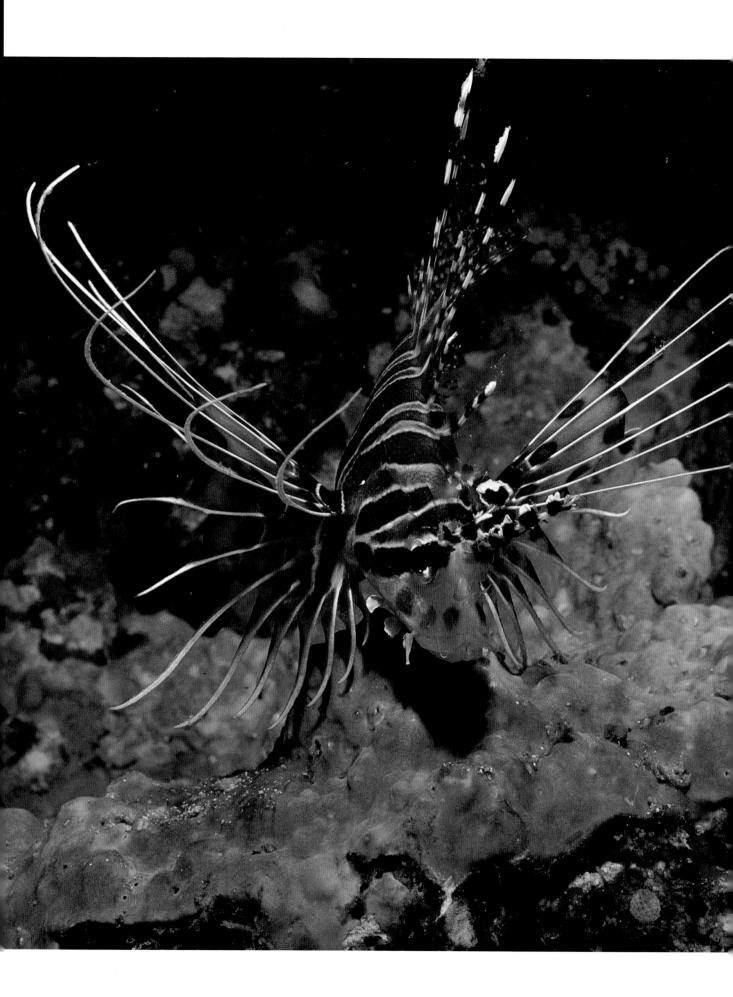

On the most simplistic level, you must follow the same basic steps underwater as you do on land in order to capture an image on film, or, in other words, to expose a light-sensitive material in a sufficiently lit environment. On land, this calls for a camera, film, a subject, adequate light (available or artificial), and knowing how to coordinate them effectively.

Underwater photography has the same requirements. However, you must first prepare the camera, film, and yourself so that they and you can operate efficiently in water. Even with the proper training and equipment—both photographic and life-supporting—you will find that underwater photography is not as simple as land photography. On land, it's easy to go to your closet, pull out a camera, and shoot that once-in-a-lifetime rainbow over your neighbor's house. But underwater, 99 percent of all once-in-a-lifetime shots are the result of intense planning as well as spending lots of time in the water. More than once I have found rare or unusual underwater subjects—which would make award-winning images—when I approached the very end of my air supply, on my way to the surface. Few obstacles are more frustrating to an underwater photographer. So, even breathing, a basic process that most people take for granted, becomes a major consideration.

After diving in this area in the Philippines for several days, I noticed that lionfish were abundant here. I wanted a picture of them in the context of their surroundings. I based my selection of camera, lens, and flash on the size of the fish. I used a Nikonos III with a 28mm lens and an Oceanic 2001 flash. The exposure was f/5.6 at 1/60 sec. on Kodachrome 25. The camera-to-subject distance was three feet.

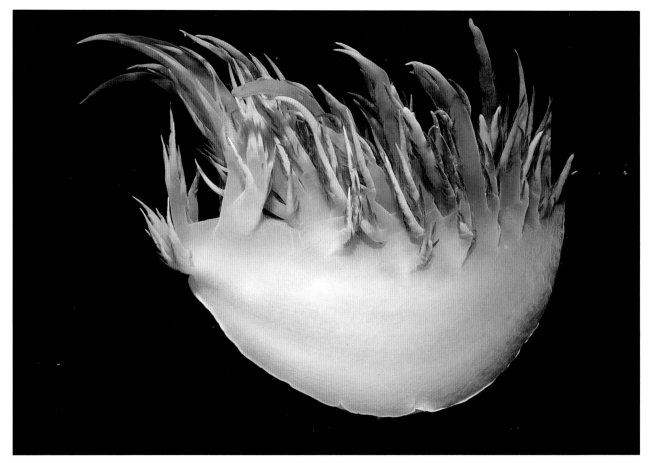

One of the most exceptional behaviors of this giant sea slug (above) is its ability to "swim" away from an attacker by gracefully flexing its huge, muscular foot. I photographed this nudibranch in British Columbia using a Nikonos III, a 28mm prime lens and a closeup lens, an Oceanic 2001 flash, and Kodachrome 25. From a camera-to-subject distance of 10 inches, I shot at f/16, 1/60 sec.

I took this shot of a reef sponge (opposite page) in the Philippines on what I call a reconnaissance dive. When I arrive at a new location, I spend one or two dives getting a sense of what kinds of subjects are in the area. Here, I had my Nikonos III and a closeup lens on the 28mm prime lens. From a camera-to-subject distance of nine inches, and using my Oceanic 2001 flash, I exposed at f/11 for 1/60 sec. on Kodachrome 25.

Thorough and organized planning is important to any shoot, but it is critical when you work underwater. You have a lot to think about: the location and condition of the environment, the nature of your subjects, and the complexity of the equipment you will need to have on hand. You also have to expect — and prepare in advance for — the unexpected. One poorly fitting flash connector or the loss of a swim fin can terminate the shoot. Alternative objectives and backup equipment are a must: underwater conditions are out of your control.

Exploring the Territory

Before you make a final decision about a potential dive site, you have to familiarize yourself with the area. This is the only way you will learn if a particular location is a practical choice.

First, you have to find out if you will enter the water from the shore or off a boat. If from shore, you will need to know where the beach access is, as well as how long the walk is from the beach parking lot to the water's edge.

If you need a boat, you will have to see what types are available. Are they outfitted for scuba diving, and can they accommodate photography gear safely? The boats may also have to transport photographers with such essentials as 120-volt lines for charging batteries (for longer trips), freshwater for rinsing and soaking gear, and secure compartments where delicate camera equipment can be stored. You might also be interested in checking out if film processing is available, either on board or on shore.

You should also ask if you will need to have an assistant in the boat at all times. If this is the case, make sure that the person — a local, presumably — knows the area well, understands how to operate all the equipment, and is aware of the purpose of your trip. Another important question to ask about arranging for a boat is whether you will be able to anchor at the site or whether the boat will follow you to pick you up when you surface.

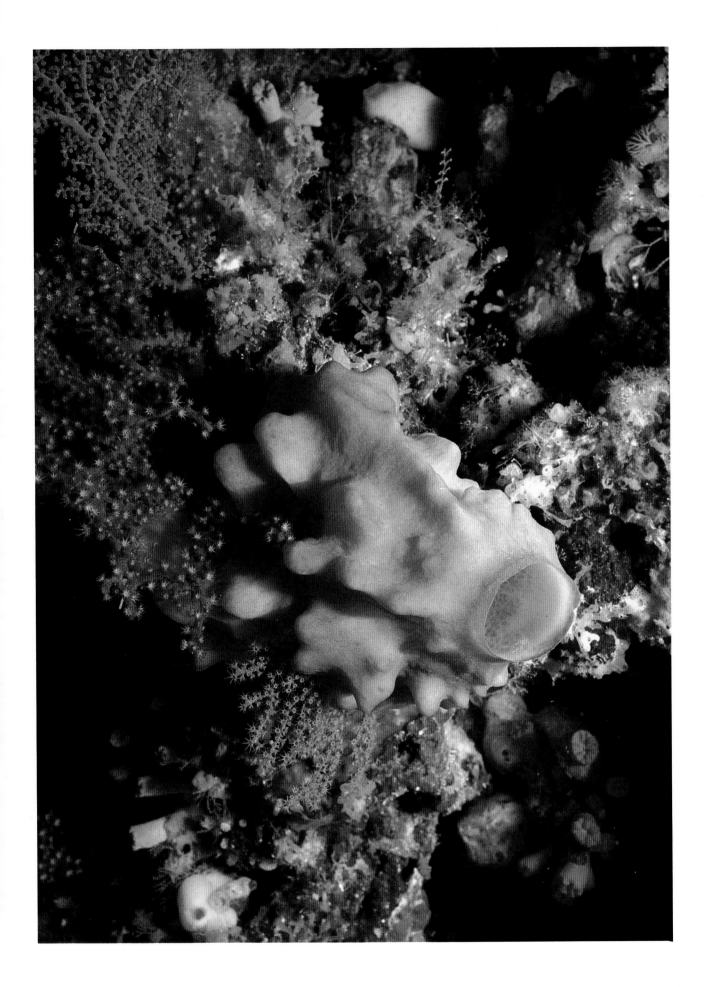

In terms of diving, you need to know if compressed air is readily available, as well as rental gear—in case you have a failure or need additional support. Other important questions to remember to ask: Where is the nearest recompression chamber? and How do I get there?

On any shoot, you also have to take into account water conditions. Find out if tides and currents will give you any trouble when you dive or want to return to the boat. And the water visibility will largely determine what kind of images you will be able to shoot. If the water is relatively clear, wide-angle shots might work best; if the visibility is poor, you might be limited to shooting closeups.

How deep you intend to dive is another key part of planning in terms of the amount of time you will have to shoot on a particular day. The deeper you go, the less *bottom* time you have.

For subjects in deep water (more than 75 feet), you might want to do an initial scouting dive in order to plan the shooting dive more precisely. You might find that you will be able to do more than one dive in that location each day, depending on water conditions, boat and diving-support availability, and decompression limits. Light may also affect your plans for deep dives. If available light is necessary, you will have to dive between 10 A.M. and 2 P.M., when the sun is at its strongest.

In order to ensure a well-planned—and successful—shoot, you have to think about these details. The need for such extensive, careful preparation underscores just how unique the underwater world is, and how poorly we are adapted to it. But the rewards for your diligence are the ability to overcome limitations and barriers, and to capture this other, very special world on film.

This species of jellyfish is fairly abundant in the mangrove channels and lagoons of Caesar's Creek in the Florida Keys. After an initial snorkeling trip, I was able to return to the boat and put together a camera setup that would accommodate the shot I had visualized. On my second dive, I used my Nikonos II fitted with a 28mm lens and balanced the available light with the light from my Oceanic 2001 flash. From a camera-to-subject distance of two feet, I exposed at f/8 for 1/60 sec. on Kodachrome 25.

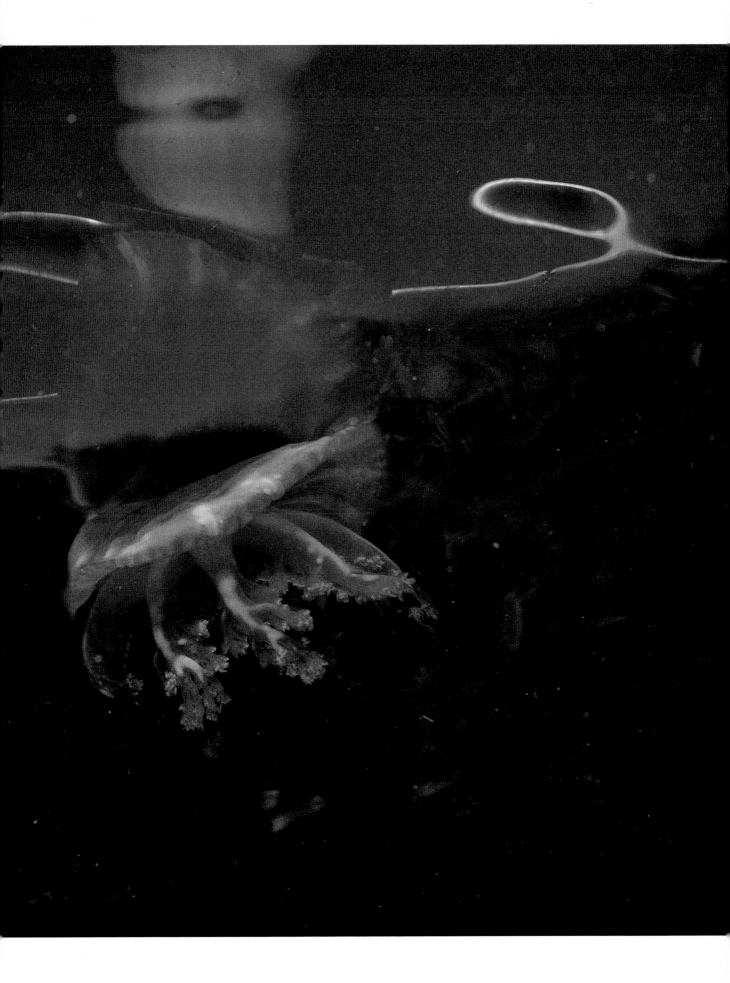

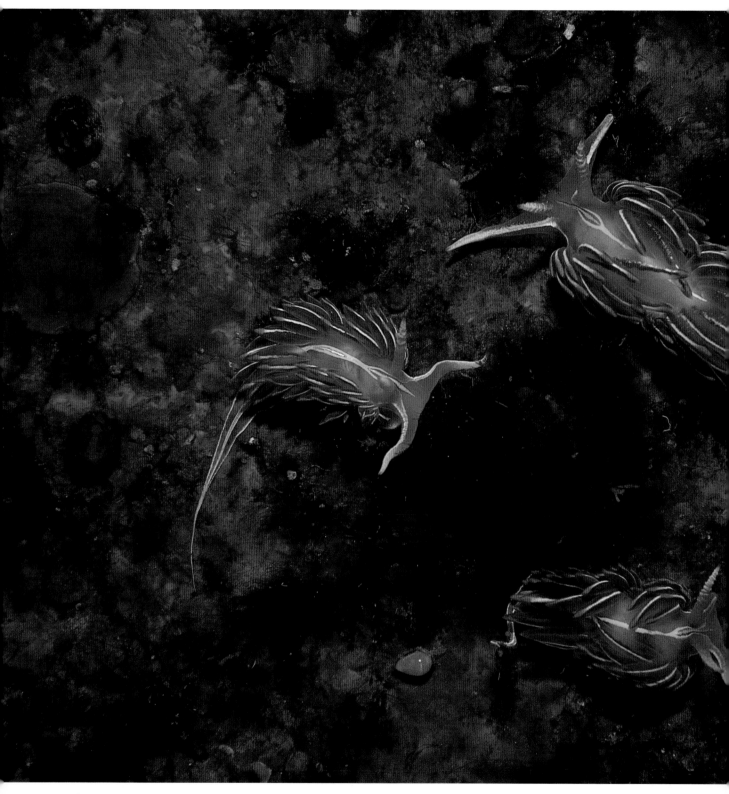

This particularly common sea-slug species feeds on a variety of organisms, such as small anemones and hydroids. I felt fairly confident that I would find some nudibranchs if I searched the rocky outcroppings where the organisms they feed on live. Shooting in the San Juan Islands, I used my Nikonos III, fitted with a 1:2.75 extension tube and 28mm lens, as well as a Vivitar 102 flash. The exposure was f/16 at 1/60 sec. on Koda-chrome 25. The camera-to-subject distance was just 3½ inches.

Considering Your Subject

When you plan a shoot, you will have to give some thought to your subjects. It will help to know something about the animals and plants you want to photograph. Where are they usually found, and, for the animals, when are they active? The more you know about your subjects the better prepared you will be. This is particularly important in regard to the animals. You will be able to anticipate their response to your presence and behavior. Having some background information is essential for any wildlife photographer.

If you will be photographing people, other considerations will become part of the planning process. Models need to be completely familiar with your ideas and goals before they enter the water: once you are submerged, you can communicate only by writing on slates and using hand signals. The models' comfort is another primary consideration. If the models get cold, they will probably look it and you will have to (or should) terminate the shoot.

With models, makeup and wardrobe are also important matters that you will have to discuss beforehand. This is also true for the type of diving equipment the models will need. Finally, decide if any props are necessary. These should be created and tested underwater long before the shoot in order for you to see if there will be a problem.

Gathering Your Equipment

All photographers choose their equipment for a shoot carefully, but this is a crucial step for underwater photographers as they plan a dive.

If you are traveling a distance, just getting the equipment to the location can be a nightmare if you don't plan well — and well in advance. Shipping such pieces of equipment as scuba tanks requires special consideration and care. In addition, you must make sure that all diving gear is in good working order. I have had some frustrating shoots that I had to end prematurely because a hose blew on a regulator or my face mask was smashed when a weight belt was dropped onto it. Now I usually take two of almost everything with me.

After you arrive at your destination and get underwater, it becomes very difficult to change or add to the photography equipment you have with you. This requires going back to shore or getting back in the boat, either of which is time-consuming and, usually, inconvenient. Having backup photo equipment with you will take away most of your anxiety — which is not unfounded — that a flash unit may not fire once it is underwater or that a camera housing is leaking.

Maintaining your equipment. Because the underwater world is so unpredictable and the unexpected often happens, you can't depend on your equipment as readily as you can on land. Alternative plans and additional gear are a must. But, by incorporating a regular maintenance schedule for your camera equipment into the planning process, you should be able to avert many potential disasters.

Keeping your underwater camera gear in good working condition depends primarily on preventative measures and careful handling. What you have to look out for most are the corrosive effects of saltwater (particularly on metal fittings) and the leaks that result from poorly fitting or damaged seals.

Most corrosion can be avoided if you rinse and soak your camera gear thoroughly in freshwater soon after it has been immersed in saltwater for any length of time. Simple rinsing is fine if you will be shooting again the next day. Soak the equipment for half an hour and then dry it off completely with a clean, absorbent towel — and, if you wish, allow it to "air dry" a while — before you put it away after a shoot. It is very important that the equipment is taken apart and inspected after each trip. Be particularly careful when you check the contacts between dissimilar metals; these points are quite susceptible to saltwater corrosion.

The one nightmare all underwater photographers have is opening a camera right after shooting images of blue whales mating to find that the camera is flooded. Floods usually happen when the seal breaks, from either a damaged or an improperly fitting O-ring. O-rings can be damaged several ways. These are frequently mishandled by photographers who are not careful and deliberate when they as-

semble their gear. Damage to the O-rings can also occur when photographers treat their gear thoughtlessly. For example, some may let it dangle off an equipment line under the boat during a lunch break. Another common way photographers cause O-ring damage is by using too much O-ring grease; they mistakenly believe that the grease makes the seal when its actual purpose is to keep the ring's rubber supple. If there is too much grease on an O-ring, it will collect dirt and grit. As a result, the seal can break or the O-ring can be impaired. Regular, close inspections of the O-rings will alert you to any nicks and will indicate when a replacement is necessary.

When a housed camera system is flooded, the camera is almost always completely ruined. This is also true of most electronic flash units. However, Nikonos cameras can, more often than not, be salvaged if the flood is detected early. (Because saltwater and electricity do not mix, there is always the possibility of your getting shocked when handling wet flash connectors and flooded flash units. Some of the larger units have capacitors and batteries that are fairly large and capable of storing significant amounts of juice. Make sure that the units are off and the connections dry when you handle them.) I always open up my Nikonos camera at the end of a day's shoot, whether or not I have used up all the film. Checking helps me sleep that night.

When a camera is flooded, you should rinse it completely in a mixture of (roughly) 50 percent freshwater and 50 percent rubbing alcohol. The alcohol acts as a drying agent, helping to remove moisture from hard-to-reach places. But it also dries out O-rings; as a result, flooded units always need to be serviced both to repair any corrosive damage and to replace internal O-rings. Next, rinse the camera again, using only freshwater this time. Place the camera in a zip-lock bag, and take it to a reliable repair shop.

This is my maintenance routine. Before a shoot, I inspect and service all accessible O-rings. First, I make sure that my hands are clean and dry. Next, I remove the O-ring in question by squeezing it out of its channel. I try to avoid using any sharp implement, such as forceps, but sometimes an O-ring can be too greasy to squeeze out. If I need to use forceps or some other tool to extract it, I look over the O-ring more carefully later for any cuts or scratches. I inspect the O-ring for any damage or wear, both by sight, under a good light, and by feel, running the O-ring through my fingers slowly. Then I dab just enough O-ring grease on my finger to cover it lightly. (Remember, the grease only helps to preserve the rubber; it has nothing to do with making the seal. Also, too much grease simply collects sand and grit, and can create a leak.) Next, I run the O-ring between my thumb and forefinger, making sure that all of its surfaces come in contact with the grease on my fingers. I inspect the O-ring again to check that no stray hairs, grit, or dirt have collected on the now greasy surface. Finally, I return the O-ring to its channel, inspecting it once again.

After I finish inspecting all of the O-rings, I go on with the rest of my maintenance procedure. I examine all fittings, and test all flash connections. Then I pack everything carefully. I repeat the procedure when I arrive on location. On a daily basis, I do an end-of-the-day rinse, soak, and inspection of the assembled equipment. Unless I suspect something is not working properly, I stop here. At the end of the trip, I break everything down and pack it. When I get home, I thoroughly inspect the equipment again before I store it in a cool, dry place. Once a year, I send all of my equipment to the manufacturer or a repair facility that specializes in underwater equipment. The inspection done at either of these places includes a careful examination of the O-rings and seals that are not readily accessible.

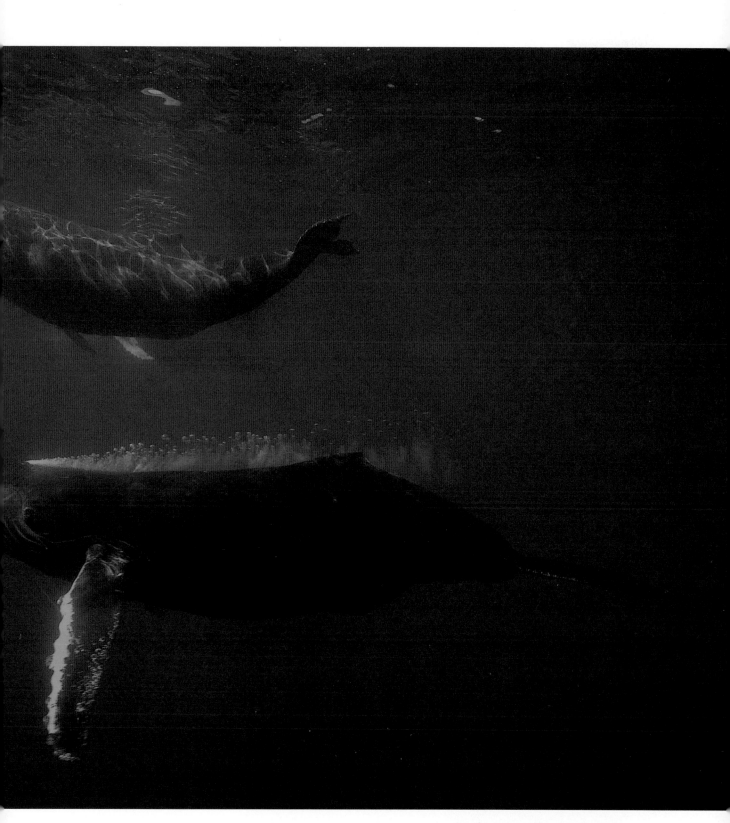

For this image of humpback whales, taken in Maui, I was in "the right place at the right time." Fortunately, my camera, a Nikonos III with a 15mm lens, was working properly, thanks, in part, to my regular maintenance routine. With available light, I exposed for 1/60 sec. at f/5.6 on Kodachrome 64 from a camera-to-subject distance of 15 feet.

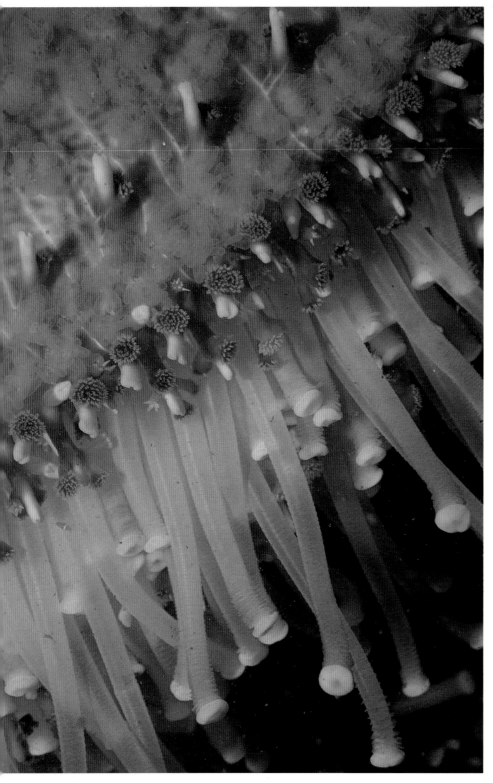

The 35mm film format allows you to work with both vertical and horizontal picture areas. This gives you more creative control. Photographing this closeup of a sun star in Puget Sound in Washington, I decided that a vertical image would be more striking. I used my Nikonos III, fitted with a 1:2.75 extension tube and a 28mm lens, and a Vivitar 102 flash. The exposure was f/16 at 1/60 sec. on Kodachrome 25. The camera-to-subject distance was 3½ inches.

Essentially, all underwater photography is done in the 35mm format. Using medium-format camera systems underwater is complicated because of the difficulty in designing and constructing waterproof housings for them. But 2¼-format camera housings are available for Rollei and Hasselblad systems. Large-format cameras, however, are never used for underwater work.

Another reason for the dominance of the 35mm format in underwater photography was the development of the Nikonos 35mm format system. Its widespread popularity in both the consumer and professional markets has had a big influence on the technological research, design, and construction of underwater camera equipment.

While the size of the consumer market for underwater camera equipment is growing, it is still quite small in comparison to the market for cameras used on land. As a result, the research and development of underwater gear are slow.

Film Choices

Within the 35mm format, film selection for underwater photography is determined by both light sensitivity and color characteristics. Although print film gives you more leeway in regard to exposure during the developing process — which can be particularly helpful in underwater use where measuring ambient light is often difficult — slide film seems to be preferred for two reasons. First, it is less expensive than print film. Given the amount of film you go through underwater, price can become an important consideration from a budgetary point of view. Second, if your images will be used commercially, transparencies are generally preferred: they reproduce better.

In addition, black-and-white film is used very little underwater; getting good shade contrast is difficult in most underwater situations. Because of this, black-and-white images usually appear dull and extremely monochromatic; they lean toward a fairly even gray tone, and everything in the picture blends in with everything else.

With the limited levels of ambient light underwater, "fast" color films are generally more useful for images in which ambient light is key. Some pho-

tographers use films with ratings of ISO 100 and higher despite the inherent problems of graininess and loss of resolution with the faster films. These include films with ISO ratings of 200 and 400, whose grain quality has been improved recently. With ambient light, your images will lean heavily toward a monochromatic combination of blue and green—a result of water's color-absorption properties. Because of this tendency, I prefer to use Kodachrome film for available-light shooting in order to try to bring out whatever red and/or orange there is in the water. I don't use Ektachrome film with ambient light because it tends to enhance the blues and greens. With color-print film, warm colors can be enhanced to a certain degree during the printing process. This can also be done with slide film if an internegative is made and a print is produced from it.

For closeup work, most photographers choose films with ISO ratings of less than 100. This is because a great deal of light is given off by electronic flash units at small flash-to-subject distances (usually less than 18 inches). The films used almost universally for such work are Kodachrome 64 and Kodachrome 25. Their ability to accentuate warm colors, such as reds and oranges, can be particularly effective with many small marine subjects: these tend to be brightly colored. In addition, Kodachrome 64 needs less flash power for exposure than Kodachrome 25 while it provides a high degree of sharpness.

However, even Kodachrome 25 can be used if the power output from the electronic flash unit can make up for the loss of about 1½ stops. I use it almost exclusively for closeup flash work because I find its sharpness to be unmatched.

One final word about Ektachrome 64 and other films that require E-6 processing, such as Fujichrome and Agfachrome. The advantage of these types of films is that they can be processed almost anywhere you go. This comes in very handy when you check that your equipment is working properly at the beginning of a location shoot. By being able to shoot and develop a test roll, you can find out if your equipment is faulty *before* you shoot hundreds of feet of film on that once-in-a-lifetime trip.

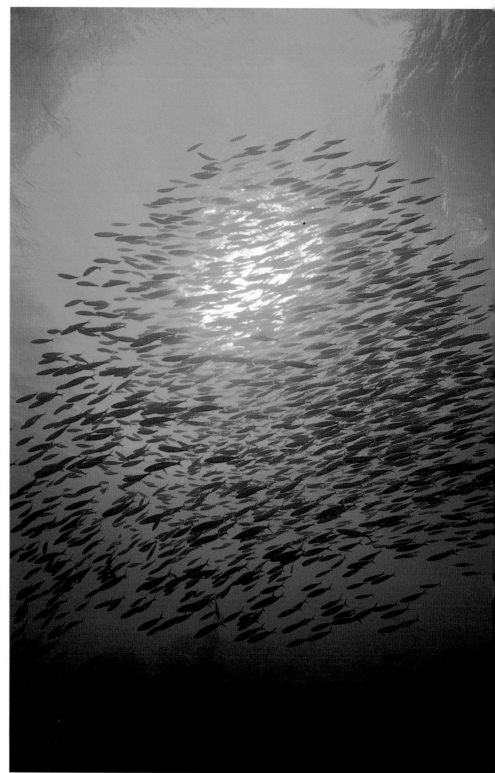

Ektachrome 64, which I used for this photograph of a school of mullet, picked up and accentuated the blue hues in the tropical waters in Bonaire, in the Netherland Antilles. With available light, I set my Nikonos III, fitted with a 15mm lens, for 1/60 sec. at f/16; the camera-to-subject distance was 10 feet.

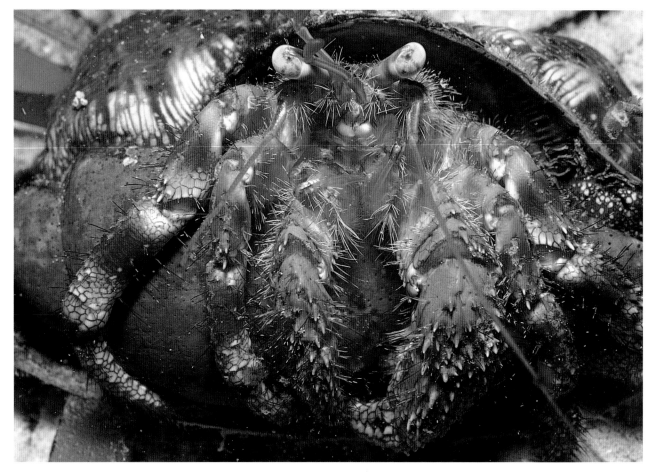

Determining exposure for closeups is simplified by their short camera-to-subject distances. For this picture of a hermit crab that I came across in St. Croix, I shot from a camera-to-subject distance of just 3½ inches. I exposed for 1/60 sec. at f/16 on Kodachrome 25, using my Nikonos III, a 1:2.75 extension tube, a 28mm lens, and my Vivitar 102 flash.

As on land, calculating exposure underwater is controlled by three primary components: film speed (the film's sensitivity to light), shutter speed (the amount of time the film is exposed to light), and the lens aperture (the amount of light that enters the camera through the lens opening).

In terms of film speed, if available light is key, you will need fast films. These have ISO numbers of 100 and up. For closeup and other types of photography that require flash, you can — and will probably want to — use slower films. These have ISO ratings of 64 or less (see page 47).

Shutter speeds for underwater photography are generally quite slow in comparison to those used on land, again for two reasons that correspond to the kind of images you want to take. In available-light situations, speeds of 1/125 sec. to 1/30 sec. are acceptable, with 1/60 sec. fairly common. While using slow shutter speeds can blur action underwater (as it does on land), potential subjects move considerably slower underwater: as a medium, water is much denser than air. When blurring happens underwater, then, it is usually the result of camera shake rather than subject motion.

With flash photography, your selection of a shutter speed depends on the fastest speed at which shutter and flash synchronization can occur. This is usually about 1/90 sec. Again, because of the relatively slow movement of most aquatic subjects, the flash duration stops the action, not the shutter speed. (But flash will stop even fast action if the exposure is mostly flash-dependent.)

Aperture manipulation will offer you the most control over determining exposure underwater. You will usually want as much depth of field as possible for both closeup and wide-angle work. Here, too, basic photography rules apply. Smaller lens openings give you more depth of field. But the high apertures that give you greater depth of

field reduce the amount of light. This must be made up another way. You can either increase the sensitivity of the film or slow the shutter speed (but both of these options have other ramifications—more grain and blurring, respectively).

When you use an electronic flash unit, its power output becomes another factor in determining exposure. A unit's power output is based on the guide number (GN) specified by the manufacturer. You should do your own tests to calculate power output as well. The manufacturers' suggested GNs for underwater flash units can vary as much as two f-stops, depending upon the water conditions the unit is used in. The GNs also tend to be a bit on the optimistic side when it comes to flash power and recycling time. To get the guide number, multiply the aperture by the flash-to-subject distance (or, as well-known underwater photographers Jim and Cathy Church say, "Think GAD").

Underwater, light diminishes with the square of the flash-to-subject distance, as it does in air. So determining correct exposures for a given flash unit and film is actually a matter of doing a test to create an exposure chart that will provide you with correct aperture settings for varying distances (assuming that shutter speed is a constant), such as this one.

EXPOSURE CHART FOR OCEANIC 2001 FLASH
(Kodachrome 64, 1/60 sec.)

Flash-to-Subject Distance (in feet)	f-stop
.5	22
1	16
2	11
3	8
4	5.6
5	4

This chart shows the results of shooting a test roll of Kodachrome 64 film for which the flash-to-subject distances above were measured carefully and exposures were made at each of these distances through the range of f-stops indicated, and then recorded. Examination of the resulting transparencies and identification of "correct" exposures would be matched against the chart, revealing the f-stop at which they were made.

Because the exposure relationships between film, shutter speed, and aperture are standardized, you will only need to make a new exposure chart for each flash unit, not for each film or shutter speed. Manufacturers provide such charts with their products, but I usually do a test roll and make my own chart in order to familiarize myself with a new piece of equipment. Frankly, the process of creating the chart usually helps me remember the chart in the field without having to refer to it.

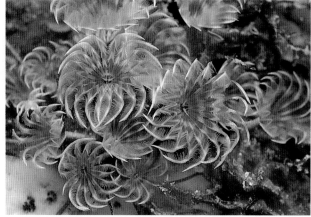

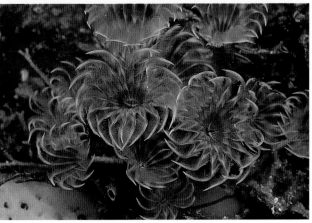

After you calculate exposure, bracketing provides some insurance that you will get at least one correctly exposed image, as you can see in these shots of tubeworms. Here, the calculated aperture was f/16 (directly above). The aperture for the image above on the left, f/11, let in too much light, "burning" the image. At f/22, not enough light reached the film; this resulted in the dark image to the left. (Notice the different depths of field.)

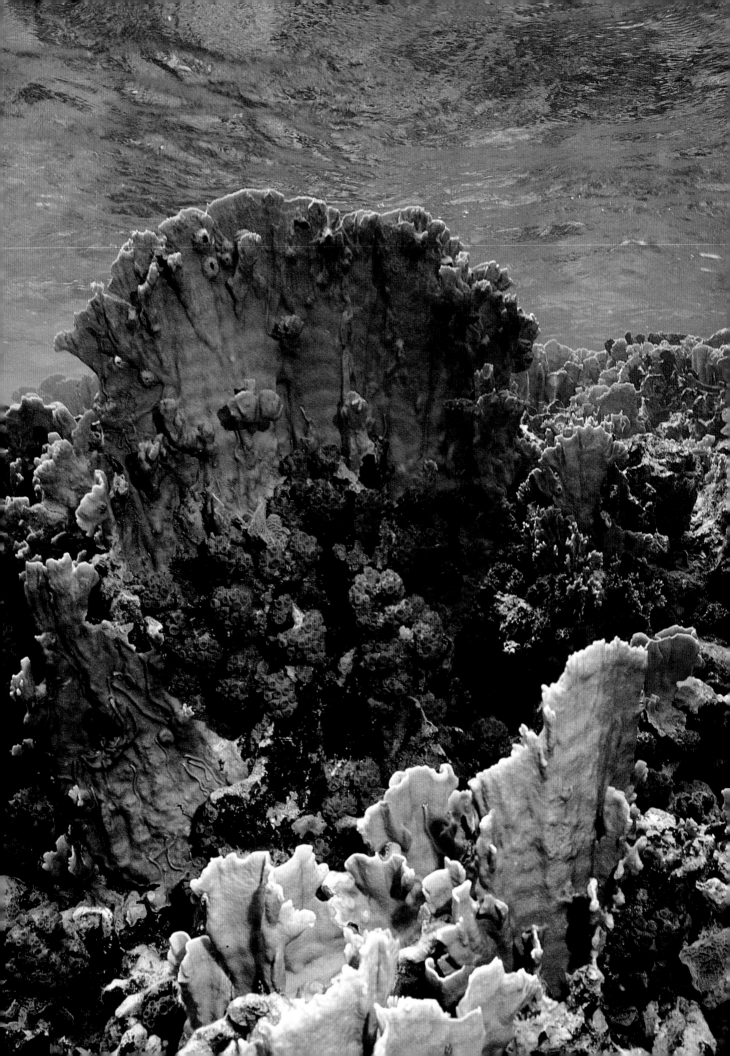

Measuring Light Underwater

Because light levels vary considerably underwater, making accurate measurements of ambient light is usually difficult at best. These levels fluctuate for a number of reasons, including meteorological conditions (clouds passing overhead), surface water conditions (waves reflect varying amounts of light, which can change instantly), and water turbidity and clarity. In addition, light may reflect differently off a subject at different depths.

As in air, light meters are used to measure light levels underwater. In shallow water, you can watch underwater light levels vary on your meter as the needle jumps with every passing wave.

In general, light varies more with upward camera angles than with horizontal or downward views. This is an indication of changes that occur in light levels at the surface. I usually direct the meter at my subject and watch the meter for a while to see just how great the range in variance is. I then try to pick the median level and bracket around it, usually plus and minus one to two full stops. You will often find yourself bracketing underwater, both with available-light and flash photography. The widespread acceptance of bracketing underwater is yet another measure of the extremely variable conditions found in the aquatic world.

For this picture (opposite page) of a shallow reef in Bonaire, accurately measuring the available-light level was critical in order to properly expose the background scenery and to adjust the light output from the flash so that it matched this amount of ambient light. This provided the color saturation in the foreground. My associate had a Nikonos V with a 20mm lens and a Helix Aquaflash 28. Working from a camera-to-subject distance of two feet, he shot at f/8 for 1/90 sec. on Kodachrome 64.
© Robert Frerck.

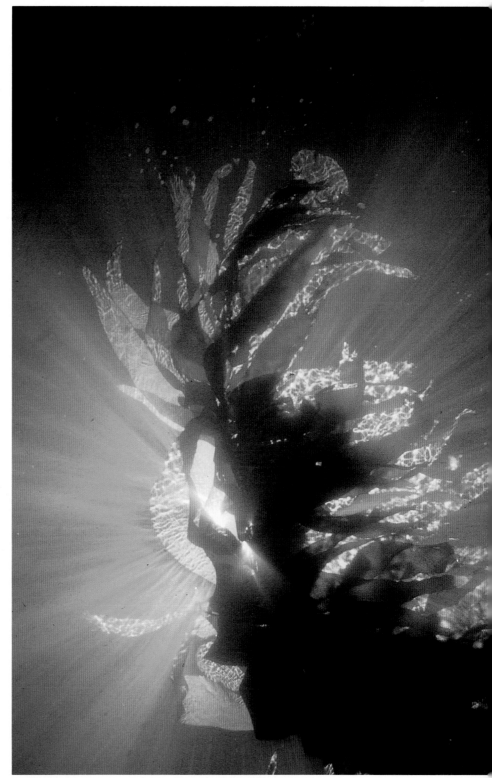

The most difficult aspect of this silhouette was timing my breathing with the sway of the kelp as it moved in the surge. I wanted the sun to be directly behind the kelp, but didn't want any bubbles from my exhaling in the picture. Shooting in Monterey Bay, California, from a camera-to-subject distance of 10 feet and using available light, I exposed for 1/60 sec. at f/8. I used my Nikonos II, a 28mm lens, and Kodachrome 64.

FOCUSING

Getting sharp, clear images underwater is hindered by several factors that vary with the type of camera system you're using. With viewfinder cameras, such as the Nikonos, your first concern is accurately estimating camera-to-subject distances. Refraction (the bending of light rays as they travel through an air/water interface, such as a face mask—see page 31) of light plays a role here: it confuses the issue on a conceptual level. As a result of refraction, the subject appears to be approximately 25 percent closer than it actually is. And, because there is another air/water interface between the camera lens and the surrounding water, the camera also "sees" the subject as being 25 percent closer than it is. So at whatever distance you estimate the subject to be from the camera, that is the correct focus setting for the lens.

Another factor you have to consider with viewfinder systems is that of parallax. This is the difference between the position of the subject through the viewfinder (which is usually mounted on top of the camera) and what the lens sees. Parallax increases as you get closer to the subject. Because practically all underwater photography requires extremely small camera-to-subject distances, parallax can be a problem if you don't take it into account. The simplest way to compensate for it is to use a viewfinder that tilts (adjusts) the horizontal view. These viewfinders are calibrated for varying distances.

Focusing single-lens-reflex (SLR) cameras underwater has its own set of difficulties. The main problems are being able to see through the viewfinder and getting a clear image on the focusing screen. Basically, you are looking through five glass interfaces: the face mask, the viewing window in the waterproof camera housing, the viewfinder of the camera in the housing, the lens, and, finally, the window on the other side of the housing through which the lens sees the subject. These problems are further complicated by the generally low levels of light underwater.

You can overcome the problem of a small viewing area in two ways. The first is simply to enlarge it. Both Nikon and Canon have enlarged viewing screens in their optional actionfinders for their top-of-the-line models. These are used extensively in housed systems. The other solution is to place a magnifying device in front of the viewfinder of any SLR camera. Although these do not provide a viewing area equal in size to that of the enlarged actionfinders, they allow you to house SLR cameras that are not in the Nikon or Canon "F" series.

In general, viewfinder camera systems are easier to use underwater than SLR systems are. This explains, in part, the tremendous popularity of the Nikonos camera system. But, although you can focus viewfinder cameras more easily, determining the picture area and composing accurately are more difficult. In both systems, you will want to maximize depth of field. With viewfinder cameras, this will greatly increase your chances of estimating subject distance correctly; with SLR cameras, increased depth of field gives you some freedom in accurately focusing on a subject.

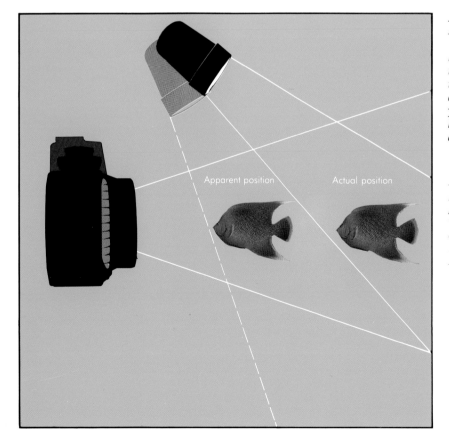

Apparent position *Actual position*

A camera "sees" underwater objects the same way you do because refraction—which causes these objects to appear to be approximately 25 percent closer than they actually are—occurs wherever there is an air/water interface, such as at a camera lens or at a face mask. So, when you hand-hold an electronic flash, you have to aim it at the actual, not the apparent, position of the subject.

With my SLR Nikon F2 in a Giddings-Felgen housing, I was able to critically focus on the eye and outline of this patient lionfish in the Indo-west Pacific while shooting from a camera-to-subject distance of 12 inches. I used a 55mm macro lens and a Vivitar 283 flash in an Ikelite housing. The exposure was f/11 at 1/80 sec. on Kodachrome 25.

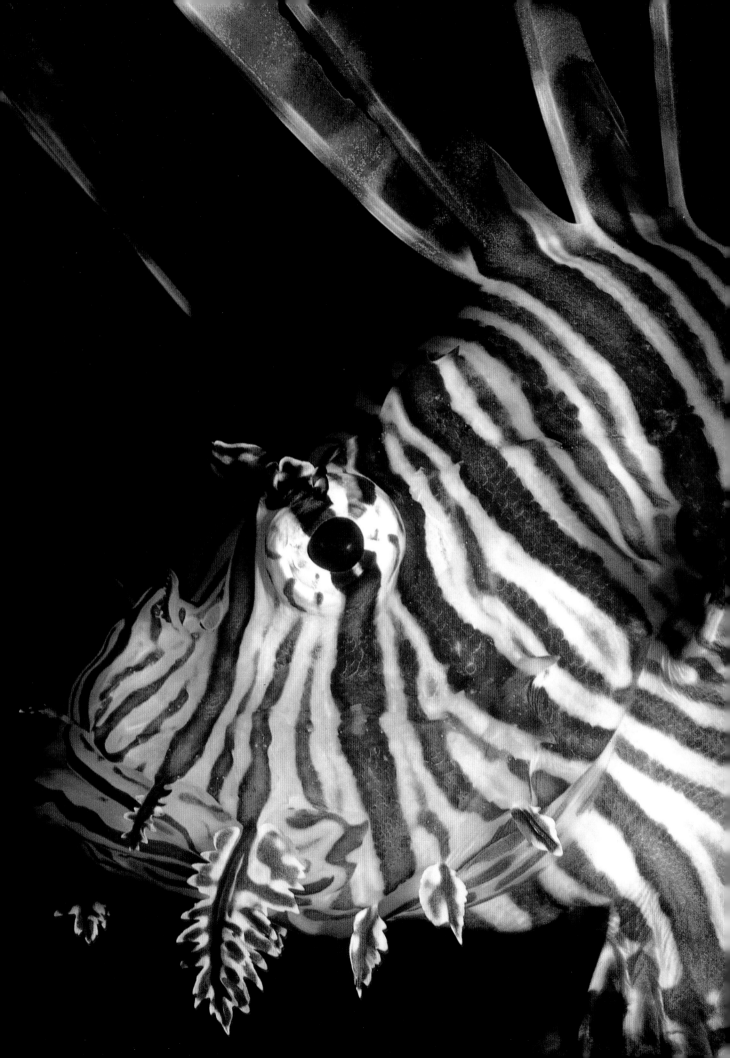

The two words that characterize all underwater photo equipment are "waterproof" and "rugged." The primary consideration in designing any piece of underwater photo gear is keeping the internal parts dry. This requirement shapes the design process for developing submersible camera systems. It calls for the use of strong, corrosion-resistant materials, as well as testing facilities that allow manufacturers to experiment with units under varying pressures.

Camera equipment for underwater photography must also be able to withstand extended periods of exposure to vibrations (such as an hour-long boat ride to a dive site), the corrosion that saltwater can cause, violent knocks and bumps (such as when a dive buddy accidentally drops a weight belt on your camera housing), and a variety of other abuses that would destroy even the most durable land camera immediately. As a result, most underwater camera equipment is heavy, bulky, oversized, and awkward to handle, at least on land. Once you and your equipment are underwater, however, buoyancy takes over and managing your gear is relatively easy — until you get back on land and carry, or drag, it to the car.

Besides your camera equipment, you have to consider the diving gear you will need to get you to the shoot site. Once again, the words "waterproof" and "rugged" apply, as do "heavy," "bulky," and "awkward." But handling your diving gear becomes easier in time, as you get used to it and develop your own system. Again, two of the key elements to successful underwater photography are acquiring superior diving skills first and being familiar with all of your gear.

Because of the diversity of underwater camera equipment available today, photographers and divers are often tempted to go overboard when buying and using gear.

CAMERA SYSTEMS

These developed along two major lines. The first consists of taking an existing land camera and designing a watertight vessel called a *housing* for it. Not only must this system accommodate getting the camera in and out of the housing in order for you to load film and change lenses, but it also must have through-vessel fittings so that you can manipulate the camera controls from outside it. However, each fitting is a point on the housing where water can seep in, and each requires a seal. Early housings were not too reliable. Today's models are made of both molded plastic and metal and are extremely reliable if maintained properly.

In the second approach, the camera *is* the housing: the camera body represents the vessel with the outside controls that are directly linked to the inner workings of the camera. These controls include the shutter-release button, the lens-aperture control, and the film-advance lever. This approach is applied to viewfinder cameras only, with which it works quite well. The degree of complexity in the workings of single-lens-reflex (SLR) cameras has, for the moment, prevented this approach from being used with these cameras.

Viewfinder Systems

There are four basic 35mm camera systems available for underwater use. For less serious work (for example, snapshots for relatives back home), there are several lens-shutter cameras available, such as the Minolta Weathermatic. These cameras will give your viewers an idea of what it looks like "down there." The most popular and widely used is the Nikonos system, manufactured by Nikon, Inc. And, the Nikonos camera is the most versatile amphibious camera available on the market today. Truly amphibious, it can be used both on land and below the water's surface to depths of 150 feet. Other attractive features of the Nikonos camera include its 35mm film format; its compact size, which is about the same as most other 35mm SLR cameras; its durability; the selection of lenses; and its price, which is affordable. The main drawback to the Nikonos system is that it is a viewfinder camera: this restricts composition significantly. However, the many accessory lenses that are available through both Nikon and other camera equipment manufacturers allow photographers to overcome this serious limitation to a degree.

The Nikonos system's long and successful past has resulted in the design and development of five basic camera models. Over the years, the features of each model have varied. However, the manufacturer has carefully maintained compatibility throughout the system. As a result, underwater photographers have been able to mix and match lenses, camera bodies, and accessories to a large extent. It is not uncommon to see Nikonos II bodies made in the 1970s sporting a 28mm lens made in 1987.

But there are some significant differences among the various models, which are identified by number.

This lionfish would never have allowed me to position an extension-tube framer against its body. Shooting in the Philippines from a camera-to-subject distance of one foot, I used my Nikon F2 in a Giddings-Felgen housing, a 105mm Micro Nikkor lens, and an Oceanic 2001 flash. The exposure was f/16 at 1/80 sec. on Kodachrome 25.

Nikonos I and its predecessor, the Calypso, are valued as collector items; few are in use today. These early models provided the technological base upon which all later models were developed. In terms of design, the Nikonos I and the Calypso consisted of a sturdy metal body into which the guts of the camera fit; it was sealed with one large main O-ring. The lens locked these two components in place, creating yet another major seal with a large circular O-ring. All of the camera controls were also sealed with O-rings.

The second model, Nikonos II, is still used today, proof of its durability. It actually varies little from the Nikonos I. The Nikonos III, put on the market in the late 1970s, is regarded by many underwater photographers as the most durable model. Nikonos III bodies are still in demand, and rumors of a secret stash of never-before-used Nikonos III cameras in a photography store in Hong Kong are heard. But they remain just that—rumors.

The Nikonos III varied from the earlier models. It had a more dependable three-pronged flash connection, an improved design of the film pressure plate, the film counter on the top of the camera, and a more dependable film rewind. In addition, the Nikonos III camera was as durable and rugged as its predecessors. All it lacked was a light-metering system.

This feature was added to the Nikonos IV, which was available in the early 1980s. With this model, however, came a radical change in the general design of the camera body, particularly in the film loading and access areas. Additionally, the main O-ring seal and body-locking mechanism were dramatically different—but for the worse. The Nikonos IV model represents a transition in the overall design of the Nikonos system, as well as a benchmark in Nikon's promise to continue to improve the Nikonos system.

The most current underwater photography camera, the Nikonos V, is far superior to the fourth model and confirms the company's commitment. In addition to solving the problems in the design of the Nikonos IV, Nikon added several important options in both the electronic light-metering features as well as in camera-flash automation. The Nikonos V has a through-the-lens (TTL) metering system. These innova-

tions not only enable novices to take reasonably good images from the start, but also make the camera easier to use for underwater photographers with more experience. In fact, the light-metering systems in the last two Nikonos models have made the cameras much more useful. They can be used for shooting on canoe or rafting trips, or for shooting outdoors on rainy days.

Housed Systems

The three other camera systems for underwater photography all involve housing a land camera (not a Polaroid camera, but one intended for above-water use) in some kind of waterproof container. The simplest (and least expensive) approach is using a giant zip-lock plastic bag. A company called EWA makes a tough vinyl bag that can hold just about any kind of 35mm camera. With a port for the camera lens and a glove-like grip for reaching camera controls, this kind of housing is a great option for taking underwater photographs when you least expect to. Although the bag has some major limitations, such as the inabilities to be used in deep water and to accommodate an off-camera flash unit, it does permit you to adapt your present camera for underwater use.

Another approach is to use a camera housing made of clear, hard plastic. These housings are quite popular, work well when maintained properly, and are widely available. One company, makes a plastic housing for just about every camera or flash on the market—and if Ikelite doesn't have what you want, it can make whatever you need. The advantages of plastic housings are their lightness, transparency, and affordability. The major problem with them is that they require a great deal of care and maintenance.

The third approach to camera housings are the most technologically advanced—and the most expensive. These housings are made of cast metal and are usually constructed from an aluminum alloy. As such, they are rugged and can take a great deal of abuse. In addition, metal housings leak infrequently. The workmanship involved in their production generally matches the kind of camera you would want to protect in such housings—both are an investment.

Nikon continues to improve its underwater photography system. On the left is the virtually indestructible Nikonos III; on the right, the electronically updated Nikonos V.

In the photograph above, a new Ikelite plastic housing for a Nikon F2 is on the left; on the right is a metal Giddings-Felgen Niko Mar III for the same camera, which still works well.

LENSES

Lens selection for underwater photography is rather limited, mainly because of the need to shoot at small camera-to-subject distances. Because there is no room for long distance photography underwater, telephoto lenses are not needed. Zoom lenses are also rarely used underwater because they require an additional control in the camera housing. Most underwater photography is done with either closeup or wide-angle lenses, both of which allow you to get close to your subject.

Whether you are shooting with a Nikonos camera or a housed SLR camera, you can evaluate the lenses available for underwater use by considering five basic elements. The first is focal length, which indicates the angle of view that the lens sees and, as a result, the size of the picture area the lens can cover. The focal length and the picture area are inversely proportional: the shorter the focal length, the larger the picture area, and vice versa. Additionally, lenses with short focal lengths offer tremendous depth of field. When

you select a lens, be sure to match the focal length with the average size of the subjects you will shoot. If you will primarily photograph people, the lens you select must be able to cover an area at least as large as a diver (or two) at a distance of no more than 5 to 8 feet, such as a 20mm lens. You must also match the lens to the angle of coverage of the flash unit you will be using with it. It is better to match the flash unit to the lens than the lens to the flash for the simple reason that if the flash unit fails, you can still take pictures by using available light.

Aperture range is the second element you should give some thought to. For example, how far does the lens open? Remember, the larger the aperture, the lower the amount of light you can shoot in. And, at the other end of the f-stop scale, the smaller the aperture, the greater the depth of field. It also gives you an idea of the amount of depth of field the lens provides at various settings.

Another critical lens feature is minimum focusing distance. This indicates how close you can get to your subject with the lens. Minimizing the camera-to-subject distance is always desirable underwater. This distance is especially important with extreme-wide-angle lenses in housed systems because a virtual image may be created in front of the lens, the result of the curvature of the dome port.

The fourth element is the quality of the lens—a vital consideration whether you shoot on land or below the water's surface. Will the lens accommodate one or more types of lens accessories? Again, your needs are the determining factors. In general, there seems to be a correlation between the quality and cost of a lens, and it is very easy to compromise one for the other. I believe in using the right tool for the right application. A lens designed for closeup work usually provides better results than a normal lens with a diopter in front of it.

Finally, you have to think about the various types of accessories available for the different lenses. Supplementary closeup lenses, wide-angle adapters, filters, and extension tubes can all add greatly to the versatility of a limited lens inventory.

The Nikonos system offers various lenses and closeup accessories. Some of these are, from left to right, a closeup lens with a framer extension bar attached, a closeup lens framer for a 35mm lens, a 28mm lens (inside framer), a 20mm lens, a 15mm lens, and a 1:2 Helix extension tube with a framer attached.

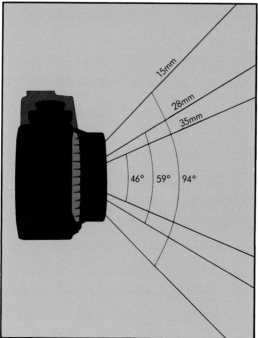

In general, focal length determines the lens's angle of view and, consequently, the picture area that a particular lens can cover. The longer the focal length, the narrower the lens's angle of view.

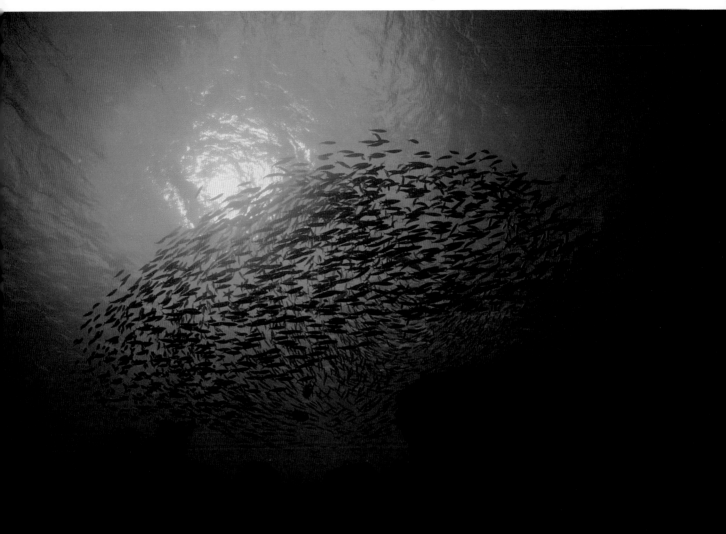

Housings are available for light meters used on land, but the industry standard is the hand-held Sekonic Marine Meter. This reflected-light meter is specially designed for underwater use. It comes in its own housing, has enlarged numbers for easy reading, allows you to see the entire scene, and is relatively durable. You can also use in-camera meters, both with the latest Nikonos models and housed SLR cameras. But these are not as easy to read.

For this shot of a school of mullet, taken in Bonaire, I used a hand-held meter while balancing the available light with the light from my Oceanic 2001 flash. With my Nikonos III and a 15mm lens, I exposed for 1/60 sec. at f/11 on Kodachrome 64. The camera-to-subject distance was 15 feet.

The Sekonic Marine Meter II, shown at left, is the industry standard in hand-held underwater light meters.

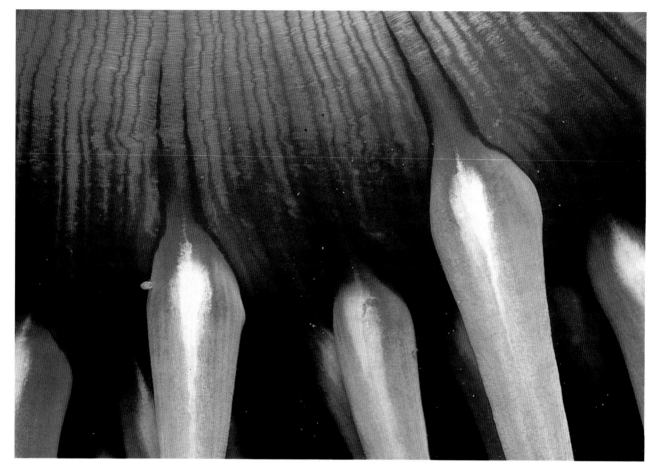

I came across this sea anemone in the Strait of Juan de Fuca in Washington. When I saw the rich colors in its tentacles, I realized that I would need an electronic flash to bring them out. So I used my Vivitar 102 flash. I also used my Nikonos III, fitted with a 28mm lens and a 1:2.75 extension tube. The exposure was f/16 at 1/60 sec. on Kodachrome 25; the camera-to-subject distance was 3½ inches.

For this image of a sea-anemone tentacle (opposite page), taken in the Strait of Juan de Fuca, I was shooting from a camera-to-subject distance of just 3½ inches. Because of my proximity, the low-powered Vivitar 102 flash I was using was strong enough to bring out the colors in the tentacle and to maintain good depth of field. Here, I used my Nikonos III, fitted with a 1:2.75 extension tube and 28mm lens, and exposed for 1/60 sec. at f/16 on Kodachrome 25.

Because of the general lack of ambient light below the water's surface, most underwater photography requires supplementary light as either fill or, more often than not, key lighting. Additional light is usually needed to show the true colors of your subjects. These are usually lost because of water's differential absorption of visible light. There are three sources of artificial light for underwater use: movie lights, flashbulbs, and electronic flash units.

Movie Lights

This source of artificial light allows you to dim the light and see in advance exactly what the picture will look like. However, movie lights designed for underwater photography are not appropriate for still photography, primarily because they require large quantities of power in order to produce enough light to adequately cover most picture areas. Another problem: the color temperature of most movie lights does not match the color temperature ratings of most still-format films.

Flashbulbs

These artificial-light sources enable you to use cameras that synchronize flash firing with fast shutter speeds. Underwater photography subjects rarely have to be photographed with flash at shutter speeds greater than 1/90 sec. because of the density of water: it significantly slows down almost any object moving through it.

Flashbulbs are no longer widely used for underwater photography. The main problem with flashbulbs underwater is getting a dependable one to make contact with the flash socket in water, usually saltwater, in order to fire. And, because flashbulbs are filled with gas, they float. This creates a problem just carrying them around with you underwater.

Electronic Flash Units

Essentially, all artificial light for underwater photography is supplied by electronic flash units. The advantages of using them include dependable firing and synchronization, adequate light

Various types of electronic flash units can be used for underwater photography. These include, from left to right, the Ikelite Substrobe 150, a wide-beam, full-power unit; the Helix Aquaflash, an all-purpose, medium-power unit; the Nikonos SB-103 Speedlight, a wide-beam, full-power unit; and the Nikonos SB-102 Speedlight, a medium-power unit.

output and area coverage, color temperatures that match existing film types, and adaptability to automatic light sensing/output or manual modes. There are a variety of makes and models to choose from, depending on your requirements.

Coverage capacity. As in air, perhaps the most important criteria for selecting a flash is matching its light coverage (beam angle) with the viewing coverage of the lens being used. Such a match provides overall even lighting of the subject. Because of the extreme light absorbance by water, if the beam angle does not equal or exceed the lens angle, you will find that uneven lighting can be very apparent.

For the most part, today's available electronic flash units fall into one of two categories based on angle of light coverage and power output. With respect to beam angle coverage, flashes with beam angles less than 85 degrees are considered small to medium. Such flashes evenly light the area of view of lenses in the 28mm to 35mm range. The coverage of these smaller units can be increased through the use of a wide-beam adapter. This accessory takes the form of some type of plastic or glass element that fits over the outside of the flash head, diffusing the light over a larger area, thereby increasing the angle of coverage. By using beam adapters, however, you lose about one full stop in light intensity. The other option for increasing beam coverage using small-to-me-

dium flash units is to use two units simultaneously. This doubles the area of coverage without any loss of light intensity.

Electronic flash units with beam angles of between 85 and 120 degrees are considered large. These units cover the angle of view of most wide-angle lenses. Using wide-beam units with medium lenses increases the margin for error in flash unit placement and resulting light coverage with such lenses as a 35mm or a 28mm. These units are bigger and bulkier than the smaller units because of their enlarged flash heads and reflectors, as well as the space allowed for larger power packs.

Light output. It is almost impossible to discuss the area of coverage without relating it to flash power, or light output. Because matching the flash coverage with the lens coverage depends on what you intend to shoot. Large subjects, such as divers, require wide-angle lenses and greater camera-to-subject distances. As a result, the flash requirements for these subjects are large beam angles and high light output. Small flash units are generally limited to medium to closeup shooting because of their low power. Large units with variable-power control are more versatile: they can be used for both wide-angles, at full power, and close-ups, at one-half to one-quarter power.

Power is usually supplied to underwater flash units from either disposable alkaline batteries or rechargeable

nickel cadmium battery units (nicads) that are either built directly into the unit or can be replaced easily. The replaceables are usually "AA" batteries for the smaller flash units and either "AA" or "C" for larger units. Both types of batteries have strengths and weaknesses, and once again it is a matter of selecting the one best suited to the application.

Alkalines are available at any drugstore or supermarket practically anywhere in the world. They provide an even supply of juice that is gradually depleted as they are used. This depletion is manifested in the time it takes the unit to recycle. With alkaline batteries, the *recycle time* (the time it takes for the "ready" light to come on in between flashes indicating the capacitor is fully loaded) simply gets longer as the batteries run down.

One of the advantages of rechargeable nicads is just that: they can be used over and over again because of their ability to be recharged. Of course, this requires a source of line voltage, which is not always available to underwater photographers on the high seas in small vessels. I always carry spare alkalines — just in case I cannot recharge my nicads — as well as several sets of nicads. I also try to use flash units that allow for such interchangeability in power supply.

One other consideration when charging nicads is their tendency to have a "memory" with respect to how many flashes a particular set of batteries will provide. This memory is cre-

ated when partially run-down nicads are fully recharged. If this is done repeatedly, they will begin to only provide as many flashes as when they were recharged. It is best to always run nicads down to their lowest storage capacity before charging them.

When charged and ready to go, nicads provide much faster recycle times than alkalines. However, when they run out of power, they do so with little warning. Unlike alkalines, which run out gradually, nicads go quickly. As such, unless you are paying close attention to the recycle times, you will find that it is easy to get stuck with a dead flash for lack of power.

Firing capability. Getting the flash unit to fire in synchrony with the camera shutter can be one of an underwater photographer's greatest frustrations. Despite twentieth-century technology, there is still a little mystery — and unpredictability — to flash-firing underwater. More often than not, the weak links in the system are the connector

and sync cord that connect the flash unit to the camera. Not only must a good connection be made between the flash connector and camera contacts (as on land), but it must also be kept dry. Wet or dry, there is the potential for your getting shocked if you touch both flash contacts, completing the circuit, so be careful. A small O-ring seal at both the camera and flash connections of the sync cord usually does this. Connectors of this type cannot be disconnected once submerged.

Several systems allow for a wet connection (such as an "E-O" connector), which can be connected, disconnected, and reconnected while underwater. These systems provide much more flexibility in terms of selecting equipment for any given dive. For example, when I know that the flash unit I have been using is almost out of power, with just enough left for about half a roll of film, I use the fully charged flash unit that I brought along as a backup. I then switch the units underwater. Another example is the

In order to maintain the light background, I had to use available light as the key light in this picture, taken in Maui. By using my Nikon SB-102 Speedlight at quarter-power, I was able to enhance the detail in the sea turtle's head and shell. With my Nikonos V and a 20mm lens, I exposed for 1/90 sec. at f/5.6 on Kodachrome 64. The camera-to-subject distance was three feet.

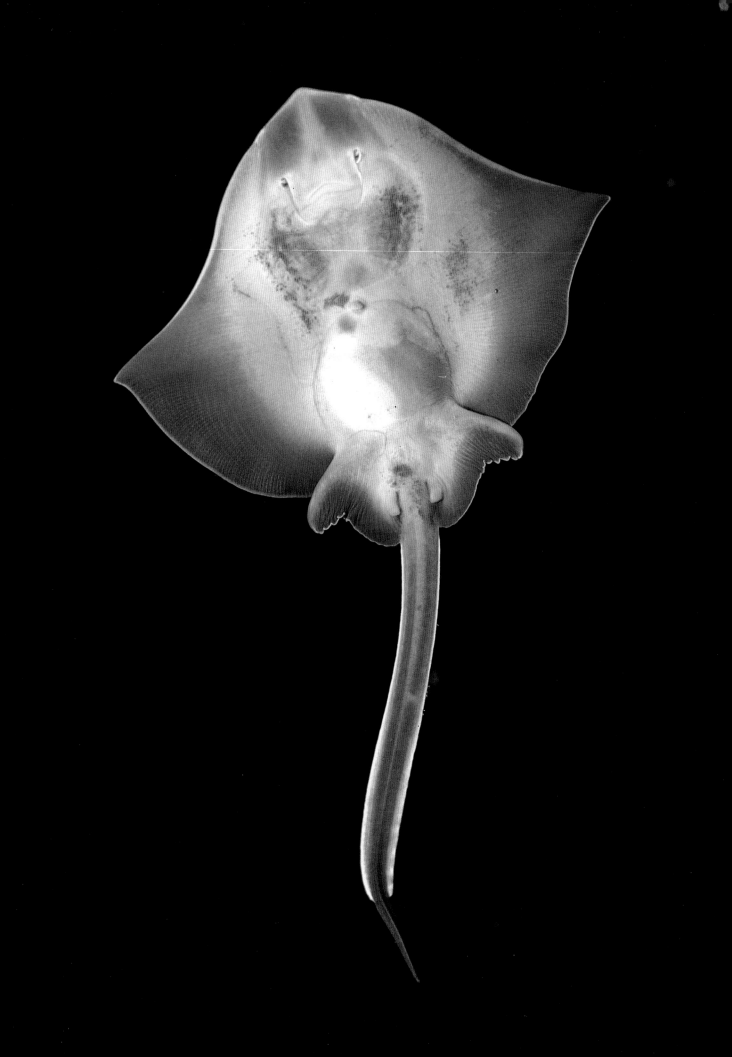

ability to take several camera systems and one large primary flash, mixing and matching during the dive rather than having to resurface every time I want to change flash units.

Additional features. Besides beam angle and power output, several other features available on some of the larger (and more expensive) flash units give you greater shooting flexibility. One of these is the unit's ability to change power output from full to half- or even quarter-power when it is in the manual mode. The greatest advantage to such control is the conservation of battery power. When shooting closeups with large units, you can use half- or quarter-power to provide all the light you need, depending upon the type of film you're using. You can also bracket exposures using a power control.

Another useful feature of many larger electronic flash units is the ability to use them as a slave to another flash unit, firing the latter in synchronization without a sync cord or connector. Such units have a light sensor connected internally to the flash-firing electronics. The sensor picks up the blast of light from the flash triggered by the camera and fires a split second later. Small units can be used as slaves, giving fill light to larger key lighting provided by a flash connected directly to the camera. The placement of the slave and its sensor in relation to the key triggering flash is more critical underwater than in air because of the scattering of light and the difficulty light has traveling through a medium 800 times denser than air. Dual-flash systems involving a slave flash are generally set up with both flash units attached to the camera on brackets or adjustable arms. It is important that the sensor on the slave flash be positioned relative to the triggering flash so that it picks up enough light to trigger the slave.

Recently, automatic flash photography has become available to underwater photographers. As in flash units designed for use in air, automatic flashes provide correct exposures by matching the light output of the flash with the reflectance and light levels necessary for a correct exposure of a subject. This is accomplished through a sensor device either on the flash or electronically hooked up to the flash

In order to catch the action of this newborn skate (opposite page) at a camera-to-subject distance of nine inches as it emerged from its egg case in Puget Sound, I used an Oceanic 2001 flash with a fast recycling time. I knew that I would have to be able to get the maximum number of shots possible during the brief period when the skate began to swim. In the photo above of a sea lily, taken on a dive in Powell River in British Columbia, I created the black field by shooting out into the open water. I knew that all of the light from my Oceanic 2001 flash would be absorbed. The short flash duration stopped the action of the swimming sea lily. For both shots, I used my Nikonos III, a 28mm lens, and a closeup lens, and I exposed for 1/60 sec. at f/16 on Kodachrome 25. In each case, the camera-to-subject distance was nine inches.

Subjects that create fairly homogeneous backgrounds can be captured accurately using automatic-flash systems. These regulate light output by reading the reflectivity of a subject. For this picture of a crown-of-thorns sea star, taken in the Philippines, I used a Helix Aquaflash. I also used a Nikonos III with a 28mm lens. The exposure was f/8 at 1/60 sec. on Kodachrome 64. The camera-to-subject distance was two feet.

through the camera (through-the-lens, or TTL), which measures the light reflecting off the subject as the flash is triggered, shutting it off when the right amount of light has been emitted. The advantage of TTL systems is that the sensor is placed at exactly the right place—in the lens. Earlier automatic systems had the sensor either at the flash or on a remote sensor attached to the camera.

Automatic flash units have some distinct advantages over manually operated systems in certain situations. As in air, they work best when the subject has an even or homogeneous reflecting surface. Here, the sensor can accurately pick up and read how much light is being reflected by the subject and can then shut off at the right time.

Subjects with variable backgrounds as well as those with great variation in shade contrast confuse the sensor; this can lead to getting a reading off just one part of the subject, under- or overexposing the rest of the image. Getting an accurate reading underwater is, perhaps, even more difficult because of the scattering and absorption of light as it travels through water. I find automatic flash systems useful when shade contrast is even and when I don't have time to make all of the necessary aperture, shutter, and other camera and flash adjustments necessary for illumination in manual flash mode. But I don't like giving up the control I have with a manual flash setting; I know exactly how much light will be available and where it will reach.

ACCESSORIES

As does any photographic endeavor, underwater shoots call for a number of tools, supplies, and other various items that are absolutely necessary, such as extra batteries, or come in handy, such as duct tape. Not only do you need tools and supplies for your camera gear, but also for your diving gear.

A small spotting flashlight is extremely useful. When attached to a flash, it tells you exactly where the flash is aimed (some of the larger flashes have a spotting light built directly into the unit). Spotting lights are particularly helpful on night dives, although some aquatic organisms react negatively to having a light shine directly on them. In such cases, I hand-hold my light off to the side of the subject.

Metal and plastic clips are helpful for temporarily attaching camera gear to your body, freeing up a hand momentarily. I usually attach the clip to my person (or diving equipment such as a shoulder strap) and a loop of line or a metal ring of some kind to the camera. It is not a good idea to keep your camera gear attached to you constantly because it can bang into you or the seafloor, or in some other way can act as a sea anchor. I like to keep gear within sight at all times if possible.

When it comes to spare parts, I carry at least one backup of everything, particularly O-rings, seals, and other waterproofing devices. Cotton swabs for cleaning O-ring channels and grooves, "crazy" glue for repairing almost anything made out of plastic, WD-40 spray for lubricating metal fittings (not for greasing O-rings), electrical ties for attaching clips and snaps to equipment, hand tools for working on both camera equipment and dive gear (such as for changing plugs and hoses, or adjusting backpacks) can be found in my tool box. I also carry all kinds of tape, spare batteries, velcro strapping in various sizes, string, cord, and surgical tubing and wire.

Filters

As on land, color-correcting filters alter the quality of light by reducing or removing one part of the spectrum so that other parts can show through. The use of filters underwater to enhance the colors lost through differential ab-sorption might seem helpful at first. However, there is usually so little ambient light that reducing it even more through the use of filters is not advisable. In very shallow tropical water (less than 10 feet deep), using a CC30R filter helps bring back some of the red, which is the color lost first. This filter, which is magenta, removes some of the blue light but allows the red to pass through unobstructed. This group of filters can aid in reviving lost skin tones when you photograph people underwater. At 20 feet, the effect is essentially unnoticeable. (As mentioned earlier, colors in color-print film can be manipulated to a certain degree during the printing process. Slide film, on the other hand, cannot, unless an internegative is produced.)

Tools

When it comes to tools, I carry all of the basics—pliers, screwdrivers, wrenches, files, a small hacksaw, vice grips, as well as tools of a more unusual nature—a set of jewelers' tools, coarse and fine forceps, various dental tools, and a magnifying glass. All of these items usually require you to carry a tool box. I prefer a large, plastic tackle box (a metal tool box is susceptible to corrosion). As you develop your own system, you will undoubtedly collect a selection of these kinds of materials that will suit your specific needs. But I never feel comfortable going on any underwater shoot without at least a pair of pliers and some duct tape. These are indispensible items for work underwater.

My tool box contains an assortment of items, including crescent wrenches, vice grips, a jeweler's tool set, a pocket magnifying glass, duct tape, nylon cord, spare O-rings and O-ring grease, a small spotting flashlight, razor blades, and extra batteries and film.

In general, the severe environmental constraints and the complexity of shooting underwater limit the range of lighting possibilities that exist in the aquatic realm. The use of available light is greatly restricted by water clarity, and by water's ability to absorb and alter the quantity and quality of light entering it. But with artificial-light sources, you first have to solve the problem of mixing electricity and water. You also have to use artificial lights that provide tremendous light output in order to overcome the light-absorbing property of water, which reduces the amount of sunlight as well.

The last lighting problem is one of *bottom time*. On land, both in the studio and the field, you often have as much time as you need to set up a lighting array, test it, adjust it, and shoot. On an average dive, you might have between thirty and sixty minutes to set up and shoot. In some situations, you might be able to make more than one dive at a location, but, for the most part, the constraints of bottom time are the limiting factors when it comes to complicated and exotic lighting arrays.

As an underwater photographer, you can combat these constraints several ways. You can select film according to light availability and source. You can also attach your various flash units to your camera so that they move with the camera. And, above all, the simpler you can keep your lighting system, the better.

In shallow water, available sunlight can be used effectively to illuminate large subjects. Here, the photographer positioned himself with the sun coming over his shoulder, frontlighting this barracuda. Through the use of a low camera angle, the water surface is included in the picture; this provides viewers with an idea of where the fish is in relation to the photographer. This available-light image was taken in the CoCo View Channel in Roatan, Honduras, from a camera-to-subject distance of two feet. The photographer used a Nikonos V with a 20mm lens set at f/8 and exposed the scene for 1/90 sec. on Kodachrome 64. © Robert Frerck.

AVAILABLE-LIGHT PHOTOGRAPHY

The sun is usually the primary source of light for land photography, but its use is much more limited in underwater photography because of water's ability to absorb and scatter light. For the most part, available light is used when the subject is too large or too distant to be lit adequately with flash. Because light from a flash unit is absorbed and scattered as readily as natural light is, a subject does not really have to be very large or very far away.

Shooting with available light underwater results in a monochromatic image: most of the colors in the light spectrum are absorbed, even in very shallow water. The color of most available light images reflects the spectral qualities of the water they are taken in. Water in temperate coastal regions tends to be green because river runoff increases the amount of suspended particulate matter. Water in open, tropical regions, however, is very blue and very clear. (In the deep sea, where no light can be found—most deep sea organisms either lack pigmentation completely or are red, which absorbs what little light there is at such depths—animals are less visible than they would be if they were black.)

Measuring the amount of light available underwater can be tricky. Every time a wave passes overhead, it bends (refracts) the sun's rays a different way. This alters the quantity of light penetrating the water as well as the direction of penetration. A passing cloud also affects available light 30 feet under the water's surface. So, for both upward and downward camera angle positions, I usually monitor my light meter for several moments before calculating an exposure setting. Doing this allows me to watch the variations in the light and take a median reading. I also bracket extensively when I shoot with available light, particularly for silhouettes.

There are several basic ways to improve your available light images. Because the position of the sun will have an effect on both the intensity of light penetrating the water as well as its color temperature—as it does with land photography—shooting between 10 A.M. and 2 P.M. is best. The sun is strongest then. (The reverse is true for land photography: shooting with available light before 10 A.M. and after 2 P.M. becomes difficult because light intensity is greatly reduced, a result of the low position of the sun in relation to the horizon.)

For this shot of a wave breaking in Hawaii, I knew that I would have to compromise. If I had exposed for the dark rock, the water and the sun would have been too light. If I had exposed for the water's surface, most of the detail in the shore would have been lost. So I bracketed extensively. The exposure was f/11, 1/90 sec. on Kodachrome 64. The camera-to-subject distance was 20 feet. I used my Nikonos V and a 20mm lens.

Try to shoot with available light in shallow water only. This enables you to take advantage of as much light as possible and, therefore, to retain at least some color contrast. Upward camera angles are useful for silhouettes, while downward camera angles work best for shooting against an even-toned background, such as sand.

Another way to improve your available-light shots is to stay as close as possible to your subject. You can do this by using wide-angle lenses, with focal lengths in the low twenties and teens. As you will learn, very little closeup work is done using available light because lenses must be opened up to compensate for the absence of illumination; this decreases depth of field. (This isn't a major consideration with wide-angle lenses.)

You can also compensate for low levels of natural light by shooting with films that have an ISO rating of 100 or higher. Nevertheless, I have found that when I am photographing in tropical waters under clear, sunny skies, I can usually get by with films with ISO ratings of 64 and 100 for most shots requiring shutter speeds between 1/30 sec. and 1/125 sec.

Whatever approach you choose, you will find that shade contrast is accentuated in available-light photography underwater. This creates opportunities for you to effectively separate the main subject from the water surrounding it. A silhouette is perhaps the most obvious example; with the sun as the source of light, you have to position yourself so that the subject is between the camera and the sun. You can also achieve separation by shooting down on a subject with an even, homogeneous background, such as a sandy seafloor or an area of open water. Here, the silhouette is more dramatic, but in both situations, the principle subject is identified clearly through shade contrast. This is one of the few types of underwater imagery for which you can use black-and-white film effectively: the image would be essentially monochromatic in color as well. A black-and-white film allows for greater exposure latitude and manipulation of film speed without a significant reduction in resolution.

A silhouette is one of the most dramatic types of underwater images. It is characterized by strong backlighting, usually provided by the sun. A tremendous amount of shade contrast is the key to an effective silhouette. For this image, taken on a salt pier in Bonaire from a camera-to-subject distance of 20 feet, I used my Nikonos III, a 15mm lens, and available light. The exposure was f/8 at 1/60 sec. on Kodachrome 64.

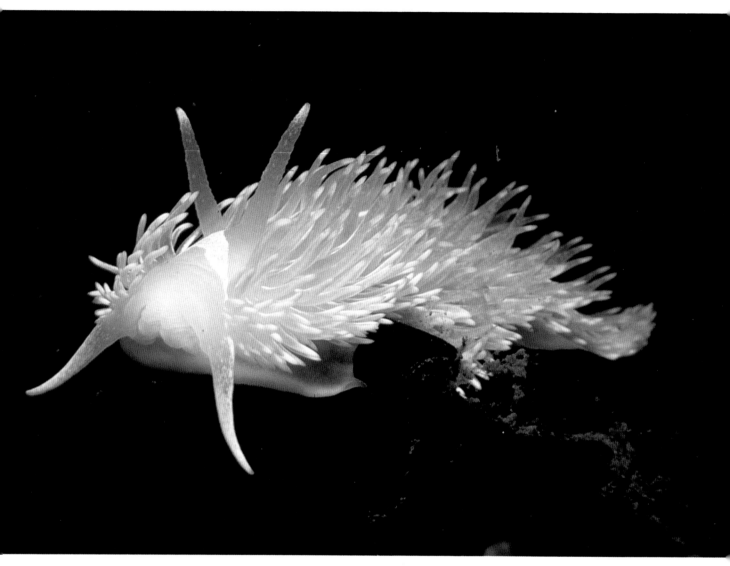

For this shot of a hairy nudibranch in Puget Sound in Washington, I placed an Ikelite Substrobe directly over my Nikonos III and aimed the flash down at the subject at approximately a 45-degree angle. The nudibranch is evenly illuminated with just one flash for two reasons. First, its highly reflective color—which is essentially white—causes light hitting it to bounce around, filling in small shadows. Also, the background, which consists of dark kelp, is highly light-absorbent; this increases the light contrast of the subject on the background, making the nudibranch stand out clearly. Using a 28mm lens and a 1:2.75 extension tube, I shot at f/16 for 1/60 sec. on Kodachrome 25.

With the addition of artificial light, the underwater world becomes a dazzling display of bright colors of every shade. Aquatic organisms tend to be considerably more colorful than terrestrial life forms.

Rich colors are most apparent on night dives in densely inhabited environments, such as coral reefs. Of course, the only light sources available at night are the artificial lights you take with you. As a result, you see the "true" colors of your subjects everywhere the dive light shines. In some ways, night photography is more accurate than daytime shooting in terms of seeing color contrast and using it as a compositional tool. Furthermore, dive lights are rarely needed during the day because ambient light provides

enough illumination for you to get around. However, colors remain muted and mostly unseen—until you develop your film. Some of my most pleasant photographic surprises were the result of shooting what appeared to be a dull subject underwater during the day only to find that it was really bright red.

The use of any artificial light underwater adds color contrast to the image. And, whenever more light is available for an exposure, you have an opportunity to increase the depth of field by stopping down. Also, depending upon how the artificial-light source is directed at the subject, you might be able to simulate sunlight; this gives you more creative control when making your images.

Single-Flash Photography

Two of the most important elements here are flash placement and direction. Even illumination of your subject occurs only when the flash unit is aimed squarely at the subject and the beam angle of the unit equals or exceeds the angle of the lens in use.

There are two ways to position and aim a flash unit. One is to attach the unit directly to the camera. You can do this with an articulating arm of some type that allows you to place the flash unit in several different planes. The main advantage here is that you can maintain a certain level of consistency in your exposures: you know exactly where and how far away from the subject the unit is aimed each time you click the shutter. However, you have less flexibility in varying the position of the unit because each change requires you to adjust the arm as well. This might sound easy, but underwater almost any equipment adjustment is a major production. (I find that I am much less willing to change the position of a flash unit if the unit is attached to the camera — especially if it is the end of the day and I'm tired and cold. At that point, any equipment adjustment seems like an impossible task. I know, though, that I am risking a missed photo opportunity.)

The alternative approach for placing and aiming a flash unit is to hand-hold it. This gives you a great deal of flexibility in positioning the flash unit, in terms of both direction and flash-to-subject distance. Being able to change that distance can be particularly useful when you want to bracket exposures: you won't have to switch the aperture setting.

There are, however, some drawbacks to hand-holding the flash unit. The first problem is the potential for inconsistent results, especially when you are just starting to learn this technique. In addition, it requires the use of another hand, which may not always be possible if you are negotiating a swift current or adjusting diving gear. Furthermore, it is almost impossible to hand-hold a flash that is being used in conjunction with a housed single-lens-reflex (SLR) camera. This problem involves trying to look through the viewfinder in order to focus and aim the flash at the same time. Not only is this difficult, but it requires two hands to

In this example of frontlighting, I placed a single flash unit over my camera and aimed it at a 45-degree angle to the plate coral.

Here, I moved the flash to the left of the camera and aimed it at the coral at approximately a 45-degree angle. Notice how the coral structure in the center severely blocks light from reaching the right side of the image.

In this second example of sidelighting, I placed the flash on the opposite side of the coral, in the same position. The severe shadows are on the left side of this picture.

For this toplighting shot, I positioned the flash off camera, directly over the subject. It is not pointed toward the lens, but the light beam is at a 90-degree angle to the focal plane. The result: dramatic shadows highlighting the plate coral.

To enhance this image, I wanted to give this fairly flat subject some relief, texture, and dimensionality. When I held a single Vivitar 102 flash at an acute angle off to the side, the light fell unevenly on the underside of the sand dollar. As a result, each row of spines looks different. Shooting in Puget Sound from a camera-to-subject distance of just 3½ inches, I used my Nikonos II on which I had mounted a 1:2.75 extension tube and a 28mm lens. I exposed for 1/60 sec. at f/16 on Kodachrome 25.

hold the housing, adjust the focus control, and depress the shutter. (It is, however, relatively easy to hand-hold a flash unit while using nonreflex systems, such as the Nikonos, in which the focus control is preset.) With these systems, you can look through the viewfinder and see the flash out of the corner of your eye simultaneously.

Placing the flash unit high and off to either side of the camera is preferable for two reasons. First, and foremost, it approximates the direction of light coming from the sun, providing your subject with even and natural-looking light. Second, it helps avoid backscatter, which is caused by the illumination of small particulate matter suspended in water (here, the light source is the flash unit). When such particles as sand are illuminated, they reflect light back toward the lens. As a result, your subject appears to be in the midst of an underwater snowstorm. The extent of the backscatter depends in part on the turbidity of the water: clearer water has fewer suspended particles from which light can reflect. If you aim the flash unit high and at an angle to the camera's lens, much of the reflected light will bounce away from the lens rather than directly back at it. You can see why backscatter is a major potential source of frustration for underwater photographers.

Aiming the flash unit is complicated even further by refraction. Remember that underwater, objects appear about 25 percent closer than they actually are. So, if you roughly estimate where to place the flash, you may miscalculate the flash-to-subject distance by this margin. If this happens, you will end up taking a photograph of what is known as the *apparent image*. If you practice, compensating for this 25 percent error will become second nature. However, attaching a modeling light to the flash head takes care of the problem immediately: you can see exactly where your flash hits the subject. The use of a modeling light is especially helpful on night dives.

The flash-to-subject distance can affect the outcome of your images in two ways. The farther away from the subject you place the flash, the larger the area of the subject it covers. However, by doing this, you also lose light intensity: the farther away from the subject you place the flash unit, the less in-

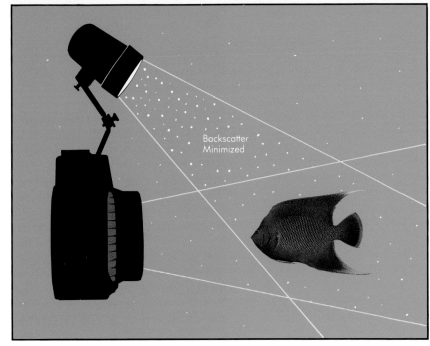

Backscatter
Minimized

By aiming a single Vivitar 102 flash directly at this anemone fish, I was able to eliminate most of the harsh shadows caused by the anemone's tentacles. This also enabled me to illuminate the shy fish within. On a dive in the Philippines, I used my Nikonos III fitted with a 1:2.75 extension tube and a 28mm lens. Shooting from a camera-to-subject distance of 3½ inches, I exposed at ƒ/16 for 1/60 sec. on Kodachrome 25.

As this chart shows, when a flash unit is placed high and above the camera, light reflecting off any suspended particulate matter bounces away from the camera lens, not directly toward it. As a result, backscatter is minimized.

75

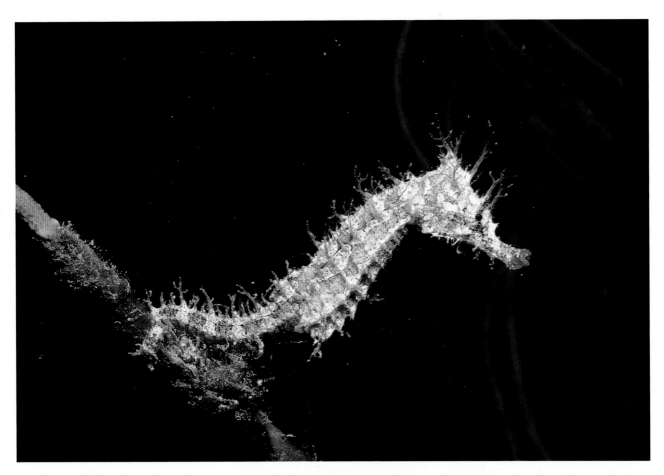

tense the light on the subject is (light falls off with the square of the distance from the subject). As a result, the closer the flash is to your subject, the more light you have to work with. You then have the potential to increase depth of field by stopping down to a smaller lens aperture. In most underwater shooting situations, you will find that increased depth of field is desirable; it is the simplest way to offset any errors in focusing housed SLR cameras or in estimating camera-to-subject distances when using nonreflex cameras, such as the Nikonos.

Multiple-Flash Photography
Every photographer knows that each time he or she adds equipment to a shoot or makes capturing an image on film any more complex than it already is, the chances of something going wrong increase dramatically. So, you should only add pieces of equipment if they will enable you to create an image that you would not be able to make any other way. Underwater multiple-flash setups definitely fall into this category: getting even one flash to fire consistently below the water's surface

can be cause for celebration.

Usually, multiple-flash photography calls for two flash units to be positioned on either side of the camera. They are placed high and aimed down at an angle of approximately 45 degrees. Lighting arrangements utilizing more than one flash unit can provide the following: illumination over a greater area, increased depth of field, and the filling-in of harsh shadows.

If you use two flash units that have the same power capacity and beam angles that do not overlap significantly, you can achieve much greater light coverage. In this multiple-flash configuration, two narrow beam flashes can be used in conjunction with a wide-angle lens, covering the lens's field of view adequately.

Conversely, if you aim two flash units of equal power so that their beams overlap, approximately twice as much light will reach the subject. You can then use a smaller lens aperture setting, which results in greater depth of field. Typically, you gain about one *f*-stop by such an arrangement. While this might not seem like a significant difference, it can provide the amount

My Vivitar 102 flash provided more than enough light for this highly reflective seahorse (above), which I found in the Florida Keys. Because of the open water in the background, I didn't have to worry about harsh shadows. With my Nikonos III fitted with a 1:2.75 extension tube and a 28mm lens, I exposed for 1/60 sec. at f/16 on Kodachrome 25. The camera-to-subject distance was 3½ inches.

Backscatter can occasionally enhance an image. The extreme backscatter in the photograph of a comb jelly on the opposite page provides a more interesting background than a pure black backdrop would. It also gives the image a "spacy" feeling, which complements the galactic shape and texture of the comb jelly. The exposure for this shot, taken in Roatan with a Nikonos IV, a 35mm lens, a 1:3 extension tube, and a Helix Aquaflash 28, was f/8 at 1/60 sec. on Kodachrome 25. The camera-to-subject distance was 3½ inches.

of light necessary to switch from one film to another, such as from Kodachrome 64 to Kodachrome 25. This configuration is particularly useful in closeup shooting.

Another multiple-flash setup can fill in shadows in two ways. The first involves positioning two flash units of equal power at different distances from the subject. The unit closer to the subject acts as the key light, and the other as fill. Because it is farther away from the subject, the light from the second flash unit has to travel through more water; as a result, more of this light is absorbed.

The other way to achieve differential light intensity is to position two flash units with different light outputs at equal distances from the subject. Flash units that have different power settings can also come in handy here. You can leave one unit at full power as the key light, and set the other at half- or quarter-power as fill. Whichever flash units you use, base your exposure on the key light only: the additional fill light from the lower-powered unit will not significantly affect your exposure.

Because having two flashes fire simultaneously underwater seems at times to be difficult (although most units available today are pretty reliable), you might want to try using double synchronizing cords. These cords connect both flash units directly to the camera, ensuring that squeezing the shutter will trigger both of them. Another option is to sync the light to the camera and use an unattached fill light, which is fired as a slave when the key light flashes. When using this option, you have to make sure that the slave sensor on the fill light is directed at the key light; if it isn't, the fill light will not fire consistently. This is not usually a problem in closeup situations, but it can be in wide-angle shots for which you use a slave.

Trying to figure out exactly where to position two flash units for key and fill lighting might seem bewildering at first. But it will be easier if you look at how the natural light shadows fall on your subject. Deciding where to put the flash units will be less overwhelming if you consider the general nature of the subject, particularly its dimensionality. Is it flat, or are there lots of points sticking out all over the place that create shadows? What is the primary feature of the subject? This is where you should aim the key light; use the fill light simply to fill in any shadows resulting from protrusions. In any event, be sure that the fill light does not fill the shadow areas completely by using a lower power setting than the key light of at least one stop. If this happens, the subject will lose all dimensionality and depth — and this defeats the purpose of adding that extra flash.

The photographer in this shot used a double-flash system with a Nikonos closeup kit system. Because the two flash units have uneven power, I had a wide variety of shadow-creating opportunities. Also, the diffuser on the larger flash head reduces the light output at short flash-to-subject distances like this one.

This star coral (right) is illuminated from the right side, creating harsh shadows to the left of each coral polyp. In the picture below, I added a flash on the left in order to sidelight the coral from the opposite side. This reduced the shadows created by the relief on the polyps.

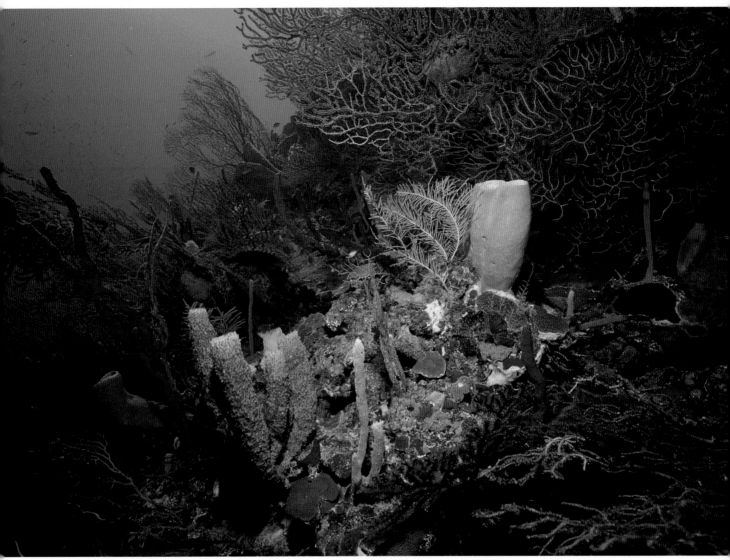

Essentially, this involves just one element: exposure control. A picture is "balanced" when the measured available-light exposure is the same as (matches) the calculated flash exposure for any given subject. Achieving balance is rather simple and can be done several ways.

In a balanced image, a subject's color contrasts that of its natural surroundings. The artificial-light source (the flash unit) provides the level of illumination falling on the foreground subject; the available-light source (the sun) illuminates the surroundings. Here, the sun acts as the key light; the flash, the fill light. A balanced image has great depth of field because while the foreground is illuminated by the flash and its colors are brightened, the

background is illuminated by the sun yet appears monochromatic. Here, the main subject is placed within a given setting; for example, a diver is floating freely or a bright sea fan is protruding from a reef wall.

The technical knowledge needed to create balanced images has been veiled in mystery. For some reason, successfully balancing two light sources underwater seems to be the pinnacle of underwater photographic prowess. But balancing the illumination of an image is actually quite simple if you approach it in a step-by-step fashion. First, you have to have some idea of what the natural light levels will be. Will you be shooting in shallow or deep water? Will you use upward or downward camera angles? These

I balanced the light in this shot of a reef wall in Roatan by taking a light-meter reading for the available-light level; this was f/5.6. Then I calculated the light output from the flash to match this reading. At such a close distance, the Nikon SB-102 Speedlight would have been too bright at full power, so I first cut back the flash to quarter-power. Next, I held the flash about four feet from the subject, which was the calculated distance for the f/5.6 exposure. I bracketed, moving the flash both away from and closer to the subject, as well as keeping the flash at four feet and adjusting the aperture. As a result, the foreground has good color contrast with the background, and the foreground subjects are in context. I used a Nikonos III with a 15mm lens and Kodachrome 64. The shutter speed was 1/60 sec.

questions are important because the primary factor is the intensity of the available sunlight.

The first step is to find the base exposure. Suppose you are shooting in 20 feet of water on a coral reef at midday using a slightly upward camera angle. The film you're using is Kodachrome 64, and the available-light meter reading is $f/8$, 1/90 sec. — the base exposure. The second step is to match the flash exposure to it. Presumably, you have made an exposure chart (see page 49), and you know that in order to get an exposure of $f/8$ with your flash unit and the ISO 64-speed film, you need a flash-to-subject distance of three feet. Move the flash unit so that it is three feet from the subject, taking care not to place it within the picture area of the lens. This should give you a balanced image.

The electronic flash unit will not have an impact on the overall exposure of the shot if it is equal to or is less than the measured available-light reading. The unit simply provides color to the image. The key light is still the sun and will not be overpowered by the flash unit. If the unit is too close to the subject, the resulting image will have a perfectly exposed background with a washed-out foreground subject. If the flash is too far from the subject, the foreground will be less colorful. This technique requires some practice in the form of a step-by-step analysis of each balancing situation and exposure calculation. And, by all means, it is necessary to bracket.

To show this salt pier in Bonaire (left), I used the strong vertical lines created by the pilings. This leads the viewer's eye away from the brightly colored sponges in the foreground. With my Nikonos V and a 15mm lens, I shot at a camera-to-subject distance of five feet. Balancing the available light with the light from my Nikon SB-102 Speedlight, I exposed for 1/90 sec. at $f/8$ on Kodachrome 64.

I came across this ship in Bonaire. With only available light, the outline of the propeller in the image on the left is silhouetted. The camera-to-subject distance was four feet. I set my Nikonos V, fitted with a 15mm lens, at $f/5.6$ and exposed the scene for 1/90 sec. on Kodachrome 64. In the photograph below, taken at the same angle, I added a single flash in order to illuminate the propeller from the camera side, thereby revealing more of its shape and detail. I used a diffuser both to broaden the beam of the Nikon SB-102 Speedlight, ensuring that it would cover the large subject, as well as to decrease the light output by about one f-stop, balancing the artificial light with the low ambient light.

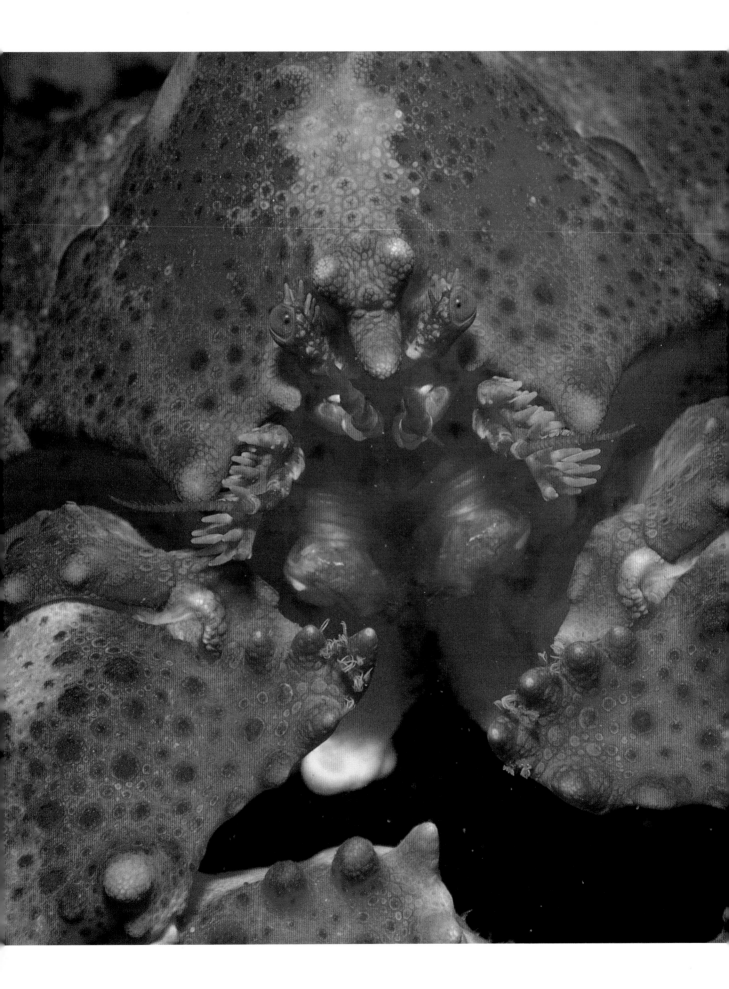

Many photographers believe that closeups are the easiest images to shoot underwater. From a technical standpoint, they are right. The proximity of the subject reduces errors in such fundamentals as exposure and focusing. So, because the technical elements of taking a picture are simplified in closeup photography, it is a good place for underwater photographers to start. In addition, because the equipment needs for shooting closeups are relatively few, the initial expenditure will be smaller.

Closeup photography is a wise starting point for other reasons as well: the abundance and variety of underwater subjects that are small and easy to find. Also, photographers can take detailed closeups of specific parts of larger organisms or objects. Such shots are effective alternatives to wide-angle pictures when water clarity is poor. Using extension tubes enables photographers to get acceptable images even when visibility is minimal.

Perhaps the most important reason why I think new photographers should begin with closeup photography is that it makes them see differently, particularly underwater. In general, as photographers, we tend to concentrate on the big picture, subconsciously absorbing fragmented details. But working with an extension-tube framer that provides a picture area of just a few square inches forces us to look at a sea star's arm instead of the entire sea star. This perspective can improve images two ways. It makes us aware of subjects that we might not otherwise find or see because we are staying too far back or are moving around too quickly. Also, by having a predefined picture area in which to work, we become more selective — and careful — when composing our photographs. Furthermore, developing a critical eye through closeup work carries over to wide-angle compositions as well.

As you can see in this photograph of a box crab, taken in the San Juan Islands, Washington, the bright reds and oranges are quite saturated on Kodachrome 25. This film picks up warm colors well. Using a 28mm lens and a 1:2.75 extension tube on my Nikonos III, and a Vivitar 102 flash unit, I exposed for 1/60 sec. at f/16. The camera-to-subject distance was a mere 3½ inches.

SUBJECTS

Subjects for underwater closeups are primarily small creatures that fall into two categories: those that are either attached to the seafloor or move slowly, and those that move quickly. These subjects can also be described, respectively, as those that allow you to maintain your faith in your ability to take closeups and those that drive you to the point of flinging your camera into the deepest part of the ocean.

Stationary or slow-moving subjects include such organisms as corals, sea anemones, sea stars, snails, and urchins. These animals make great subjects for beginning underwater photographers because they sit still and allow themselves to be photographed. They also have rudimentary sense organs that do not readily detect your presence.

The most difficult element in photographing these animals can be composing the image. Usually, you have the opportunity to try several camera angles (this is not true for all attached organisms). Keep in mind, though, that many of these creatures are highly sensitive to touch. In fact, I avoid coming in direct contact with them.

The other group of subjects for closeups includes shrimp, crabs, brittlestars, worms, and, of course, most fish — as well as seals, dolphins, whales, and other largely inaccessible marine life. Getting a technically perfect, well-composed image of such creatures requires stealth, anticipation, knowledge of your subjects' behavior patterns, and planning.

As with most terrestrial wildlife, you can use either of two strategies with

Placing a framer around the bodies of most types of fish is difficult because they get nervous. But the juvenile scrawled cowfish is more approachable than most. I found this cowfish in the Florida Keys, near the branches of the soft coral in the background. From a camera-to-subject distance of 3½ inches, I was close enough to the branches so that my Vivitar 102 flash illuminated them; however, the fish was far away enough from them so that I could leave them out of focus. This helped to build contrast, thereby making the fish pop out. For this shot, I used a 1:2.75 extension tube mounted between my Nikonos III and 28mm lens. The exposure was f/16 at 1/60 sec. on Kodachrome 25.

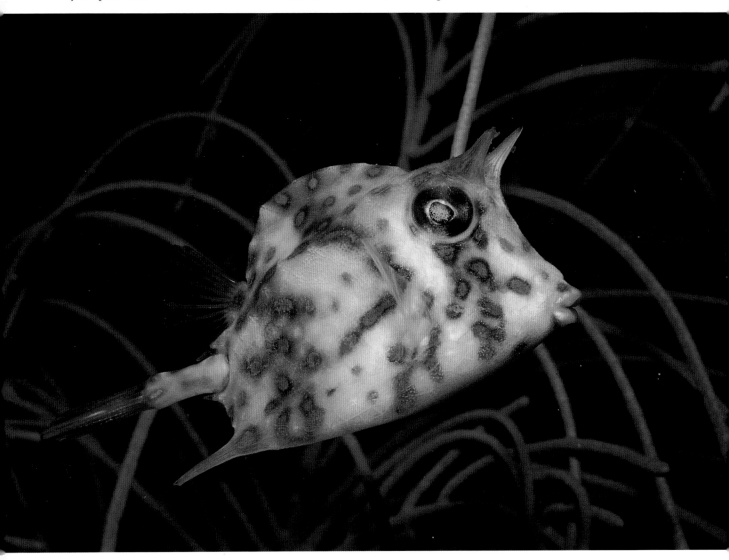

aquatic creatures. Your success depends, in part, on the subject. The first is the "sit-and-wait" approach. Find your subject, evaluate the surrounding area and the subject's response to it (such as sitting in a current or swimming against it), get into a position that will enable you to shoot easily and effectively, and wait for the subject to come to you. This approach works particularly well with creatures that maintain territories, which many fish do, and with small subjects, such as shrimp, that move rapidly only when disturbed. (I should mention here that underwater photographers sometimes have to sit in one place underwater for extended periods of time in order to get one shot. As a result, the photographers' dive buddies must be very patient individuals. And, of course, underwater photographers go through a lot of dive buddies.) When photographing moving subjects closeup, you have to remember the various environmental constraints, particularly time. You might have just half an hour to get into position, wait and hope that the subject will pass within the boundaries of the short camera-to-subject distance, and shoot.

The alternative approach is to stalk your subject. Whether the creature is small or large, you have to anticipate the direction it is headed in and intercept it. Never chase your subject: even the slowest swimming fish can beat a photographer in a race. There are probably more shots of fish tails than any other underwater images.

Aquatic animals are often covered with a thin mucus layer that reflects light in interesting ways. In this picture, the light from the single flash placed off to the right hits the tips of the sea anemone tentacles and seems to bounce around a bit inside the mucus, creating a glowing effect. For this shot, taken in the Sulu Sea near the Philippines, the camera-to-subject distance was 3½ inches. I used my Nikonos III with a 1:2.75 extension tube mounted between it and a 28mm lens, a Vivitar 102 flash, and Kodachrome 25. The exposure was f/16 at 1/60 sec.

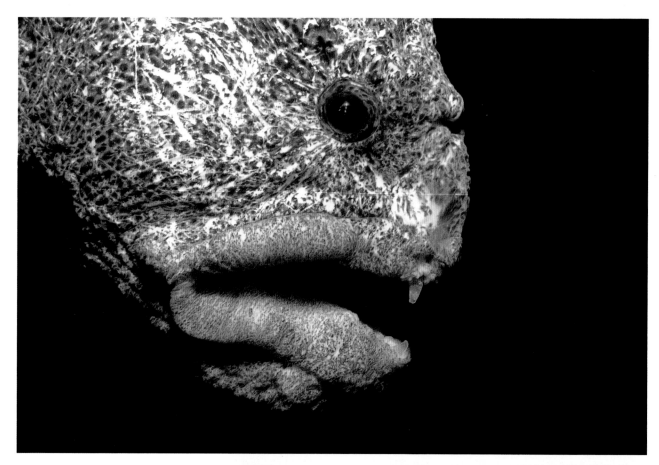

For this shot of a large male wolf-eel, taken in the Strait of Juan de Fuca (above), I used my Nikonos III, a 28mm lens, and a closeup lens kit. As such, I was able to hold the camera as well as operate both the shutter and the film advance lever with my right hand. The wolf-eel's "neck" is resting in my open left hand just outside the picture frame. Because the fish was so cooperative, I was able to photograph it throughout the entire dive. In the shot on the right, I placed a Vivitar 102 flash to the side to illuminate the inner throat area. The strong shadows created by the single flash intensified the ominous effect of the gaping mouth. Here, I added a 1:2.75 extension tube and set the aperture at f/16 for 1/60 sec. on Kodachrome 25. The camera-to-subject distance was 3½ inches.

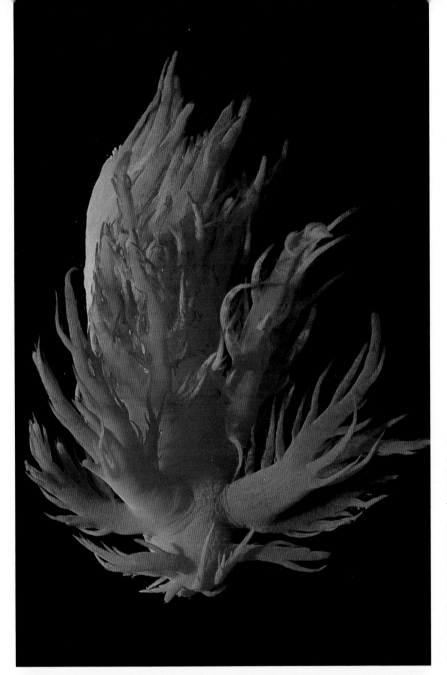

When I came upon this giant shell-less snail in British Columbia, I realized that it would be a good subject for a shot using a closeup kit; I knew the snail probably wouldn't react to the framer—unless it touched the snail. When the snail began to "swim," which it does by rapidly flexing its body, I found it easier to work with a framer than a housed camera to compose the image. To get the entire animal in the framer, I needed to use a vertical orientation. With my Nikonos III, a 28mm lens and a closeup lens, and an Oceanic 2001 flash, I exposed at f/16 for 1/60 sec. on Kodachrome 25 and shot from a camera-to-subject distance of 10 inches.

Extension tubes allow you to take abstract photographs by framing of parts of an organism, not an entire animal. I found the arrangement of these sea star arms in Puget Sound in Washington quite pleasing. I positioned the framer so that the lines created by the three arms were parallel diagonals. The detail in the gill structures and spines also adds greatly to the image. Using my Nikonos III and a 28mm lens, a 1:2.75 extension tube, a Vivitar 102 flash, and Kodachrome 25, I shot at f/16 for 1/60 sec. from a camera-to-subject distance of 3½ inches.

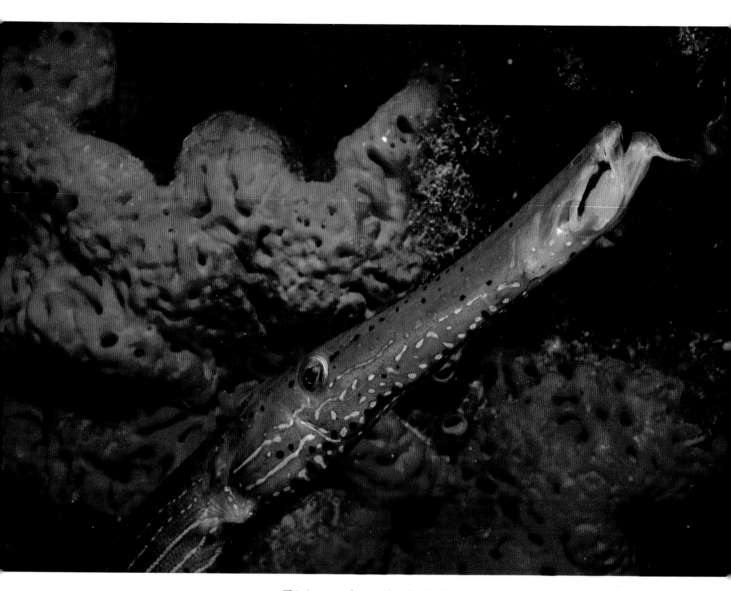

This image, taken in the Florida Keys, was a surprise. Usually, this trumpetfish is wary of divers, and at first I didn't really even consider putting a framer around its head. But as I approached it to take a medium-wide-angle shot, I sensed that the fish was pretty calm and might tolerate a closeup — which it did for two frames. I wanted the fish's line to cut across the picture diagonally; I also wanted to use the orange sponge in the background for color contrast. At a camera-to-subject distance of 10 inches, I exposed for f/11 at 1/60 sec, on Kodachrome 25. I used a Nikonos III, a 28mm lens and a closeup lens, and an Oceanic 2001 flash.

EQUIPMENT

Because the equipment for closeup photography is relatively simple to use and master, your chances of getting good, if not excellent images are high. Basically, there are three ways to take closeups underwater: adding extension tubes to nonreflex cameras (such as the Nikonos), mounting a closeup lens in front of another lens on a nonreflex camera, or using either macro lenses or diopters on housed single-lens-reflex (SLR) cameras.

Extension Tubes

These pieces of equipment are exactly what their name suggests: metal tubes that extend the lens a certain fixed distance from the film plane. This alters the focal length and results in a close-focusing distance significantly less than that of the prime lens without the tubes. Bellows provide the same results, but their lengths can be adjusted. And, because you don't add any lens elements in order to change the focal length, the quality of the prime lens does not change.

For underwater work, extension tubes are used most often with the Nikonos camera system. Because the Nikonos is a nonreflex camera, the focusing distance is preset (usually to the closest focusing distance allowable on the prime lens); this eliminates one technical factor. Of course, if the focusing distance is fixed, the picture area will be also. However, determining just what the focusing distance and resulting picture area are with nonreflex cameras has been solved through the use of thin, metal framers that are attached to the tube. The framers extend out in front of the lens to the tube's predetermined length. A framer is shaped something like a football goalpost and outlines the picture area of the particular tube it is connected to. Whatever is in the plane of the framer will be in focus. This makes working with extension tubes for underwater closeups quite simple.

Subject magnification and picture size are expressed as a ratio for each tube length. With a 1:1 extension tube, the subject's actual size appears on a 35mm slide or negative. The framer for a 1:1 extension tube is approximately the same size as the image area of a 35mm slide. With a 1:2 tube, the size of

In the shot on the left, the diver is working with a typical Nikonos extension tube setup used for closeup photography. The image above is the result.

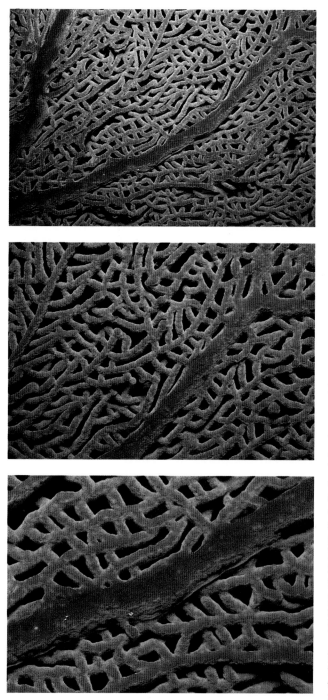

Shooting with a Nikonos V and a 35mm lens, I photographed this sea fan using a 1:3 extension tube (top), a 1:2 extension tube (center), and a 1:1 extension tube (bottom).

the subject is reduced by 50 percent, and a 2:1 extension tube doubles the size of the subject. The most commonly used tube is a 1:3 extension tube because it provides the largest picture area.

The only real problem is in getting used to aiming and positioning the framer around your subject so that you see approximately what the framer sees. Looking directly through the framer at the subject is difficult because the framer is so close — usually within a few inches. You can overcome this by positioning the framer around the subject while viewing the subject at an angle as you stand off to the side of the camera. This requires visualizing the image you want and then correcting for the error in perspective. The process becomes pretty simple with some practice.

Getting correct exposures with extension tubes is also greatly simplified because you are so close to your subject. And, by placing the light source very close to your subject, you can use slower film speeds. I shoot Kodachrome 25 almost exclusively with extension tubes, taking advantage of its superior color saturation and resolution. Working close to your subject also allows you to use smaller aperture settings, thereby giving you more depth of field (which is missing in closeup photography). You can also use a less powerful flash unit or use a lower power setting on a "megaflash" for small camera-to-subject distances to prolong battery life. Multiple-flash photography is also easier to coordinate when you do closeup work, and it is used often with small subjects.

The biggest drawback to using extension tubes is the very characteristic that makes them so simple to work with: their fixed — inflexible — nature. For example, when you mount a 1:3 tube between your camera body and lens, you are locked into a large picture area and a particular distance from the subject. Because you must select subjects that fit that area, your compositions are limited.

Working with extension tubes can cause other problems as well. The use of a framer can make your approaching some subjects, such as small fish, practically impossible. In addition, you have to handle framers very carefully: they can bend easily when they

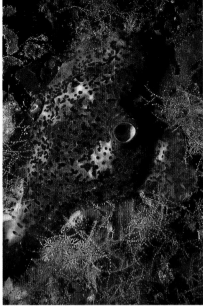

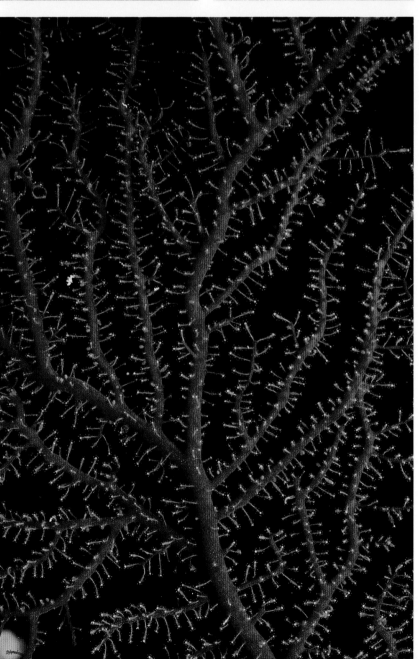

For this picture of a Caribbean sponge assemblage (top left), I used a Nikonos V, a 28mm lens, and a Nikonos closeup lens. The picture area was approximately 9½ × 6 inches. Switching to a 35mm lens, I added a 1:2 extension tube for the center picture of the same scene and a 1:1 extension tube for the image on the right.

This hydroid colony (left) is just a few inches high, so seeing detail meant getting quite close. In order to show the nearly transparent polyps and the white tentacles protruding from the hard skeleton, I had to create a black background for contrast. You can do this most easily by using a camera angle that places the subject between the camera and open water, where there is nothing to reflect the light from the flash. If you stop down sufficiently, the background will be black. For this shot, taken at CoCo View Wall in Roatan from a camera-to-subject distance of three inches, I used a Nikonos III mounted with a 1:2 extension tube and a 35mm lens; the flash was a Helix Aquaflash 28. The exposure was f/16 at 1/60 sec. on Kodachrome 25.

Serendipity plays a fairly large role in closeup underwater photography when you work with extension tubes. I am always amazed by the number of subjects that just happen to fit the framer I have on a particular dive. This image of a Spanish dancer egg mass that I came across in Maui is a result of serendipity. A slight current "blew" the individual layers of eggs in several directions, changing the overall shape and size of the mass. I waited until the current pushed the mass around into a shape that both fit in the framer and created a pleasing arrangement of the layers. I shot with my Nikonos III fitted with a 1:2.75 extension tube and a 28mm lens, and a Vivitar 102 flash. I exposed for 1/60 sec. at f/16 on Kodachrome 25 from a camera-to-subject distance of just 3½ inches.

are knocked around the ocean floor or are improperly packed in a gear bag. If the framer gets bent, your transparencies will come back with your subjects' tiny heads cut off, or worse. For the most part, however, you will discover that using extension tubes is the easiest and simplest way to take closeups underwater of most aquatic subjects.

Closeup Lenses

An alternative approach to closeup photography is to put an additional lens in front of the prime lens, thereby altering its close-focusing distance. Most of these types of lenses are, again, designed for use with the Nikonos system. As with extension tubes, the focusing distance of closeup lenses is preset and fixed, so any trouble with this technical factor is eliminated. In general, you move the focus setting on these lenses to infinity and leave it there. By adding another lens element, you replace the quality of the prime lens with the quality of the closeup lens. Take this into consideration when you first select your lenses. There is no point in buying a high-quality prime lens if the supplemental

closeup lens is not of the same quality.

Estimating subject distances and picture area is as difficult with closeup lenses as it is with extension tubes. You can solve the problem the same way: attach a framing device, which has an exact focusing distance and outlines the resulting picture area, to the extra lens. In general, closeup lenses cover a larger picture area with a greater camera-to-subject distance than an extension tube does.

The size of the picture area also depends on the prime lens you are using. A popular configuration is the Nikonos body with a 35mm prime lens to which a Nikon closeup lens and framer are added. The Nikon framer sticks out about nine inches and covers a 5 × 7-inch area. However, the shape of the framer and the extent to which it defines the picture area vary with the manufacturer. Some provide you with only a measuring "wand," forcing you to visualize the picture area.

The major advantage of using closeup lenses is that you can put them on or take them off the prime lens when you are underwater. Essen-

tially, this gives you two options when you shoot with a nonreflex camera. For example, if you have a Nikonos camera with a 28mm lens and a closeup kit, you can take medium-wide-angle shots with the prime lens alone, as well as closeups of most subjects with the addition of a closeup lens. (Occasionally, a small bubble of air might get trapped in this space, requiring you to remove the lens completely in order to dislodge the bubble. You can also dislodge it by gently but firmly shaking the camera up and down.)

The benefits of using closeup lenses are, however, undermined by a fixed focusing distance and picture area as well as a narrow depth of field—the same limitations extension tubes have. And, the potential for bending the framer is even greater with closeup lenses because the necessary framers are so large.

Notice the position of the diver in the shot on the left, who used a Nikonos III camera with a 28mm Nikonos closeup lens kit, as well as a Helix Aquaflash 28. He is off to the side of the camera, not directly behind it. The giant anemone in the picture below, taken in Bonaire, is the result. Shooting from a camera-to-subject distance of 10 inches, the photographer exposed at f/16 for 1/60 sec. on Ektachrome 64.

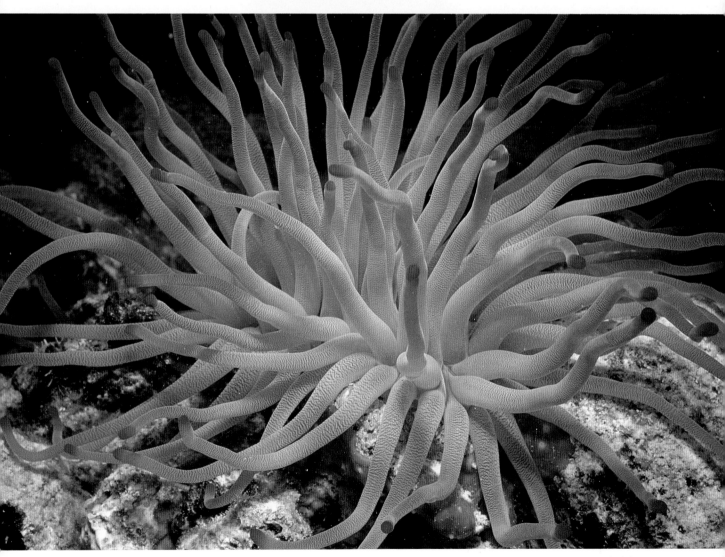

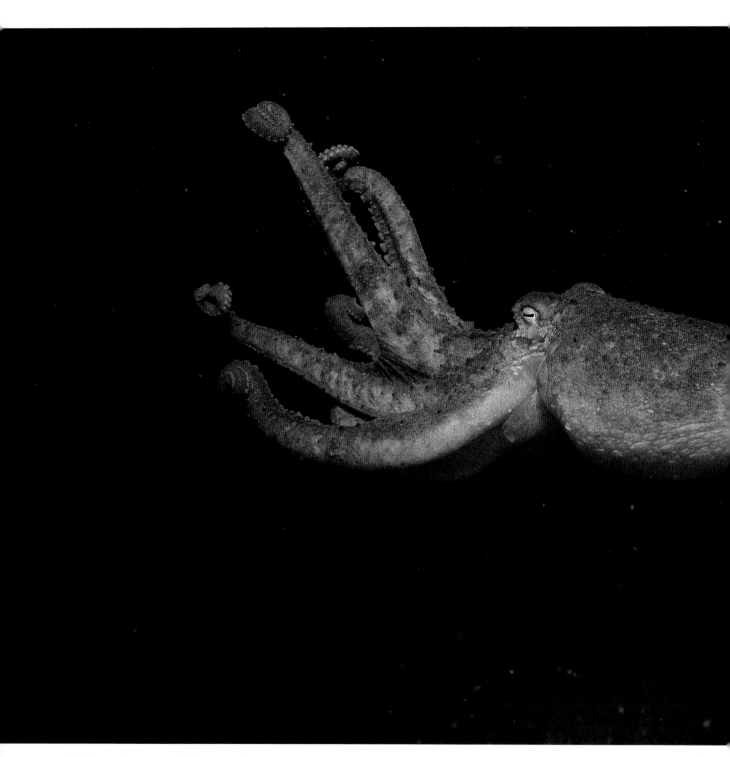

This juvenile octopus, which I spotted in Washington's Puget Sound, fit perfectly within the picture area of my Nikonos closeup lens framer with a 28mm lens. Unlike most fish, the octopus was not very wary of the framer and did not react to having it placed around its body. With my Nikonos III camera and Oceanic 2001 flash, I set the exposure at f/16 for 1/60 sec. on Kodachrome 25; the camera-to-subject distance was 10 inches.

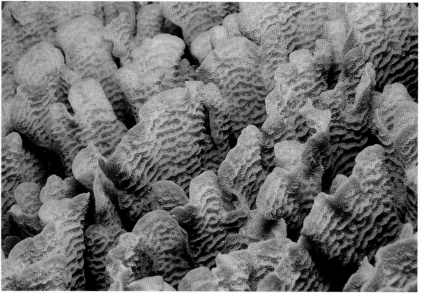

SLR Camera Systems

In general, SLR systems offer the greatest flexibility — both on land and underwater — in terms of determining camera-to-subject distances and picture areas and composing. This is true of closeup photography as well. Most closeup work done with SLRs requires a macro lens that can focus from infinity to a distance of one foot or less, and that can take in a small picture area. The most popular lenses for closeup photography are the 55mm and 105mm macro lenses. Additional closeup lenses (diopters) are also available on the market, but they have a limited use because of their narrow focusing range. The large number of picture areas within a given range gives you complete compositional control. This is the main advantage SLR systems have over nonreflex systems in any situation.

However, SLR cameras must, of course, be housed. This creates an air/water interface through which the lens sees "the ocean world of Jacques Cousteau." However, macro lenses do not distort images because they have narrow picture areas. In fact, adding a flat port to a macro lens acts like another lens, magnifying the subject approximately 25 percent, a result of refraction. This can help when you photograph tiny sea creatures. A dome port can also work here, and, if you are going to use the housing for both wide-angle and closeup lenses, you might want to select a dome that accommodates both. A flat port allows only for closeup shots.

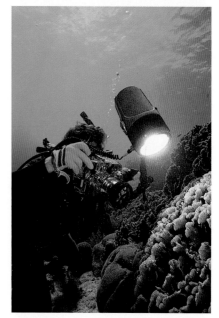

While plastic housings are not as rugged as metal housings, they are light, transparent, and affordable. In addition, housed SLR systems offer the ultimate creative compositional control. The photographer in the picture immediately above used a Nikon F2 SLR camera with a 55mm Micro Nikkor lens in a plastic housing. The plate coral in the shot at the top of the page was taken at CoCo View Reef in Roatan with a Nikon F2 with a 55mm Micro Nikkor lens in an Ikelite housing. The SLR camera's critical focusing and framing ability enabled me to focus on the center ridge of coral, which would have been impossible with a framer and extension tube setup. From a camera-to-subject distance of one foot and with an Ikelite Substrobe 150 at half-power, I shot at f/11 for 1/80 sec. on Ektachrome 64.

The problem with using housed SLR cameras is that focusing accurately on small subjects underwater is often hard. This is because of the predominantly low levels of light below the water's surface. The difficulty is compounded by the narrow depth of field that characterizes most macro lenses. To get good closeups underwater, you need to be patient and to practice focusing under low levels of light. In addition, you have to get one piece of equipment that is, essentially, mandatory for closeup work with SLR cameras: an enlarged viewfinder (an *actionfinder*) available for top-of-the-line SLR cameras. Using this device is the only actual way to make closeups feasible with SLR cameras. However, there are magnifying eyepiece devices available for a greater number of 35mm cameras that also improve accuracy in focusing.

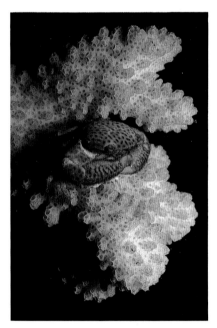

The coral crab is a recluse and is found only in the inner reaches of coral heads. Because it was impossible to work with a framer to get this shot, I used my Nikon F2 in a Giddings-Felgen housing, which allowed for both critical focusing and framing from a camera-to-subject distance of 10 inches. I also had a 55mm Micro Nikkor lens and an Oceanic 2001 flash. The exposure was f/16 at 1/80 sec. on Kodachrome 25.

Some underwater subjects don't let you get near them with or without a framer. The yellowhead jawfish is quite territorial, living in burrows in the sand that it retreats to when an intruder approaches. To get this shot, I needed a 105mm Micro Nikkor lens, which allowed me to focus at a camera-to-subject distance of 20 inches. With my Nikon F2, I was able to extend the Substrobe 150 flash out in front of the Ikelite housing; this decreased the flash-to-subject distance somewhat and enabled me to gain about one f-stop. I exposed for 1/80 sec. at f/11 on Kodachrome 25.

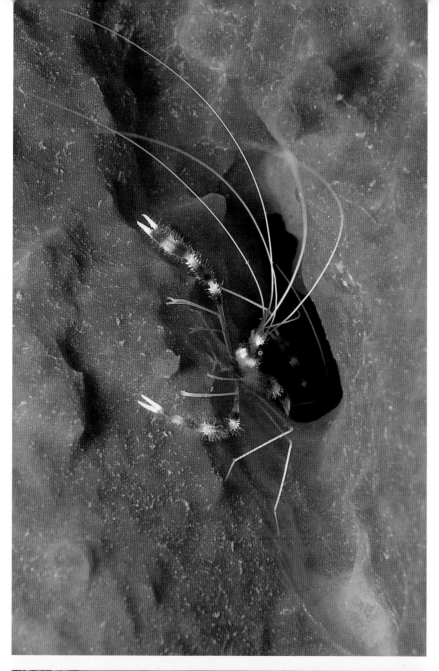

By using a Nikon F2 in an Ikelite housing with a 55mm Micro Nikkor lens, I was able to focus and frame this banded coral shrimp from a camera-to-subject distance of one foot. I knew that I wouldn't be able to get the body and all of the antennae in focus, so I focused on the primary areas: the outline of the body, the eyes, and one or two antennae. I also used a Substrobe 150 flash and exposed at f/11 for 1/80 sec. on Koda-chrome 25.

The small remora attached to this fish's cheek distinguishes this photograph from other barracuda shots. I selected a low camera angle to give the background some color; a totally black background seemed too harsh. Shooting from a camera-to-subject distance of two feet, I used a Nikon F2 in an Ikelite housing, with a 105mm Micro Nikkor lens and a Substrobe 150 flash. The exposure was f/5.6 at 1/80 sec. on Kodachrome 25.

LIGHTING CLOSEUPS

Essentially, all closeup photography underwater involves the use of one or more electronic flash units. Available light is rarely used as key light. For the most part, this is because essentially all closeup lenses and accessories, such as extension tubes, provide little in the way of depth of field. With the small camera-to-subject distances involved, closeups are the one type of underwater pictures in which the quantity of light is not a major issue. It is true that the longer the extension tube, the more light is needed for an exposure; however, even here it is simply a matter of moving the flash unit closer to the subject or using a more powerful one. You can often position the flash unit for closeups using the Nikonos system with extension tubes or additional closeup lenses by hand-holding the unit. This works well for closeups because the margin for error is quite small because of the short camera-to-subject distances. But hand-holding the flash unit does not work well with housed SLR systems in general; this applies to closeups as well.

Finally, most subjects suitable for closeups are quite colorful and require some type of artificial light to show these bright colors. You will find that color contrast is an important compositional element in closeup work underwater.

Housed SLR systems are most appropriate for capturing subjects that shy away from extension tube framers, such as this dusky damselfish. Here, I used a Nikon F2 with a 55mm Micro Nikkor lens in an Ikelite housing, an Ikelite Substrobe 150, and Kodachrome 25. The exposure was f/11 at 1/80 sec.; the camera-to-subject distance was 14 inches.

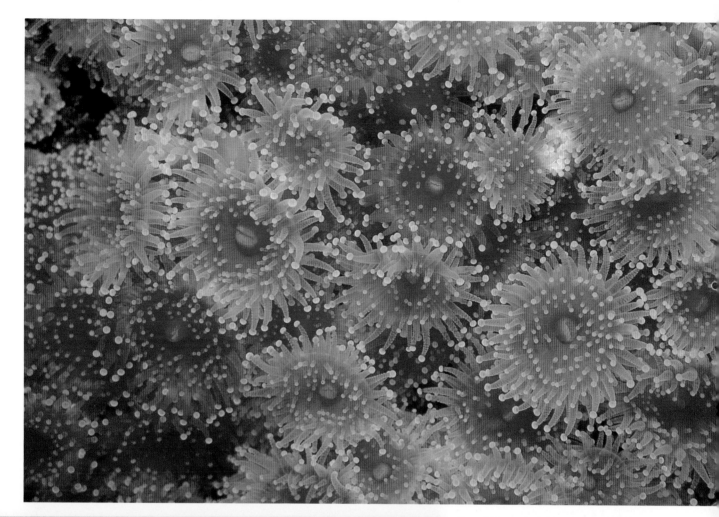

One of the easiest closeup compositions is a field of repeating shapes or organisms, particularly attached forms, such as these strawberry anemones found in California's Channel Islands (above). The challenge was to get the framer close enough to the anemones so that they would be in focus without touching their sensitive tentacles; this would cause them to shut. To get around this problem, I looked for a section of the colony growing on a slightly convex section of rock, pushing them toward rather than away from the framer. I shot from a camera-to-subject distance of 3½ inches using my Nikonos II fitted with a 1:2.75 extension tube and a 28mm lens, and two Subsea 100 flash units. I exposed for 1/60 sec. at f/22 on Kodachrome 25.

This shot of sea fleas (left), which I took in the San Juan Islands, is a favorite because they look so alien. The small amount of backscatter in the dark background adds to the otherworldly feeling. Shooting from a camera-to-subject of just 3½ inches with a Nikonos II, and 28mm lens and a 1:2.75 extension tube, and a Vivitar 102 flash, I exposed for f/16 at 1/60 sec. on Kodachrome 25.

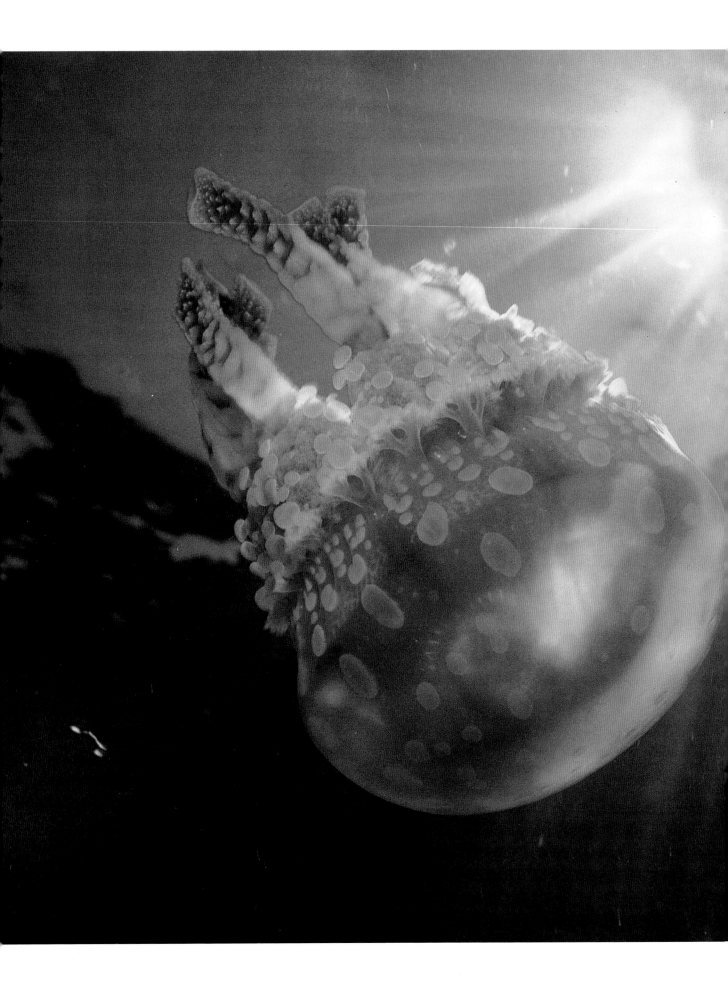

Unlike closeups, these images include a large variety of subjects, as well as many lighting and compositional elements. Such versatility is possible for several reasons. First, medium-wide-angle lenses used alone cover a broad range of picture areas from several feet to infinity, depending upon the camera-to-subject distance. You can adjust this distance to fit the subject at hand (unlike closeup lenses, which are usually fixed at a particular focal length). Many medium-wide-angle lenses can be used in conjunction with add-on lenses, altering their picture areas from closeup to wide angle.

Medium-wide-angle lenses also offer increased depth of field, which allows you to use both available and artificial light in several configurations: available light only, flash only, or mixing and balancing the two. The ability to adjust the picture area and mix light sources increases substantially the number of different types of shots that are possible with a medium-wide-angle lens system.

When I first saw this jellyfish in the Philippines, the sun was directly behind it; I thought it might make an interesting silhouette using only available light. But when I looked at it more closely, I saw the detail on the short tentacles and wanted to include them in the picture as well. In order to balance the backlighting from the sun and the frontlighting from my Oceanic 2001 flash, I first took a meter reading at an upward angle, but not directly at the sun. Although I tried to position the flash to arrive at f/11 for the foreground light, I bracketed extensively because of the angle of the sun and the differences in flash output at various distances. For this image, in which the sun's rays are streaming directly at the subject and the underside of the jellyfish is properly exposed, I shot at f/11 for 1/60 sec. on Kodachrome 25. I used my Nikonos III and a 28mm lens. The camera-to-subject distance was two feet.

EQUIPMENT

Medium-wide-angle lenses cover picture areas of 45 to 70 degrees. And, in general, they enable you to focus from 2½ feet to infinity. Within this range, the potential number of picture areas is almost unlimited. As such, you can match a picture area with a subject. Typical subjects for medium-wide-angles include reefs, medium-size and large fish, divers, and parts of such very large subjects as shipwrecks.

One of the major characteristics of medium-wide-angle lenses is great depth of field; this is a striking contrast to closeup lenses. From a creative point of view, it permits you to use both the foreground and background of a scene as sharp compositional elements in your images. Greater depth of field, however, also allows for greater error in estimating camera-to-subject distances.

Lighting equipment for medium-wide-angle systems is relatively simple. Most medium-powered flash units can adequately cover the various picture areas involved. In fact, a single flash unit is sufficient in most cases.

Viewfinder Systems

The Nikonos 35mm lens is without question the most popular underwater lens sold. The reason: its versatility. It can be used both above and below the water. The 35mm lens is the standard lens that comes with a new Nikonos body. The 28mm lens, however, is designed for underwater use only, and its wider angle of view allows you to get closer to your subject. This Nikonos viewfinder system is the one recommended most often for underwater photographers who are just starting out. With the addition of both a small- to medium-powered electronic flash unit and a set of extension tubes, beginners can photograph quite a variety of subjects, ranging from the very small to the very big. This combination of equipment is a wise — as well as an affordable — initial investment.

In the picture above, the photographer was shooting with a Nikonos and the standard 35mm lens setup. The image of a sea fan and coral on the right is the result.

Having seen the blue-striped grunts in the same place on a reef in Roatan several days in a row, I was able to size them up and go back with the right system. I decided to stack them vertically in the branches of the soft coral and let it frame them. Shooting from a camera-to-subject distance of three feet, I used a Nikonos V, a 35mm lens, a Nikon SB-102 Speedlight aimed almost directly at the grunts, and Kodachrome 64. The exposure was f/11 at 1/90 sec.

To accurately position this queen angelfish in the center of the picture area, I used an adjustable viewfinder. I was then able to correct for parallax at the camera-to-subject distance of two feet. Diving in the Florida Keys, I shot this image with my Nikonos III and a 28mm lens, and an Oceanic 2001 flash. The exposure was f/8 at 1/60 sec. on Kodachrome 25.

Shooting with a viewfinder camera and a medium-wide-angle lens offers several immediate benefits. First, you can preset the focus for the estimated camera-to-subject distance. This frees you from having to deal with critical focusing at the beginning. Lenses in the 35mm-to-28mm range provide enough depth of field to allow for a reasonably good margin of error in focusing. You, then, can concentrate on getting used to carrying and handling camera equipment underwater.

Medium-wide-angle lenses also allow you to photograph most of the subjects found (or placed) in the underwater world, from tiny aquatic organisms to your diving partner cruising a tropical reef. At its minimum focusing distance of two feet, the Nikonos 28mm lens is perfectly suited for shots of medium-sized to large fish, portrait shots of other divers, and closeups of such subjects as the porthole of a shipwreck. At infinity, both the 28mm or 35mm lenses can be used to take available-light images, such as a silhouette of a diver.

Furthermore, most medium-wide-angle lenses designed for the Nikonos system can accommodate both exten- sion tubes and accessory press-fit closeup or wide-angle lenses. The ad- dition of these accessory lenses and tubes greatly increases the range of subjects available to you without your having to invest in an enormous amount of equipment. The key to such flexibility is the standardization of the size of the lens diameter at both its front and rear elements. One of the best accessory-lens systems is the He- lix extension-tube and wide-angle-adapter lens set. It is composed of a series of extension tubes, framers, and supplementary lenses that can accom- modate almost any closeup or me- dium-wide-angle shot when you use it in conjunction with a Nikonos 35mm or 28mm lens. These lens accessories are a good example of the old 80/20 rule: You get 80 percent of the camera's capability in exchange for a 20 percent investment of your time, energy, and money.

Another advantage a medium-wide-angle lens has to offer as a first lens is that its picture area can be covered by most small and medium electronic flash units. As such, you can buy a flash unit that can provide light for both wide-angle shots and closeups.

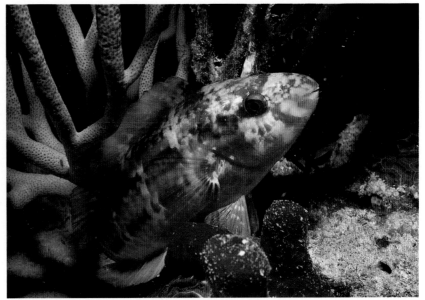

By shooting low and close, I was able to force the perspective of this stoplight parrotfish somewhat using a 28mm medium-wide-angle lens. Working with the curving line of the fish's body as it rested among these branches of soft coral in St. Croix also helped to create this effect. Using a Nikonos III and an Oceanic 2001 flash, I exposed for f/8, 1/60 sec. on Kodachrome 25. The camera-to-subject distance was two feet.

Housed Systems

Most of the 35mm cameras taken underwater in a waterproof housing are SLR cameras. Medium-wide-angle lenses for these cameras range from 35mm to 24mm in focal length and can cover areas of 45 to 70 degrees underwater. This amount of coverage is roughly a 25 percent reduction of the angle of coverage these lenses have on land; the decrease is a result of the effects of refraction. Like the Nikonos 35mm and 28mm viewfinder system, a housed system with medium-wide-angle lenses enables you to get close to subjects that are either enormous or too large for even the biggest closeup framer. These include shots of any subject that is more than two feet long, high, or wide.

The greatest advantage a housed SLR system has over a viewfinder system is its ability to help you compose accurately: you view the subject directly through the camera lens. Here, "what you see is what you get." In addition, parallax problems do not exist with SLR cameras. (While parallax is not as great a concern with wide-angle photography as it is with closeup photography, it is still a consideration, particularly at close range.)

Because medium-wide-angle lenses have the potential for significant depth of field, focusing them in housed systems is less critical than focusing macro lenses, even at low *f*-stop settings, such as *f*/5.6. In general, the range of focus of medium-wide-angle lenses falls anywhere from two feet to infinity, depending on the aperture. But it is easy to make a mistake in framing when you use a housed wide-angle system because of light falloff at the edges of the viewfinder. This happens most often when the subject is suspended in open water, leaving you with nothing to focus on at the borders of the picture area.

The main disadvantage to using medium-wide-angle lenses housed behind flat ports is distortion. The source of the distortion: refraction. This distortion, however, might not be very apparent in some shots, particularly those in which the principal subject is centered and the edges do not include any object with straight lines or those that simply include open water without any objects at the edges. Although using flat ports with medium-wide-angle lenses in the 50mm to 35mm range might create an acceptable amount of distortion, I prefer using dome ports with any lens wider than 50mm — just to be sure.

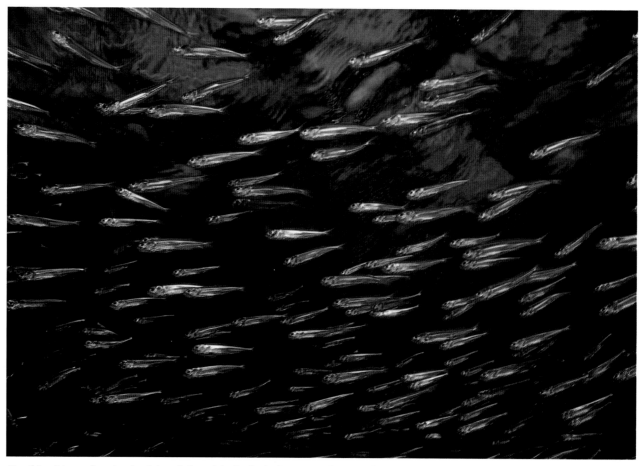

For this picture of anchovies (above), found in St. Croix, I included the background to increase the depth of field and to make the fish stand out. I shot at a camera-to-subject distance of two feet and balanced the available light with the light from my Oceanic 2001 flash. With my Nikon F2 in a Giddings-Felgen housing and a 24mm Nikkor lens, a medium-wide-angle lens, I exposed for 1/80 sec. at *f*/11 on Kodachrome 64.

Because this gray angelfish (right) was almost two feet long, I decided to use a 24mm medium-wide-angle lens on my Nikon F2, which I put in a Giddings-Felgen housing. This allowed for great depth of field. Shooting in the Florida Keys from a camera-to-subject distance of two feet with an Oceanic 2001 flash, I exposed for *f*/11, 1/80 sec. on Kodachrome 64.

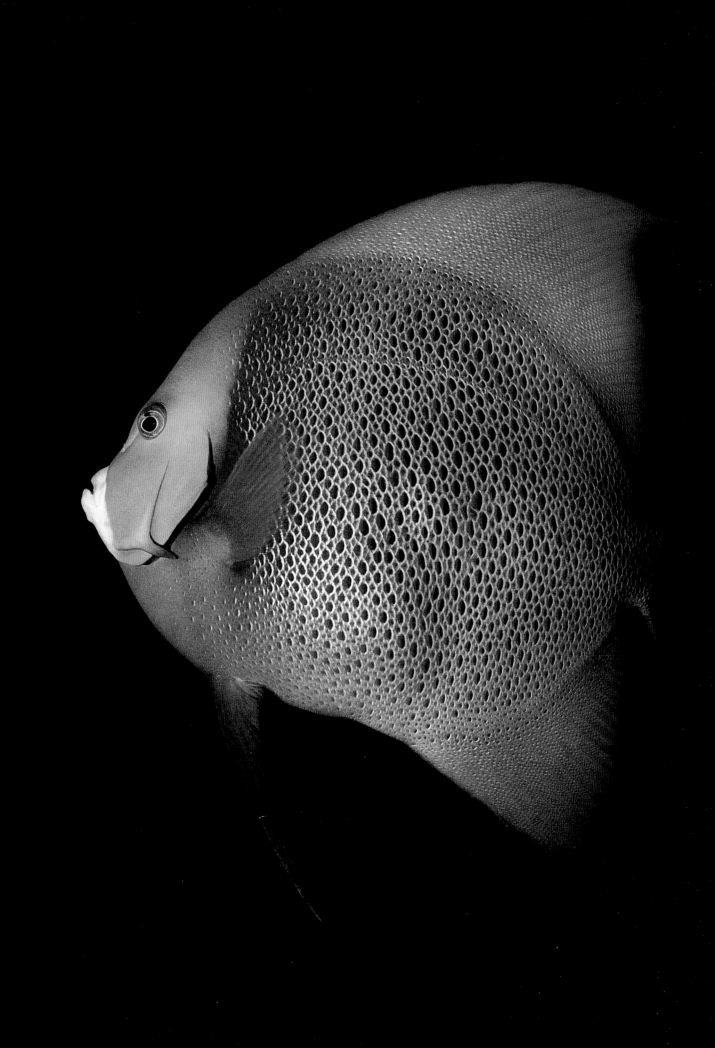

LIGHTING MEDIUM-WIDE ANGLES

Your main concern about lighting when you work with any wide-angle system is being able to adequately match the coverage of the flash unit to the size of the lens picture area. For most lenses in the 35mm to 24mm range, you can use medium-powered flash units that have beam angles of about 70 degrees. To ensure that these units have enough coverage, you can add a diffuser. This increases the angle of coverage and causes the loss of, at least, a full *f*-stop at the same time. Larger flash units with beam angles of 90 degrees or more match medium-wide-angle lenses easily.

Another option is to use a double-flash system. While the addition of another flash increases the potential for flash failure, it gives you greater creative control in terms of exposure and composition. This is particularly true of flash units that have multiple power settings.

Unlike closeup lenses, wide-angle lenses allow you to take pictures that include the surrounding environment — the big picture. But it is often impossible (or undesirable) to light the entire scene. The solution is to allow the ambient light to illuminate the background with ambient light and to balance the flash unit's lighting of the main subject in the foreground with the ambient exposure. This brings out the colors of the primary subject while giving it the context of its surroundings.

In the picture above, the photographer was working with a Nikonos V with a 28mm lens, which is a medium-wide-angle lens built specifically for underwater use.

For this shot of a lionfish (right), taken in the Philippines, I wanted to put the subject in the context of its environment. This required balancing the artificial light (from my Oceanic 2001 flash) in the foreground with the ambient light. But the most difficult part of taking this picture was waiting for the fish to turn toward the camera. I used a Nikonos III fitted with a 28mm lens and shot at a camera-to-subject distance of two feet. I exposed for 1/60 sec. at f/11 on Kodachrome 25.

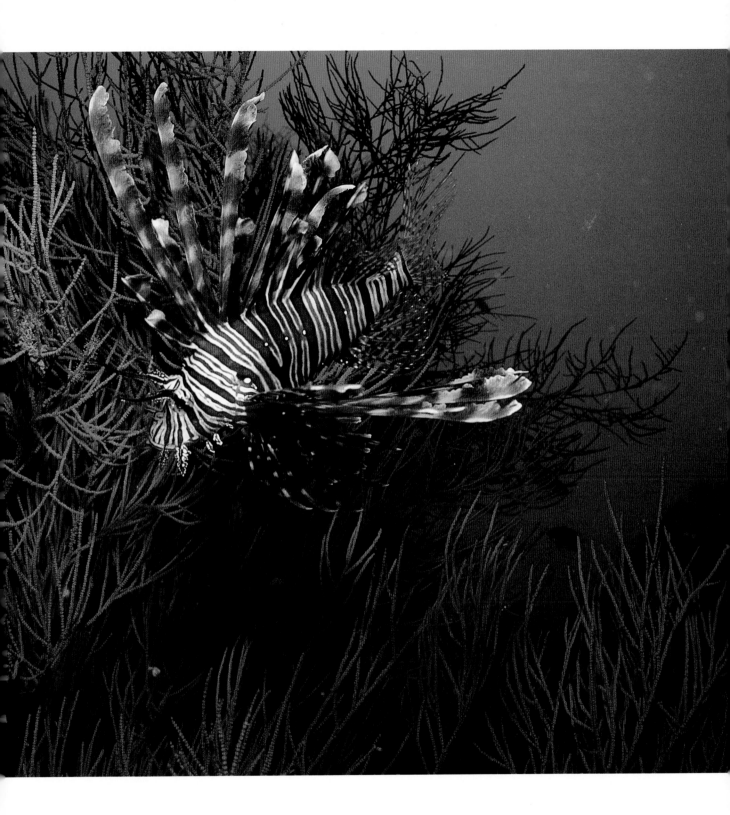

Although the mucus cocoon surrounding this queen parrotfish is highly visible (above), it's not readily apparent that I took this picture at night. Perhaps a black background would have made that clearer. I was working in St. Croix at a camera-to-subject distance of three feet. I used a Nikonos II fitted with a 35mm lens, and a Vivitar 283 flash. The exposure was f/8 at 1/60 sec. on Kodachrome 64.

With the picture on the opposite page, I was attracted to this particular plumose anemone, found in Puget Sound in Washington, because of its perfectly radial feeding tentacles that seem to sit on its elongated, upright body. In addition, the anemone was freestanding, enabling me to move around it easily in search of an acceptable camera angle. I shot from a camera-to-subject distance of two feet and used a Nikonos III, a 28mm lens, and an Oceanic 2001 flash. The exposure was f/11 at 1/60 sec. on Kodachrome 25.

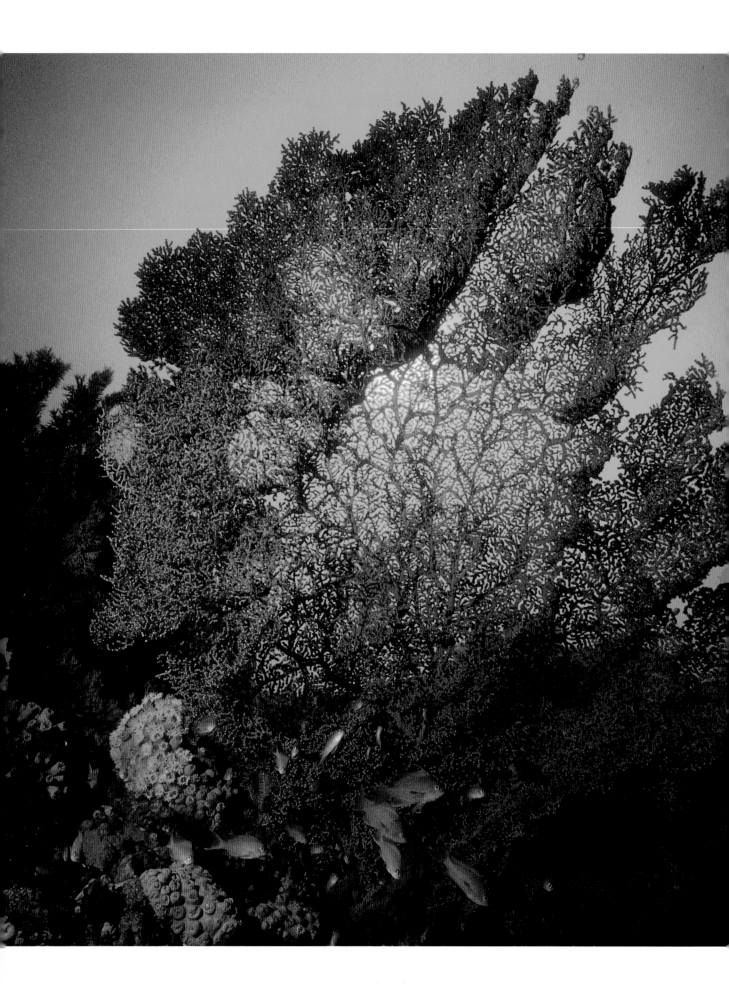

Like closeup lenses, wide-angle lenses are built with a specific purpose in mind: to reduce the camera-to-subject distance when large subjects are being photographed. Wide-angle lens configurations are particularly useful for photographing divers or groups of divers, shipwrecks, and such aquatic animals as dolphins and whales. The lenses also come in handy for shooting when visibility is poor; in these conditions, it is essential that camera-to-subject distances be kept to a minimum. Wide-angle lenses are also appropriate in low ambient-light situations because of the great depth of field they offer—even when you have to use large apertures.

Perhaps the greatest technical challenge to shooting wide angles is lighting the large picture areas they provide. Lighting systems for wide-angle photography almost always require wide-beam, high-power flash units, and they often call for double-flash systems to provide the necessary light coverage and intensity. These are the most sophisticated and complex systems in terms of lighting equipment and design for underwater photography.

The problem in taking this picture of a sea fan and a reef in the Philippines was maintaining some of the dramatic, strong backlighting while illuminating the foreground just enough in order to show some color and detail. Even though I was shooting at a depth of 80 feet, the sunlight was fairly intense, and I had to position my Oceanic 2001 flash five feet away from the subjects. Using my Nikonos III and a 15mm lens, I exposed at f/11 for 1/60 sec. on Kodachrome 64. The camera-to-subject distance was three feet.

SUBJECTS

You can make five basic kinds of images when you shoot with a wide-angle system. The silhouette involves an upward camera angle that places a large subject, such as another diver, the bottom of a ship, or a school of fish, between you and the sun. This creates tremendous shade contrast, which outlines the subject clearly. Ambient light is usually the only light source for a silhouette, but a little fill light can provide some color to the underside of the subject. A wide-angle lens allows you to include the entire subject in the picture from a close distance, ensuring a sharp, distinct delineation between the subject and the background. And, the lens's extensive depth of field keeps the subject in focus as well as sharpens the surface of the water.

Another typical wide-angle image is the reef scene. Commonly referred to as a *seascape*, this is a shot of an entire underwater area, such as a coral reef, kelp bed, or seagrass meadow. A wide-angle lens enables you to get close to a large section of this environment and allows the viewer to take advantage of the lens's great depth of field in order to see almost the entire area in focus. In

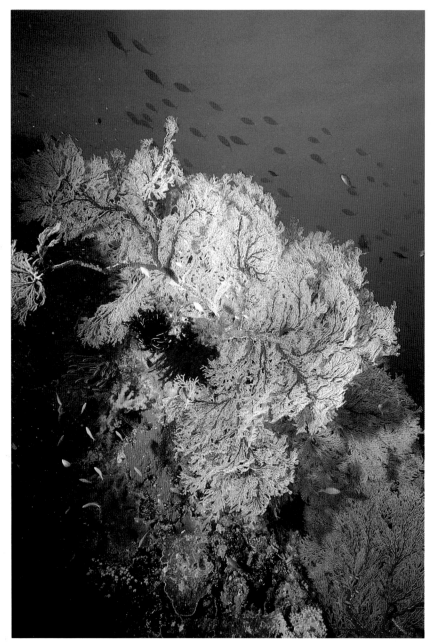

To get this wide-angle picture of a reef wall in the Philippines, I used my Nikonos III with a 15mm lens. I balanced the available light with the light from my Oceanic 2001 flash and exposed for f/5.6 at 1/60 sec. on Kodachrome 64. The camera-to-subject distance was four feet.

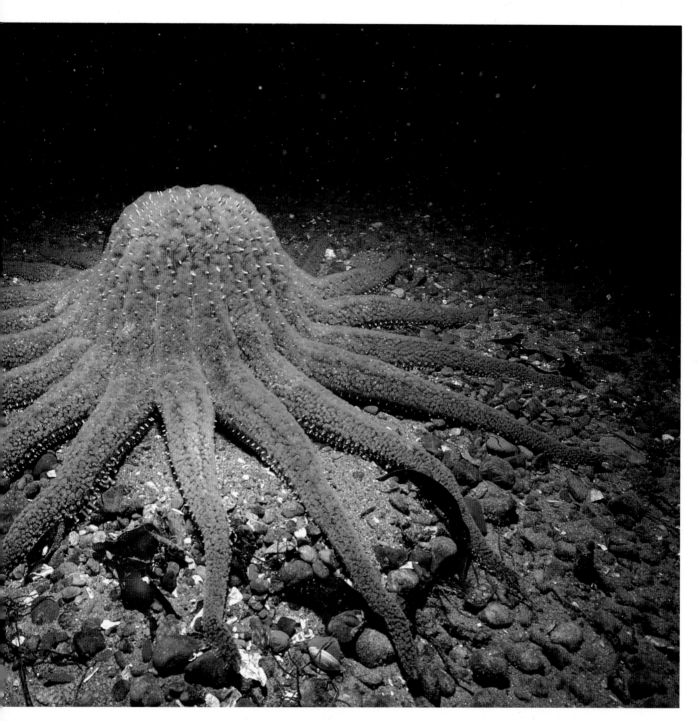

Visibility is often a problem in the waters off the Pacific Northwest coast. So, to capture such large subjects as this three-foot-long sea star, you must use wide-angle lenses. Limited by a visibility of 15 feet, I used a 20mm Nikkor lens. To minimize the inevitable backscatter, I positioned my Oceanic 2001 flash high over the subject. I also tried to find a camera angle that included as much of the homogeneous gravel bottom as possible, hoping the backscatter would blend in. This worked pretty well. The camera-to-subject distance was 18 inches. Using my Nikon F2 in a Giddings-Felgen housing, I exposed for 1/80 sec. at f/11 on Kodachrome 64.

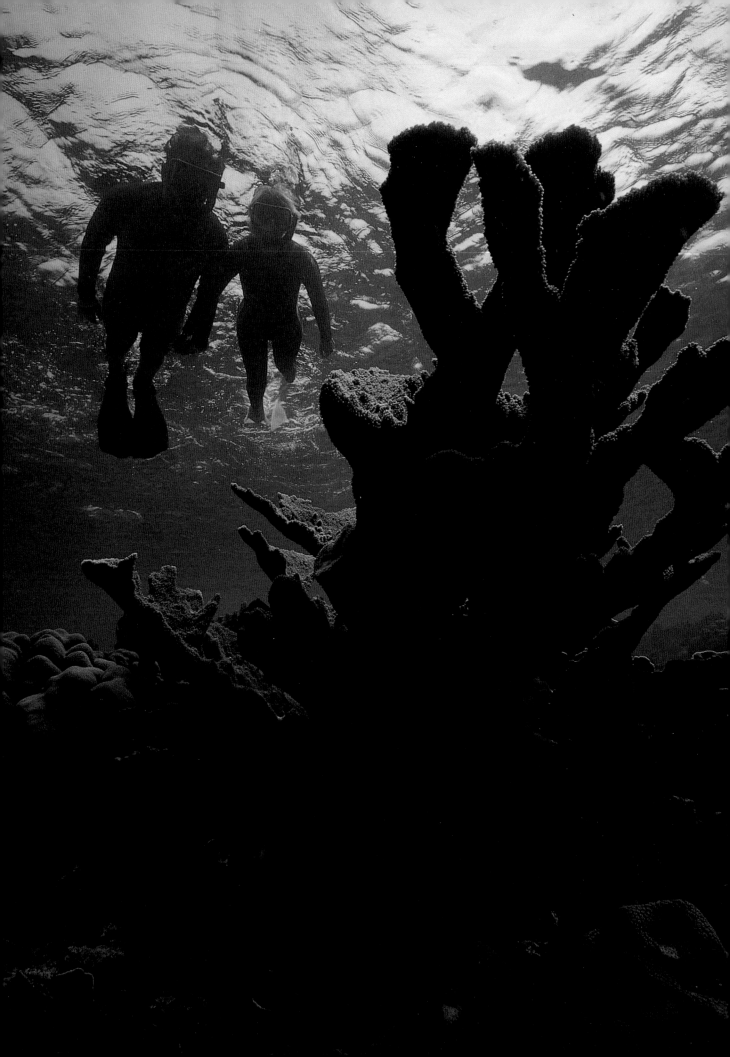

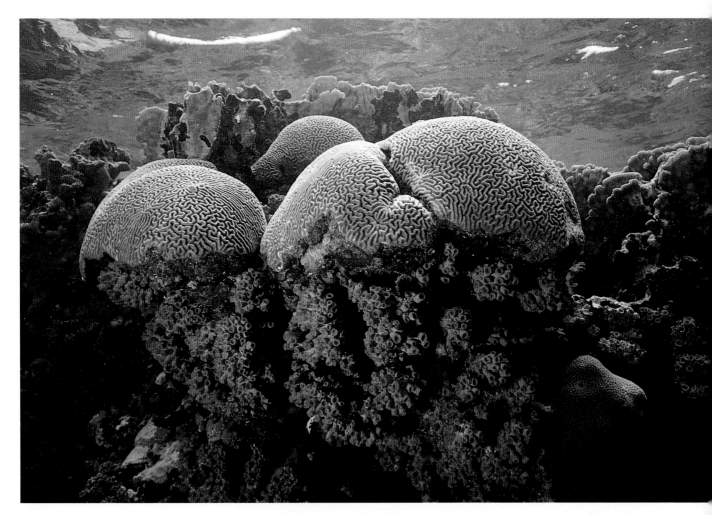

When I came across this coral head in Bonaire (above), I found it to be quite striking. I liked the tube corals growing underneath the brain corals, the orange color of the tube corals, and the tight pattern of the round brain corals. By using a 15mm wide-angle lens in my Nikonos V, I was able to accentuate the effect of the repeating shapes. I used a single Nikon SB-102 Speedlight, with its wide beam, to illuminate the orange tube corals from below. The amount of available light that illuminated the rest of the image was abundant. Shooting from a camera-to-subject distance of two feet, I exposed at f/11 for 1/90 sec. on Koda-chrome 64.

Wide-angle lenses can distort features. For the image on the opposite page, I got as close as I could to the elkhorn coral because I wanted it to seem imposing. By shooting from a camera-to-subject distance of four feet and upward from the base of the coral, it looks larger than it is — especially in relation to the snorkelers. Working in Bonaire, I used my Nikonos V with a 15mm lens and available light; the exposure was f/8 at 1/90 sec. on Kodachrome 64.

most seascapes, some identifiable part of the foreground — for example, a large sea fan — is illuminated; this artificial light is then balanced with the ambient light illuminating the background. These images can be stunning, and they offer the most accurate view of an underwater scene.

A variation of the seascape requires the addition of a diver to the picture, usually in the background swimming over the reef; the diver is often silhouetted. Here, the great depth of field of the wide-angle lens keeps both the diver in the background and the main subject in the foreground sharp. Placing a diver in any scene helps put the viewers in the environment, making them feel involved with, or perhaps even part of, the image.

Another wide-angle image is the "diver" shot. Here, the lens enables you to get very close to the subject, revealing such details as eye expressions, hand placement, and specific equipment. The subject is usually no more than three feet away from the

camera. Also, you can completely illuminate the diver. By carefully selecting the subject's dive gear for color and shape, you can arrange to have both shade and color contrast between the diver and the background.

The last wide-angle shot takes advantage of two characteristics of wide-angle lenses: good depth of field and perspective. In this picture, a small- to medium-sized subject, such as a sponge, is placed in the foreground, which is completely illuminated. You then place the camera extremely close to the subject — around a foot — and, usually, angle it upward. Then, when you balance the key artificial light with the ambient light, the foreground subject "pops" out of the picture as a result of color contrast. It appears to be large because of the forced perspective, which results from the proximity of the lens to the subject and the acute upward camera angle. This picture requires a lens with an angle of coverage of more than 80 degrees that can focus on an object 12 inches away.

For underwater photography, a lens must have an angle of coverage that exceeds 70 degrees in order to be considered a wide-angle lens. This type of lens has three major attributes. It has tremendous coverage, a product of its short (less than 24mm) focal length. As a result, you can get extremely close to large subjects, such as whales, and include the entire subject in your picture. A wide-angle lens also has great depth of field, which provides a generous margin for error in focusing. And, any help in focusing is welcomed underwater: it is difficult to focus accurately on a subject through two or more pieces of glass and, often, in low levels of light. Being able to maintain a large picture area while decreasing the camera-to-subject distance, therefore, is a necessity for photographing large objects underwater. Here, clarity and resolution become major considerations when you are just a few feet away from your subject.

When I came across this elephant-ear sponge in the Philippines (above), I wanted the sponge to stand out against the reef wall. I also wanted the numerous white sea cucumbers to be visible. Because the cucumbers provided an eerie look, I decided to enhance it by letting the surroundings go dark. To accomplish this, I aimed my Oceanic 2001 flash directly at the sponge from a short distance; this reduced the beam angle. And, by shooting from a camera-to-subject distance of two feet using a 15mm wide-angle lens, I was able to show the reasonably small cucumbers. With my Nikonos III, I exposed at f/11 for 1/60 sec. on Kodachrome 64.

For this shot, taken in Bonaire, the flash of the model's camera was set to go off when my flash fired. This is called a slave-triggering *system. It took several frames to balance the ambient light with the light from my Nikon SB-102 Speedlight to get the key light to trigger the slave flash, and to determine the power setting on the slave unit so that the anchor would be properly illuminated. From a camera-to-subject distance of 10 feet, I used my Nikonos V with a 15mm lens and exposed at f/5.6 for 1/90 sec. on Kodachrome 64.*

Viewfinder Systems

Several wide-angle lenses are available for viewfinder cameras, such as the Nikonos. The Nikonos system includes a selection of lenses with focal lengths that range from 21mm to the ever popular 15mm.

Wide-angle lenses for viewfinder cameras that will be used underwater require an optically corrected viewfinder. It acts like a lens, approximating the picture angle that the wide-angle lens "sees." The resulting view takes in more than what you can see normally. (The human eye has about the same picture angle as a standard 50mm lens used on land.) This is a little disturbing at first, and it is easy to ignore or overlook the outer limits of the picture when you look through an optically corrected viewfinder. Because of this oversight, the subjects in your first few sets of pictures might be smaller than you remember. When you use optical viewfinders, keep in mind that you have to get close to the subject as well as to compose the picture through the viewfinder. Only then can you see what the lens "sees," and not how you see the scene with a naked eye.

I took this photograph of a school of goatfish and a photographer in Bonaire. The only real problem was the high reflectivity of the silver scales on the nearly white fish. And, although I wanted the goatfish to be illuminated in the foreground, I didn't want them to completely dominate the scene. I liked the features of the pilings in the background, which were clearly visible in available light. The solution: I positioned my Nikon SB-102 Speedlight high above and at an angle to the goatfish so that any bright spots would bounce light away from my Nikonos III. I used a 15mm lens and shot from a camera-to-subject distance of three feet. The exposure was f/8 at 1/60 sec. on Kodachrome 64.

Housed Systems

One of the great advantages of a housed system over a viewfinder system designed for underwater use is that you have at your disposal all of the lenses manufactured for the land single-lens-reflex (SLR) camera that you will house. In most cases, this gives you a much broader selection of lenses of varying focal lengths in comparison to, for example, the relatively limited lens selection available for the Nikonos system. In terms of wide-angle lenses for SLR cameras, this selection ranges from relatively distortion-free 20mm lenses to fisheye lenses, which completely distort views and require special dome ports and lighting techniques. Having a large range of lenses to choose from gives you greater creative control in composing your images. It also allows you to match the correct focal length with the subject at hand.

With SLR systems, you immediately see what the lens sees because the lens acts like a viewfinder here. Even so, you might be too far away from your subject—a common mistake many beginners make—or you might look over the camera and think that the subject is close enough. Check again: it probably isn't.

Remember also that when you work with wide-angle lenses housed in a dome port, you have to correct for the distortion caused by refraction. Here, too, the dome acts like another lens element, altering the angle at which light enters the camera. And, keep in mind that there is no such thing as a port that is too domed for a wide-angle lens. But dome ports that do not curve enough in order to correct for distortion do exist. So, be sure to consult the manufacturer of the housing to guarantee that you match the right port with the right lens.

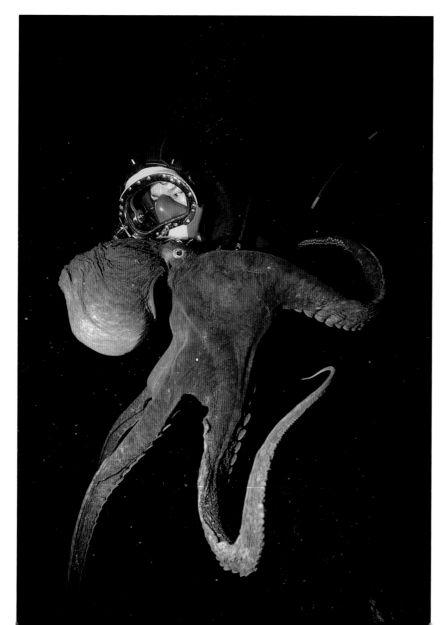

Setting up this shot in the Point Defiance Aquarium in Tacoma, Washington, required both shooting into as much water as possible and keeping my Oceanic 2001 flash close to the subjects. Shooting from a camera-to-subject distance of three feet, I used a Nikon F2 in a Giddings-Felgen housing, and a 20mm Nikkor lens. The exposure was f/11 at 1/80 sec. on Kodachrome 64.

Wide-angle lenses provide great depth of field, as in this picture of anchovies, which I took in the Florida Keys. The fish seem to be swimming off into the sunset. I used my Nikon F2 in a Giddings-Felgen housing and a 20mm Nikkor lens. Balancing the light from my Oceanic 2001 flash with available light, I exposed at f/8 for 1/80 sec. on Kodachrome 64. The angle of the light minimized the reflective quality of the anchovies' silver scales. The camera-to-subject distance was four feet.

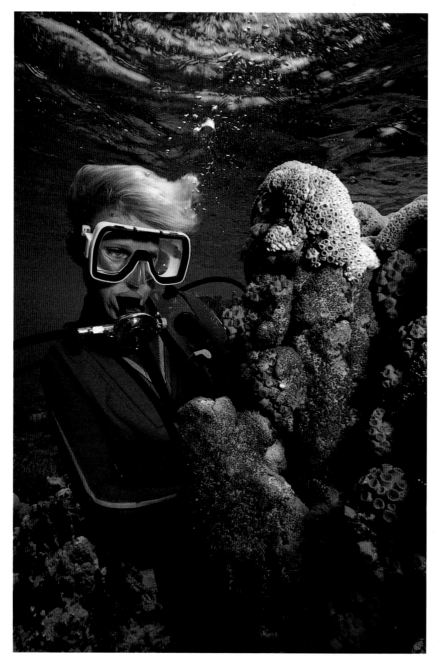

Providing light for wide-angle images is the most challenging lighting situation in underwater photography. Coverage and power are even more important with wide-angle lenses than they are with medium-wide-angle lenses. Only the largest and most powerful underwater electronic flash units can adequately cover lenses in the 90-degree category, and, in fact, two large units are often necessary. Power output becomes important because a great deal of energy is needed to spread light over a large area. As such, flash units must have battery systems and capacitors that can hold a substantial amount of juice.

Selecting a camera angle for a particular subject and background figures significantly in achieving adequate light coverage. An even background, such as a sandy ocean floor, will show any errors in flash placement clearly, while a subject protruding from a heterogeneous background, such as a tube sponge on a reef, will not show these errors as readily. Because the reef is irregular and the light is distributed evenly on it and the sponge, it is more difficult to tell just where the edge of the light is.

Flash placement is an important consideration in wide-angle shots for other reasons as well. With viewfinder systems, seeing images with the edge of the flash unit actually in them is quite common. The unit might not have been placed back far enough, and its obtrusive position had not been detected through the accessory viewfinder. The proper placement of the flash unit is essential also because if you don't position it high enough off the camera, backscatter will probably occur — even in clear water. The best flash placement for most wide-angle shots is high and directly above the camera. If you use two flash units, place them high above and at equal distances from the camera. Long flash arms or arm extenders are often necessary in order to accomplish this type of placement.

A popular alternative for flash placement for viewfinder cameras with wide-angle lenses is to hand-hold the key flash. Here, your arm acts like an extender. This technique works well

This image of a diver and a reef in Bonaire was taken in shallow water. We had plenty of time to set the shot up, were able to surface and talk about the shoot periodically, and, of course, had plenty of available light. I used a Nikon SB-102 Speedlight on quarter-power to balance the available light in order to brighten the orange tube corals, the model's matching equipment, and her eyes. The camera I used was a Nikonos V with a 15mm lens; the camera-to-subject distance was 18 inches. I exposed at f/11 for 1/90 sec. on Kodachrome 64.

When I was taking the photo on the opposite page, the challenge was to illuminate the entire school of goatfish with one Nikon SB-102 Speedlight. By stopping down and shooting into open water, I eliminated the possibility of creating any harsh shadows in the background. This decision also caused the scene to go black, thereby enhancing its dramatic effect. Shooting in Bonaire from a camera-to-subject distance of two feet, I used my Nikonos V with a 15mm lens. The exposure was f/11 at 1/90 sec. on Kodachrome 64.

with a system, such as the Nikonos, which has a 20mm or 15mm lens and allows you to look through the viewfinder with one eye and see where the flash unit is with the other. Remember to visualize the subject as being 25 percent farther away than it actually is to counteract the effects of refraction.

A good deal of wide-angle work involves balancing flash light and ambient light. This is directly related to the extensive coverage of wide-angle lenses, which enables you to capture the big picture. Artificial light alone is almost always inadequate for these spectacular scenes. The key to balanced lighting is accurately measuring the amount of available light, and then adjusting the power of the flash unit to match it. You can accomplish this by either placing the flash unit closer to the subject — which will make the flash "hotter" — or by adjusting the variable-power setting on the unit. This adjustment is much more convenient, and it requires less of a struggle with flash placement through flash-arm adjustments (unless, of course, you are hand-holding the flash).

Because of the number of variables in lighting wide-angle shots, I tend to bracket my exposures more when I photograph wide angles than when I shoot other kinds of images. I think making sure that I get a shot that might have required an entire dive to set up is worth a few more frames (and, sometimes, even a few rolls).

Bracketing exposures for wide-angles can be done several ways; the result you want determines which bracketing technique you employ. For example, when using only flash as key light, I bracket right off the aperture setting, shooting the first frames at the calculated setting. Then I make sure to shoot a few frames one or even two full stops above and below the calculated exposure.

When balancing available light with flash, I bracket two ways. First, to make sure that I have the ambient exposure correct, I keep the flash unit at the calculated distance and bracket the ambient-light reading by adjusting the lens aperture (described above for straightforward flash shooting). Next, I adjust the aperture setting according to the meter reading; then I bracket the matching flash exposure by changing the flash-to-subject distance or the power setting on the flash. The easiest and fastest way to do this is to hand-hold the flash.

What's most important to remember when bracketing either for exposure, focus, or composition (the latter two elements are necessary with viewfinder systems only) is to do something different with each frame. It's simple to take several shots the same way and think they are different. Be sure to significantly change the exposure, or with a viewfinder system, be sure to move the camera. Bracketing may seem a little like cheating, but given the unpredictability of shooting underwater, it's a technique that is widely accepted and used by professional photographers to ensure that they get the images they want.

What underwater photographers share with photographers who shoot on the 25 percent of the earth that remains relatively dry is how subjects are composed through the eyepiece of a camera. While much of what makes a "good" picture is in the eye of the beholder, some general techniques and guidelines will improve the arrangement of a subject and its surroundings — and will make viewers look at your pictures longer.

Basically, composition refers to how you position your camera with respect to both your subject and the area surrounding the subject. The subject's relationship to its environment is also a factor in composition. Underwater, there are three general spaces that constitute backgrounds for 90 percent of the images taken: the water's surface, open water (an unobstructed view below the water's surface), and the seafloor. The way you arrange subjects in each of these settings through the viewfinder is not unique to the underwater world. Rather, the settings are. And it is the subject's response to these spaces — in terms of its behavior — that makes underwater images so engaging. After all, the underwater world is foreign to most people. Applying basic compositional techniques to the arrangement of subjects in these settings will add greatly to the visual excitement your images will hold for your audience. Your photographs will, undoubtedly, captivate them.

This image, taken in Puget Sound in Washington, is strong compositionally for two reasons. The squid are oriented to form parallel diagonal lines across the image. Also, the very visible, large eyes of the squid act as focal points, giving you something to return to as you scan the image. You can't miss the eyes because they are located on the diagonal lines created by the squid's bodies. I used my Nikonos III, a closeup lens over the 28mm primary lens, and an Oceanic 2001 flash. From a camera-to-subject distance of 10 inches, I exposed at f/16 for 1/60 sec. on Kodachrome 25.

BASIC COMPOSITION

A simple way to begin composing a picture is to divide the image into smaller, equally sized units. By doing so, you will be able to see spatial relationships among the subjects more easily and determine whether or not you want to rearrange — and improve — them. A standard division of picture area is known as "the rule of thirds." This approach divides the picture into three equal units vertically and horizontally, creating nine equal areas and four equidistant line intersections. This framework (see below) provides a conceptual structure within which you can manipulate the relationships between objects and spaces.

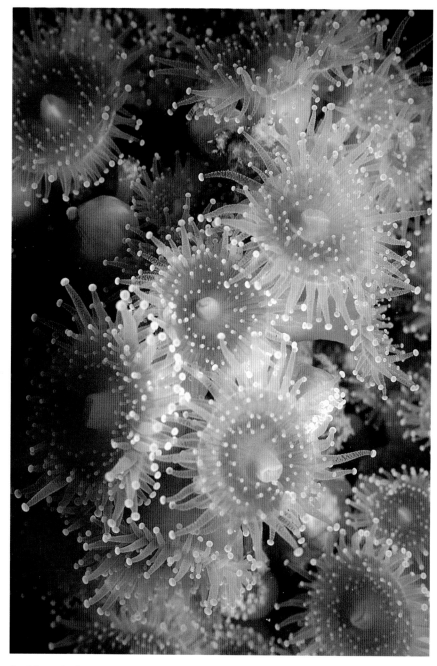

In this vertical image of strawberry anemones, the space between the groups creates two parallel diagonal lines and divides the groups into distinct units. The anemone in the upper left corner balances the anemones in the lower right. The central cluster of anemones contains a bit of a curve, which adds to the overall radial pattern. Shooting in British Columbia, I had mounted a 1:2.75 extension tube and a 28mm lens on my Nikonos III. I also used a Vivitar 102 flash and exposed at f/16 for 1/60 sec. on Kodachrome 25. The camera-to-subject distance was a mere 3½ inches.

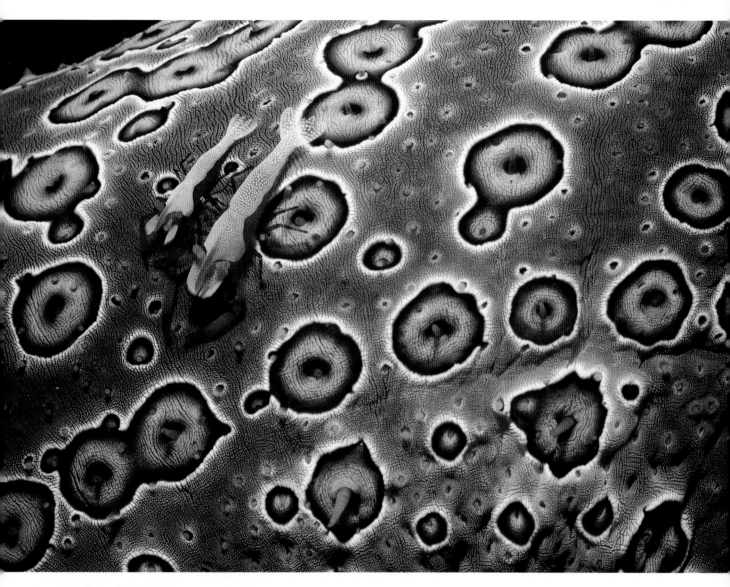

I used the "rule of thirds" when composing this image in the Philippines. I positioned the shrimp at the intersection of two imaginary lines, and it acts as a focal point in the picture. I also considered the curve of the line of repeating round shapes, which was created by the tube feet of the sea cucumber starting in the lower left corner and sweeping across the bottom of the image. This curve subtly underscores the placement of the shrimp. I used my Nikonos III, a 1:2.75 extension tube, a 28mm lens, and a Vivitar 102 flash. The camera-to-subject distance was 3½ inches. The exposure was ƒ/16 at 1/60 sec. on Kodachrome 25.

There are other ways to divide the picture area using "connect-the-dots" approaches. One of these strategies adds diagonal lines to the grid (see opposite page). Now, diagonal lines are formed by connecting points, such as point A to N, which crosses points E and J. As a result of these diagonal lines, your eyes move across the entire picture area, usually from left to right. Any object that falls on these lines is seen immediately, particularly an object that falls on the points where the lines intersect. When shooting, then, try to find lines in your subject, and position the camera so that they create diagonals across the image.

Another connect-the-dots approach is called "the lazy S." You see it most often in automobile ads in which a vehicle is being driven on a winding road. Here, the "S" is created by connecting points H, B, J, and G with a curved line. It moves the eye across the entire picture area as it divides the picture area into two sets of roughly equal and facing spaces: the lower left is opposite the upper right, and the upper left is opposite the lower right. Also, notice that the curved line runs through one of the central intersections, point J. In the car ads, the vehicle is usually positioned at one of these imaginary intersections. As the eye follows the road, it eventually reaches the focal point of the picture: the car. Keep this idea in mind when you look through the viewfinder. Composing graphic lines strengthens pictures.

The spaces created by imaginary lines, such as diagonals and the lazy S, can be considered either positive or negative space. Positive space is easy to identify because it contains the subject or some part of it. Negative space is usually part of the background, against which the subject is placed; it can emphasize or obscure the main subject, depending on how you use it. Underwater subjects are often effectively isolated in negative space against a black background, which is created by shooting into open water at a small aperture.

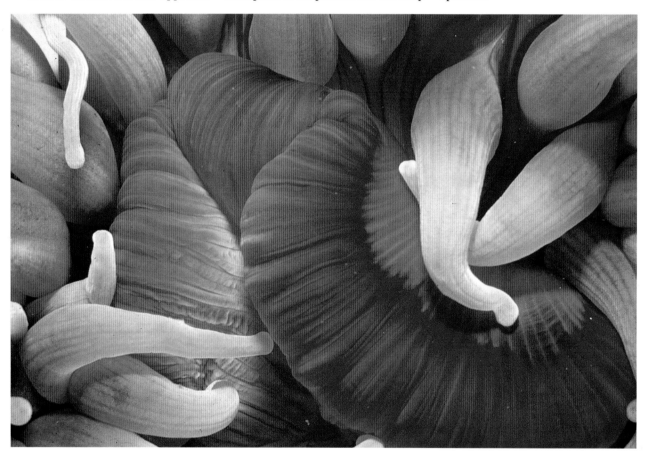

There are three strong compositional elements in this image of a sea anemone's mouth, taken in the Strait of Juan de Fuca. First, the tentacles in the lower left corner oppose the tentacles in the upper right. This balancing, along with the orientation of the mouth, forms a diagonal. Finally, a soft, S-shaped curve is formed by the mouth in the lower left and travels through the middle of the image to the lower right corner. Shooting from a camera-to-subject distance of 3½ inches, I used my Nikonos II on which I had mounted a 1:2.75 extension tube and a 28mm lens, as well as a Vivitar 102 flash. The exposure was f/16 at 1/60 sec. on Kodachrome 25.

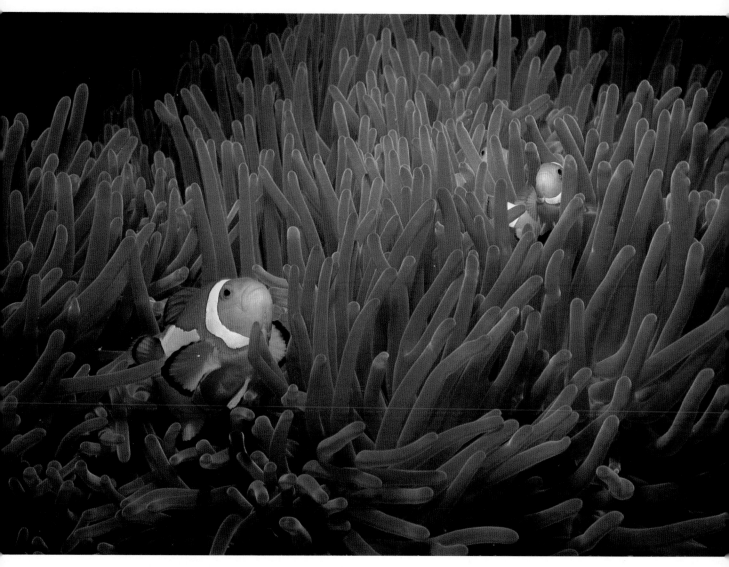

Anemone fish are relatively easy to photograph because they don't wander far from their anemone hosts. They are also fun to work with compositionally because of the lines created by the anemones' tentacles. For this shot, taken in the Philippines, the whole group cooperated. I positioned the larger adult at the intersection of two imaginary lines in the lower right and the two juveniles at the intersection of two lines in the upper left. The diagonal line running between these two points connects the fish. From a camera-to-subject distance of 10 inches, I photographed these anemone fish with my Nikonos III, fitted with a closeup lens over the 28mm prime lens, and an Oceanic 2001 flash. I exposed at f/16 for 1/60 sec. on Kodachrome 25.

Negative space also plays a key role in creating a balanced image. This can most clearly be seen in a picture that has a strong diagonal line running from an upper corner to the opposite lower corner. The line effectively divides the picture into two roughly equal parts (see right). With the creation of a significant amount of negative space in both areas, the picture becomes balanced. You can also achieve balance by placing paired subjects in opposing upper and lower corners of an image, thereby creating a diagonal line that connects them. More often than not, the paired subjects will fall on opposing line-intersection points. So, recognizing and using negative space are important elements of composition.

In this picture of a school of mullet, taken in Bonaire, the fish form a diagonal that extends from the upper left corner to the lower right. This creates an effective balance of negative space: the dark area in the lower left portion of the picture and the open water in the upper right. Shooting from a camera-to-subject distance of 10 feet with a Nikonos IV fitted with a 20mm lens, my associate took advantage of the available light and exposed for f/8, 1/60 sec. on Kodachrome 64. © Robert Frerck.

Another fundamental way to compose an image is a direct result of the rectangular picture area of the 35mm film format. You can manipulate the position of this rectangle to create a horizontally or vertically oriented picture simply by holding the camera in the usual way or by turning it on its side, respectively. Most pictures, however, are taken horizontally because it is easier: the controls on 35mm cameras make a horizontal orientation for shooting more convenient and comfortable. Theoretically, about 50 percent of your images should be horizontal; the rest, vertical. Some subjects simply cry out for a vertical format, such as a jellyfish's long, trailing tentacles or a diver suspended in the water. Be aware of vertical subjects, and take the extra time necessary for turning the camera on its side.

A final basic rule of composition is to find or create a strong focal point for an image. The eye recognizes the focal point and then explores the rest of the picture. By placing the focal point at the intersections of imaginary lines (points E, F, I, or J in the figure on page 129) and connecting these points with a diagonal or a curved line, you can direct the viewer's eye through the photographs. A good example of a focal point is a subject that stands out against a background because it is brightly colored or has a marked shade contrast with the background. (This technique is often used to isolate a subject using available light.) An effective — and frequently used — focal point for a closeup is the eye of a fish.

As you can see, all of these various compositional techniques work together to create a visually exciting and pleasing photograph: focal points, diagonals, curved lines, balance, positive and negative space, and camera orientation.

This photograph of sea-lily arms, taken in the Philippines, shows clearly what happens when you turn a camera on end and shoot a subject vertically. It also shows how repeating diagonals keep your eyes moving across an image. I had mounted a 1:2.75 extension tube and a 28mm lens on my Nikonos III, and, at a distance of just 3½ inches from the subject, I exposed the scene at f/16 for 1/60 sec. on Kodachrome 25. I also used a Vivitar 102 flash for this shot.

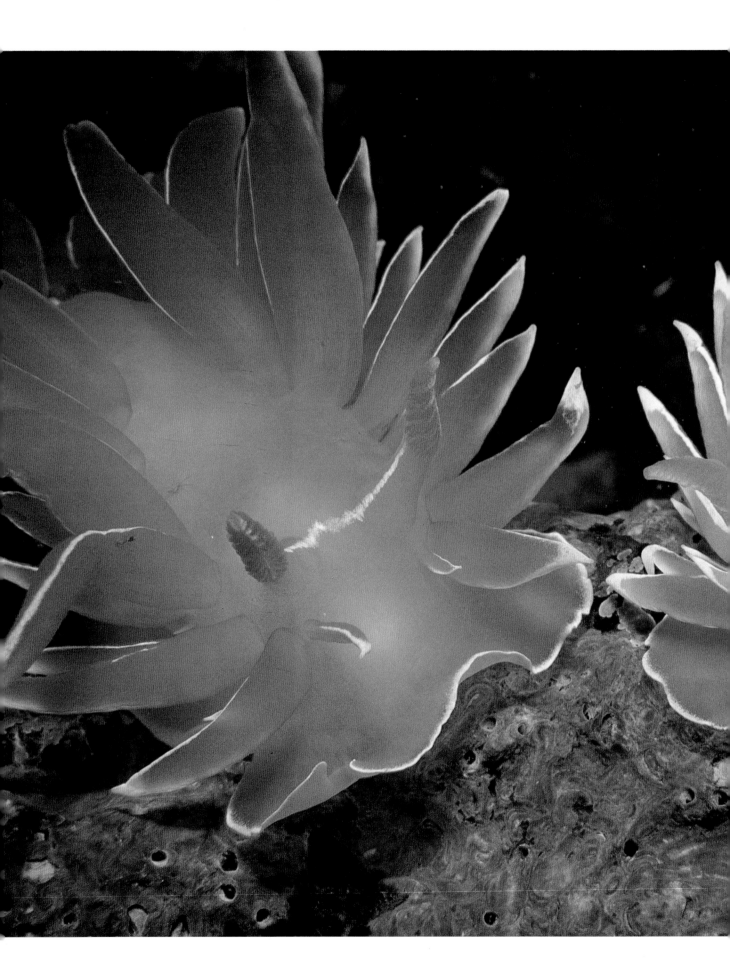

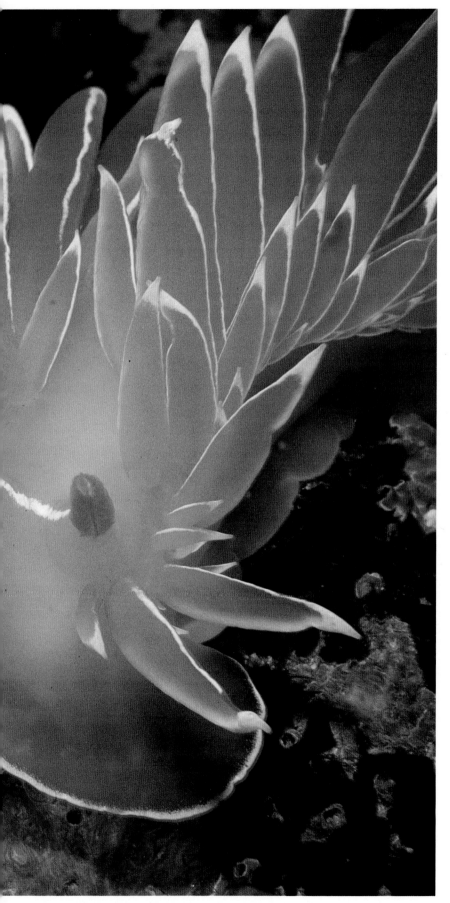

The opposing curves of these two alabaster nudibranchs balance this picture as they pull your eyes into the center of the shot. Mirror images like these can often be used for balancing spaces in photographs. For this picture, taken in the San Juan Islands, I used a Nikonos II, a 1:2.75 extension tube, a 28mm lens, and a Vivitar 102 flash. The exposure was f/16 at 1/60 sec. on Koda-chrome 25. The camera-to-subject distance was just 3½ inches.

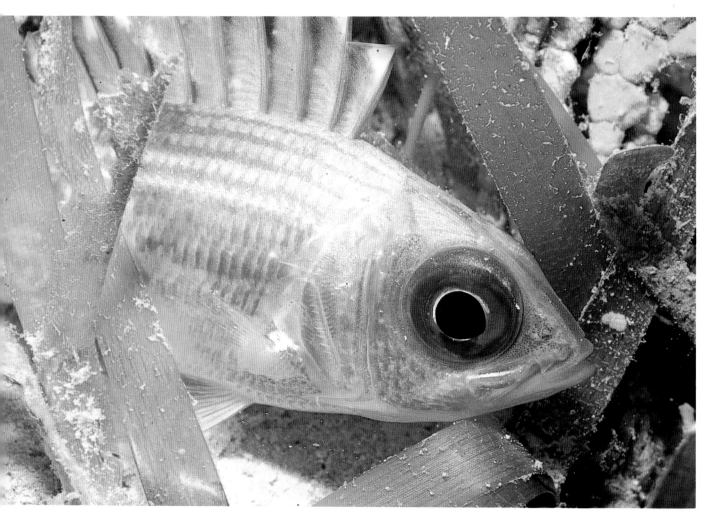

In the picture above, taken in St. Croix, the eye of the squirrelfish is clearly the point of focus. As such, I positioned it at an intersection of imaginary lines. The curved lines on the top and bottom of the fish then pull the viewer's eyes across the picture. The fish is framed by the two diagonal lines created by the seagrass on both the left and right sides of the image. I shot at a camera-to-subject distance of 3½ inches and used a Nikonos II, a 1:2.75 extension tube, a 28mm lens, and a Vivitar 102 flash. I exposed for f/16 at 1/60 sec. on Kodachrome 25.

I decided that a vertical orientation of my camera was appropriate for this black coral that I came across at the CoCo View Hall in Roatan. The gently curving diagonal lines of the coral (right) lead your eyes to all parts of the image and back again. I used a Nikonos V, a 1:1 extension tube, a 35mm lens, and a Helix Aquaflash 28. The exposure was f/16 at 1/90 sec. on Kodachrome 25.

The long, trailing tentacles of this jellyfish (opposite page), which I found in Puget Sound in Washington, clearly call for a vertical orientation of the camera. I used my Nikonos III, mounted with a 1:2.75 extension tube and a 28mm lens, and a Vivitar 102 flash. I exposed at f/8 for 1/60 sec. on Kodachrome 25. The camera-to-subject distance was just 3½ inches.

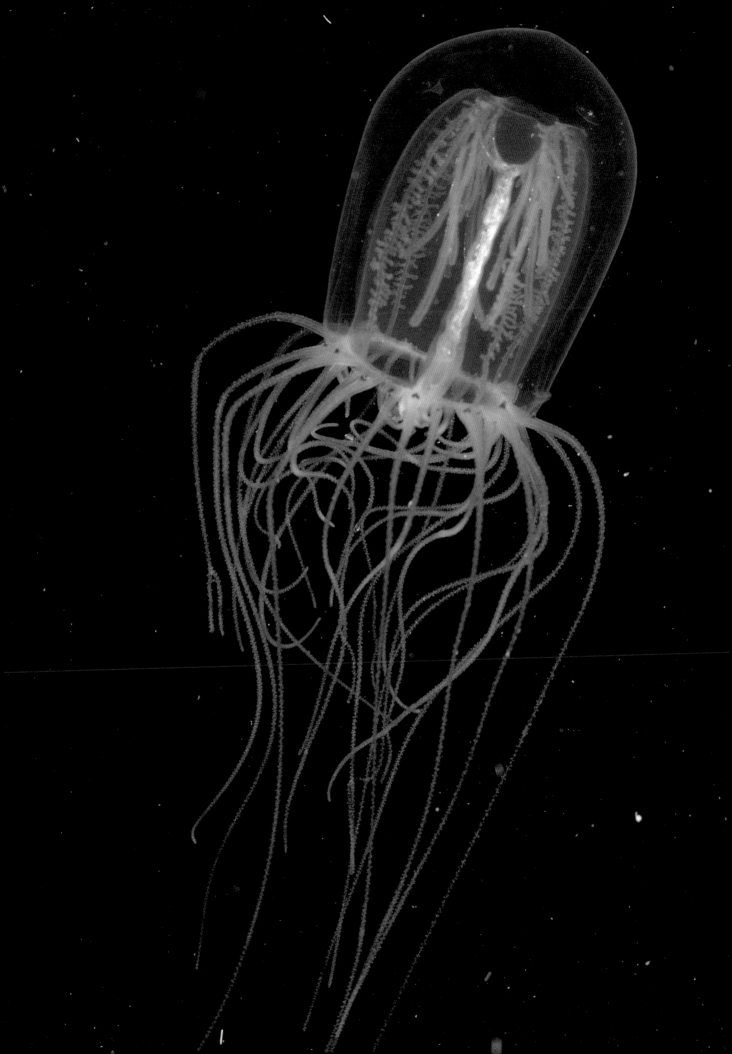

UNDERWATER COMPOSITION

A few composition considerations are unique to the underwater world. In some cases, they are advantageous; in others, they make composing an image most difficult.

One of the most important issues is weightlessness. Underwater you can often get a 360-degree view of your subject in every plane. This gives you the opportunity to look over a subject completely as you search for the best camera angle. It also allows you to manipulate lighting, particularly available light. You can backlight the subject on one side, creating a silhouette. And, by swimming around to the opposite side, you can frontlight the subject, revealing its details. You can even change your position in relation to subjects that are attached to the sea-floor through the flip of one of your fins. As you can see, weightlessness gives you great flexibility in terms of composition.

The ability to alter camera angles by repositioning your body underwater depends entirely on your diving skills. The most critical of these is buoyancy control, which enables you to quickly and easily place your body and, thus, your camera in any attitude: up at a passing manta ray, down at other divers descending an anchor line, or sideways around a coral reef. Having both the ability to change body positions with ease, control, and grace and a sense of where your body is in relation to other objects greatly increases your chances of composing images well and taking good pictures.

When I saw this rather serious-looking tiger rockfish in Puget Sound in Washington, I decided to add to its dramatic look by framing the fish in darkness. The arrangement of negative space helps to balance the area in the lower left and the dark area in the upper right. The rockfish's fin in the lower right of the picture connects it to the perimeter of the image; the fin pulls your eye around the entire picture. In addition, the lines on the fish's cheek also help to draw your eyes to its eye, a focal point of the image. I used a Giddings-Felgen housing on my Nikon F2, a 55mm Micro Nikkor lens, and an Oceanic 2001 flash. I exposed at f/11 for 1/80 sec. on Kodachrome 25. The camera-to-subject distance was one foot.

You can ordinarily use the sun as a focal point in some way for silhouettes. In this shot, I placed the sun near an intersection of imaginary lines and connected the jellyfish to it. Notice that the jellyfish is in a tipped position to create a diagonal line.
Shooting in the Florida Keys from a camera-to-subject distance of two feet, I used my Nikonos III with a 28mm lens. I balanced the light from my Oceanic 2001 flash with the ambient light. The exposure was f/11 at 1/60 sec. on Kodachrome 25.

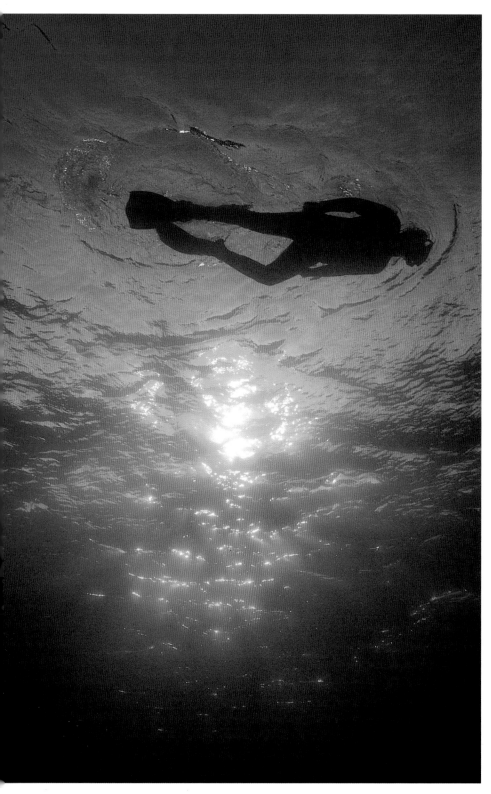

While the pattern of available light filtering through the water's surface in this photograph is appealing, the addition of the diver's form greatly increases the interest level in the picture. Because the diver is high in the frame, he balances the light below and is clearly silhouetted against the contrasting light background of the sky. Shooting in Roatan, I used my Nikonos III with a 20mm lens and exposed at ƒ/11 for 1/60 sec. on Kodachrome 64. The camera-to-subject distance was 10 feet.

Buoyancy control near the seafloor is particularly important. If you can keep from stirring up sand, silt, and other particulate matter, you will help eliminate backscatter from your photographs. So knowing where your fins are and what they are doing at all times is essential in such situations. In fact, I don't wear ankle weights because I want to keep my negatively buoyant fins off the seafloor as much as possible. Sometimes, when I find a camera angle I like, I even take my fins off. (One other point about buoyancy control: it can help you avoid inadvertently kicking a delicate branching coral, rubbing an elbow over a sponge, or squashing a tubeworm as you look for a handhold on a rock — some of the very subjects you are trying to immortalize on film.)

Finally, there are some environmental factors underwater that can affect your ability to compose an image. As it is on land, the position of the sun is of utmost importance underwater because of its direct impact on the amount of light available. Light levels underwater tend to be inadequate, and the variability of light intensity increases when the sun is low on the horizon.

In addition, any kind of water movement can be either a help or a hindrance as you compose underwater. Strong water currents can prevent you from remaining stationary. Positioning yourself in a current is the ultimate test of your diving skills: often you need to be able to read tide tables but you should always exercise good judgment in planning a dive before you even enter the water. Getting into a suitable position can be hard enough when you are the only moving object; it is more difficult when the subject is moving as well. Both compound the problems of composition. Furthermore, using a housed single-lens-reflex (SLR) camera is "challenging" in situations involving high currents or surging waves. Knowing ahead of time that such conditions exist might make you switch to a viewfinder system for a particular dive.

Small amounts of water movement can, however, be helpful. By positioning yourself so that your subject is up current, you can eliminate any potential backscatter from disturbed particu-

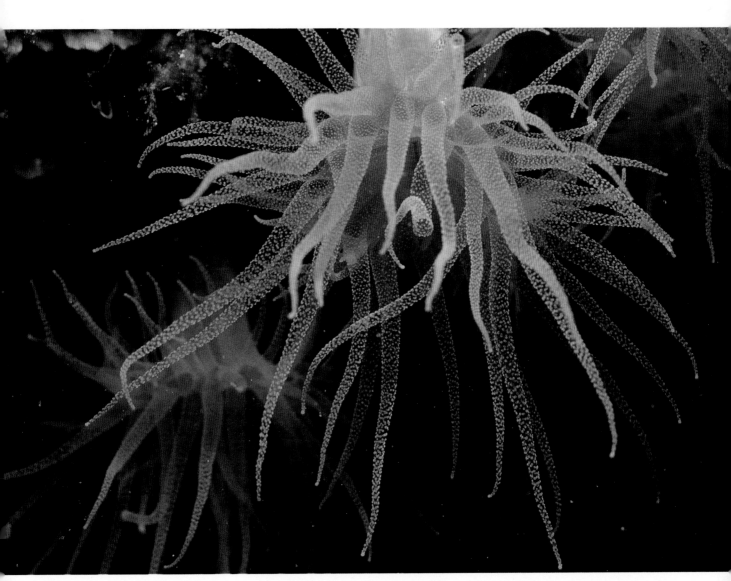

late matter on the seafloor. You can also use currents to predict the direction in which a subject will travel as well as the subject's position in relation to the current, such as swaying kelp and fish that move with the current.

In underwater photography — as in any kind of field photography — getting you and the camera in position in relation to your subject is essential in terms of composition. You can, however, have superb technical knowledge or a tremendous eye, or both, but neither will be much good underwater if you do not have excellent diving skills. These are necessary for you to be able to apply your photographic expertise. Developing such skills and gaining confidence requires good training initially and logging time underwater. You need to practice and become proficient at various tasks, including buoyancy control, air consumption, and navigation. The higher the level of your skills, the more comfortable you will feel underwater and the more time you will have to concentrate on finding subjects and composing images.

An outstanding physical characteristic of this tube coral, which I came across on a dive in the Philippines, is the arrangement of the stinging cells in the almost transparent tentacles. In order to enhance this, I used a camera angle that allowed the open water to be part of the background. The repetitive pattern of the polyps also serves to strengthen the image, creating a diagonal from the lower left corner to the upper right. Shooting from a camera-to-subject distance of 3½ inches, I used my Nikonos III, a 28mm lens, a 1:2.75 extension tube, and a Vivitar 102 flash. The exposure was f/16 at 1/60 sec. on Kodachrome 25.

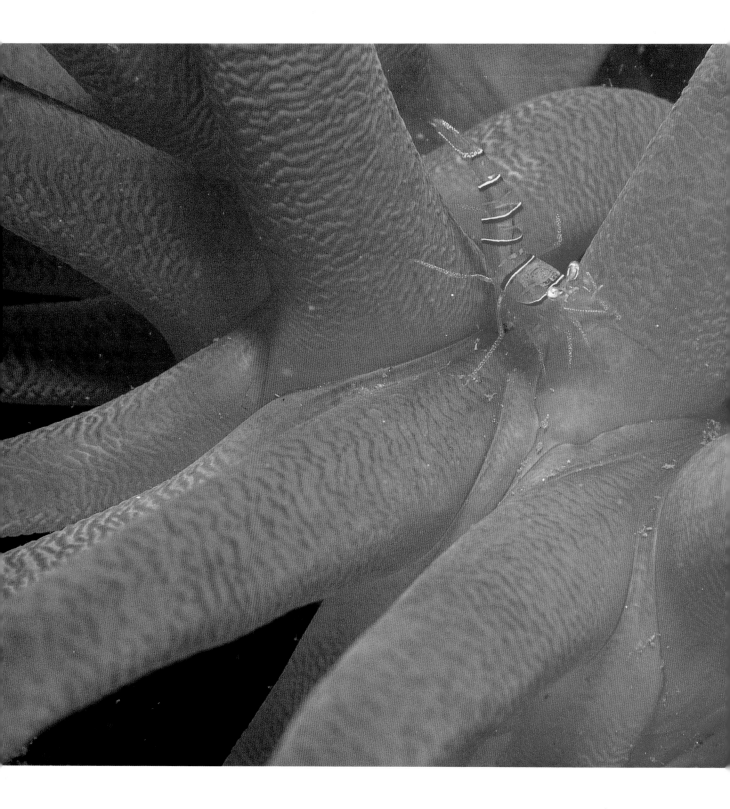

When I came across this black-spotted pufferfish in the Philippines (above), I decided to isolate it by surrounding it with darkness. To do this, I photographed the fish in open water. From a camera-to-subject distance of 10 inches, I used my Nikonos III, a closeup lens over the 28mm prime lens, and an Oceanic 2001 flash. I exposed at ƒ/16 for 1/60 sec. on Kodachrome 25.

You can sometimes use the outline of the picture area itself as a compositional tool. In the photograph on the left, the focal point is the anemone shrimp. Shooting in British Columbia, I positioned the shrimp in the center of the radiating tentacles; these extend to the edge of the picture. No matter where you look in this image, your eyes eventually follow a tentacle line back to the shrimp. I used a Nikonos III, mounted with a 1:2.75 extension tube and a 28mm lens, and a Vivitar 102 flash. The camera-to-subject distance was a mere 3½ inches. The exposure was ƒ/16 at 1/60 sec. on Kodachrome 25.

SCIENTIFIC NOMENCLATURE

The following is a list of the common and Latin names of the organisms featured in this book. Page references are in parentheses.

INDEX

Edited by Liz Harvey
Designed by Jay Anning
Graphic production by Hector Campbell